# JEAN LUC MYLAYNE

TWIN PALMS PUBLISHERS 2007

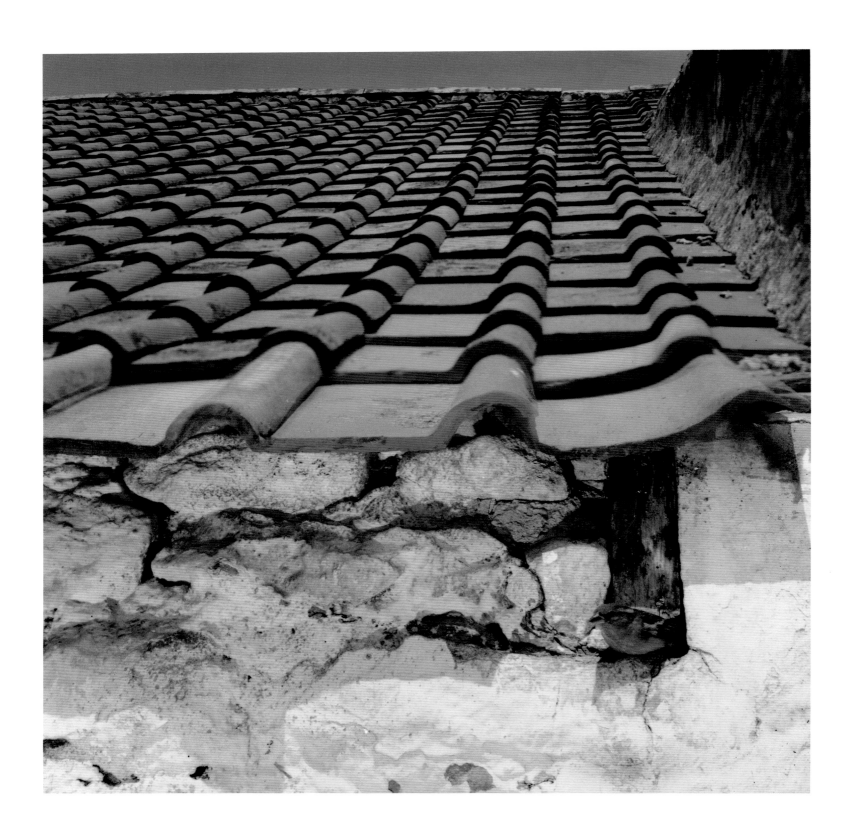

*Plate 1.* No. 28, June July August 1981, 40.5/40.5 in.

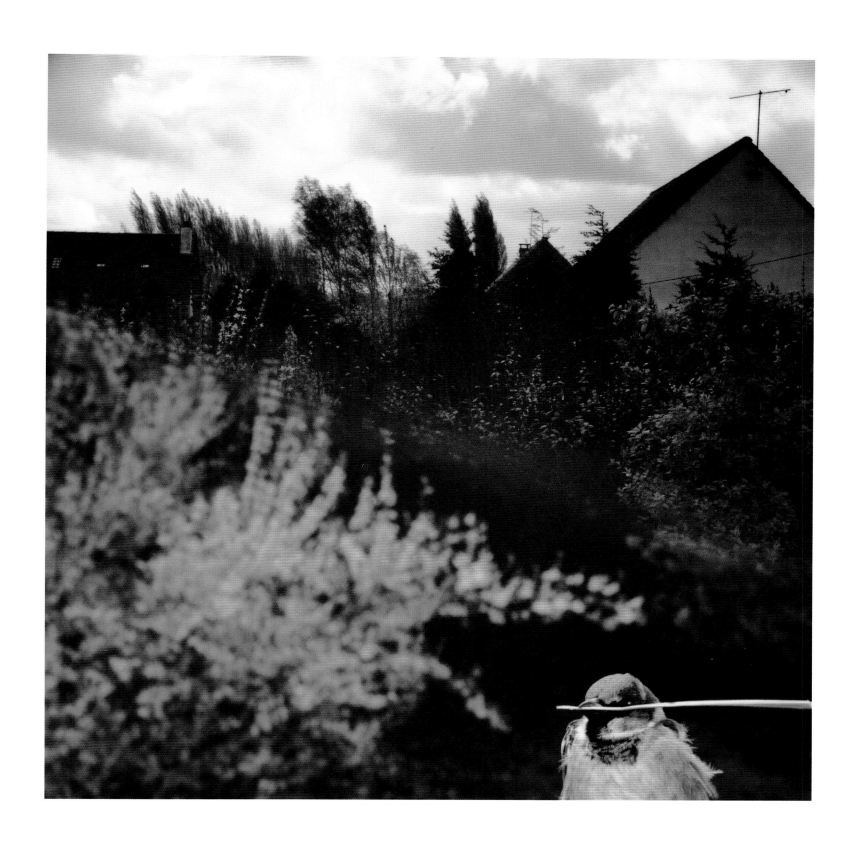

*Plate 2*. No. 41, April May 1986, 40.5/40.5 in.

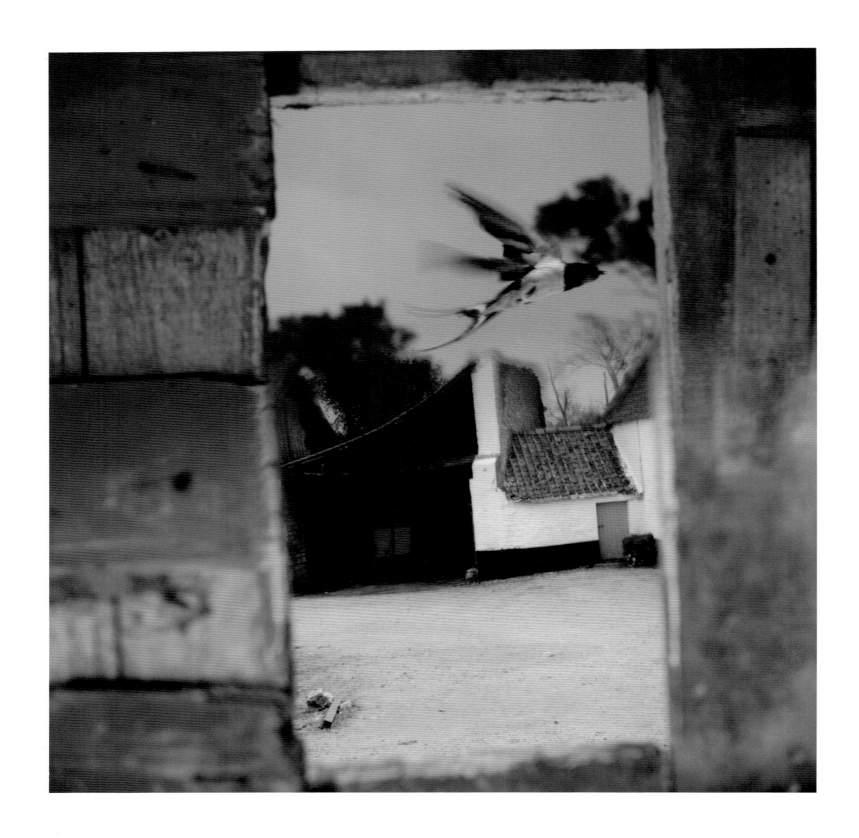

*Plate 3.* No. 4, June July August 1979, 48.5 / 64.25 in.

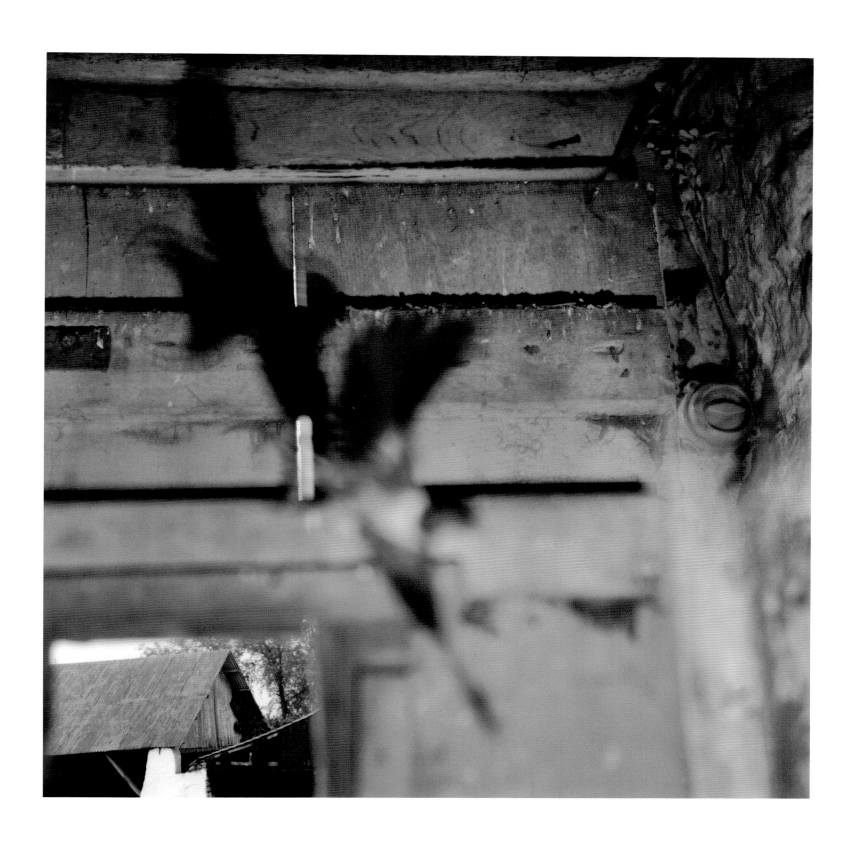

*Plate 4.* No. 6, June July August 1979, 34.75/34.75 in.

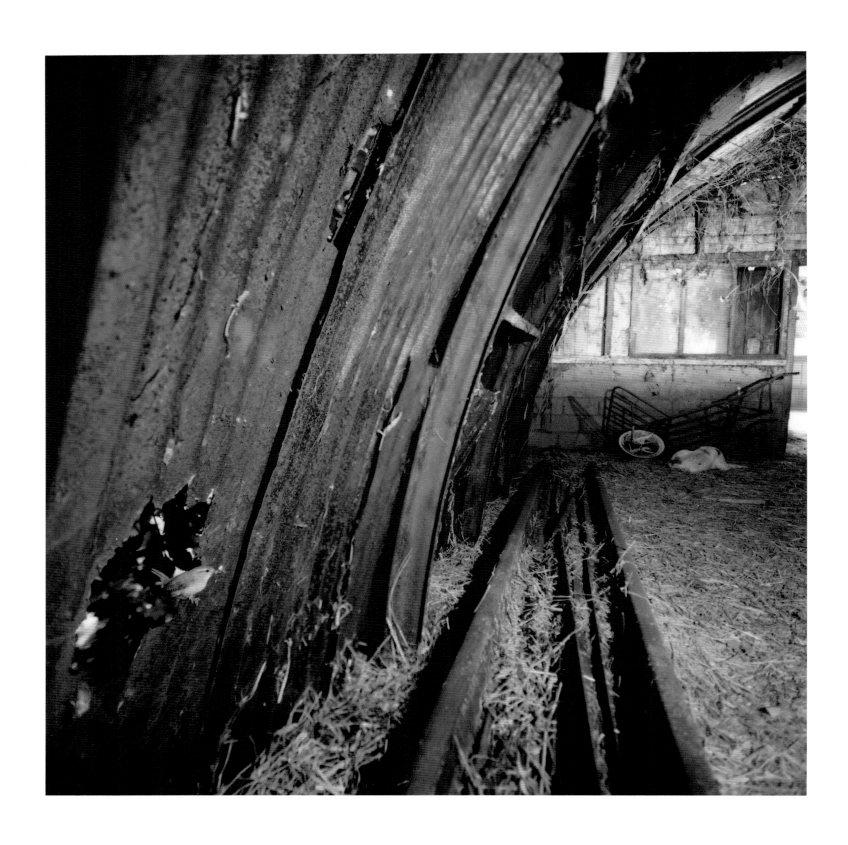

Plate 5. No. 43, June 1986, 40.5/40.5 in.

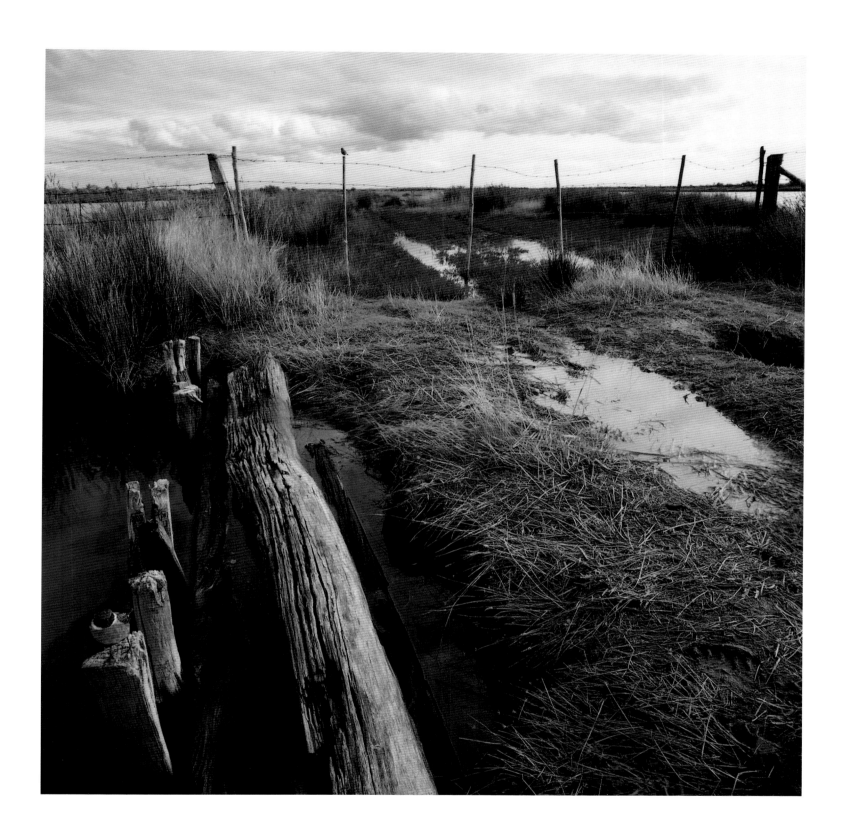

*Plate 6.* No. 97, August 1990–December 1991, 24.75/24.75 in.

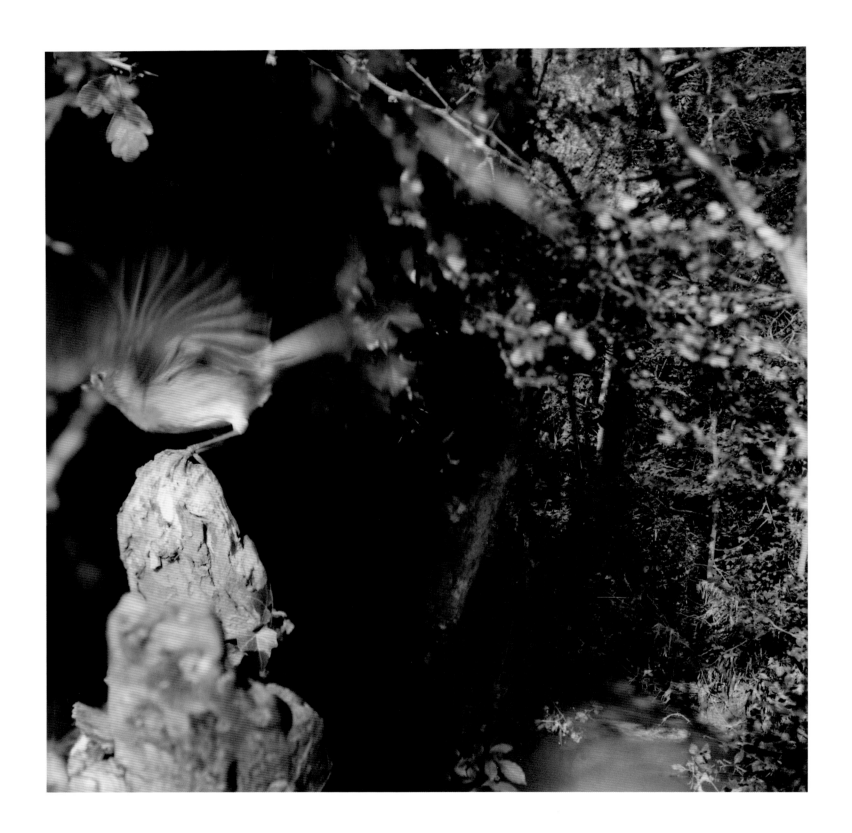

*Plate* 7. No. 8, September 1979, 40.5/40.5 in.

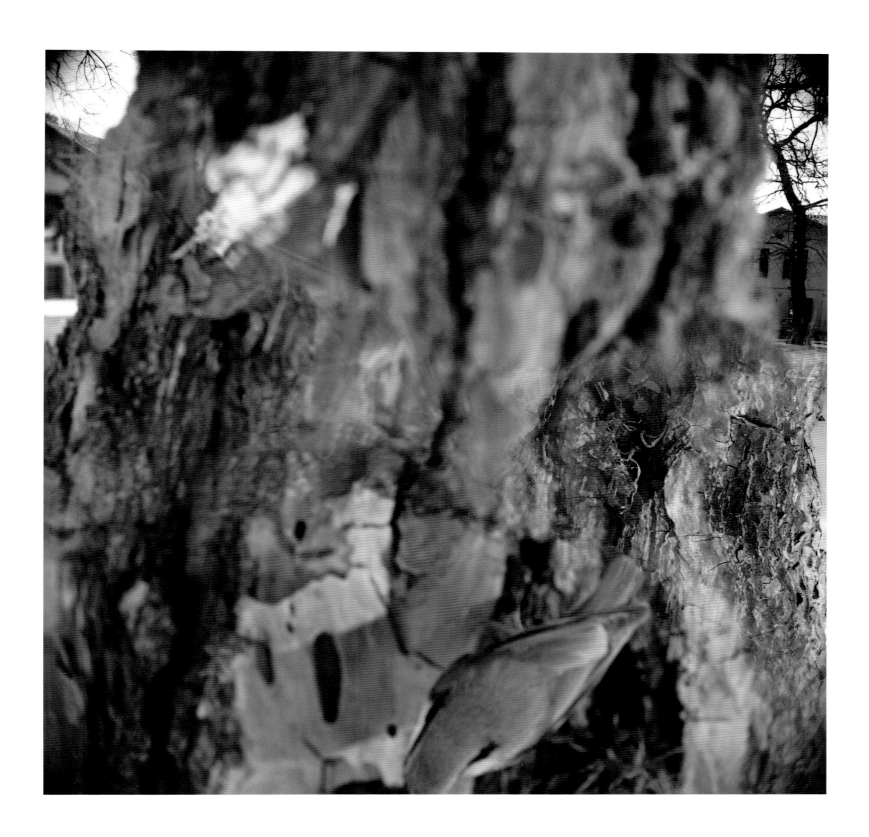

*Plate 8.* No. 95, March April 1991, 72/72 in.

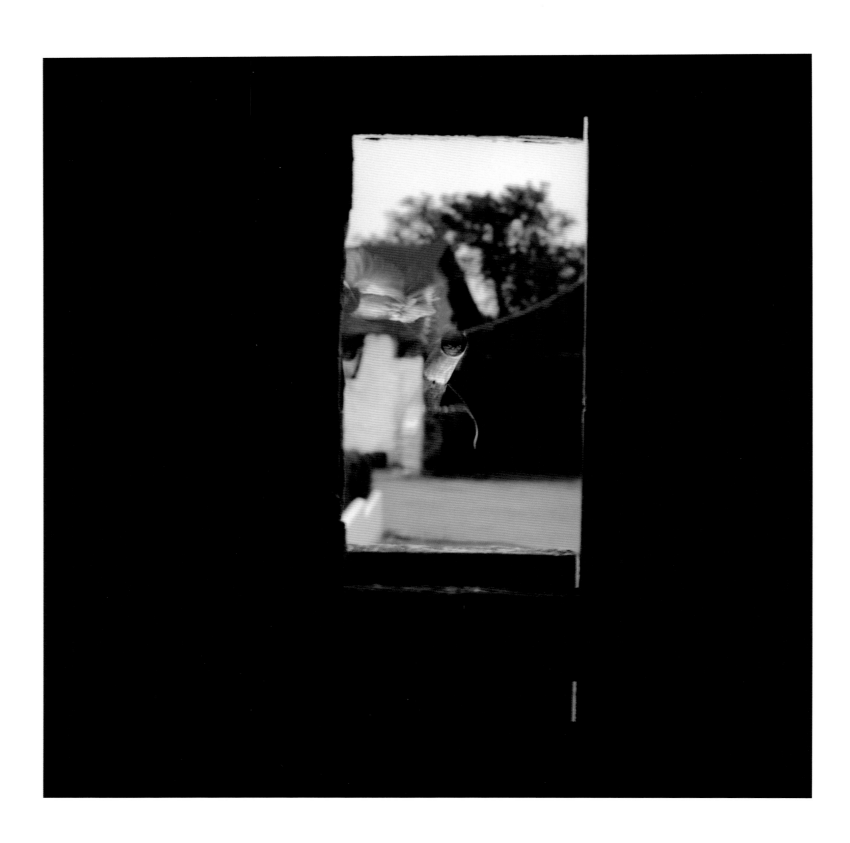

*Plate 9.* No. 5, June July August 1979, 34.75/34.75 in.

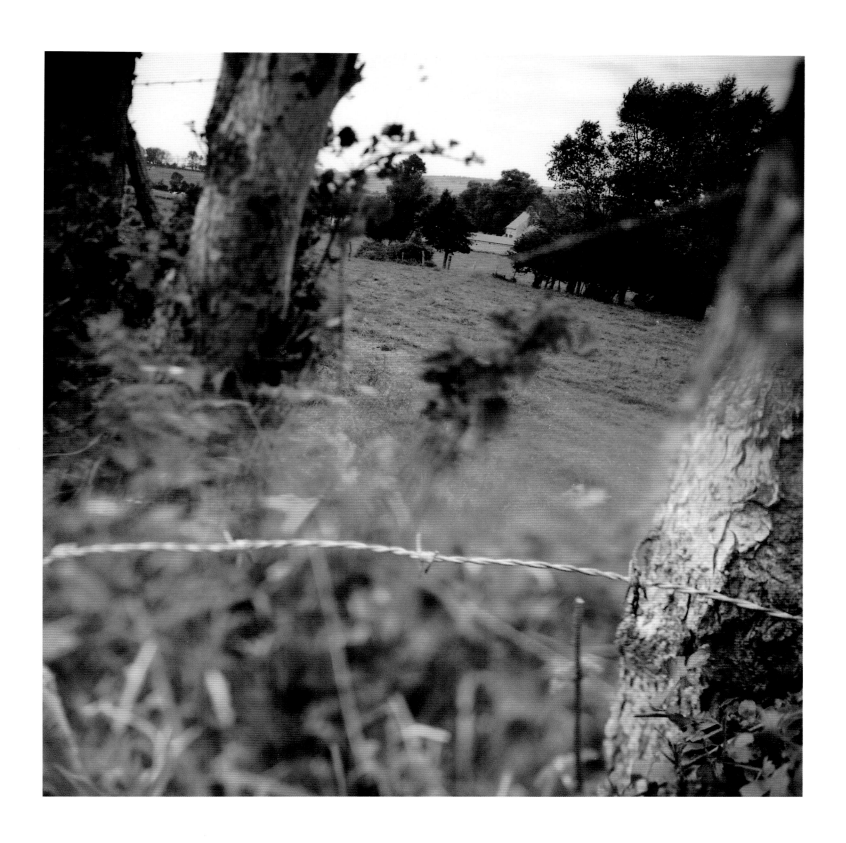

*Plate 10.* No. 3, June July 1979, 28.75/28.75 in.

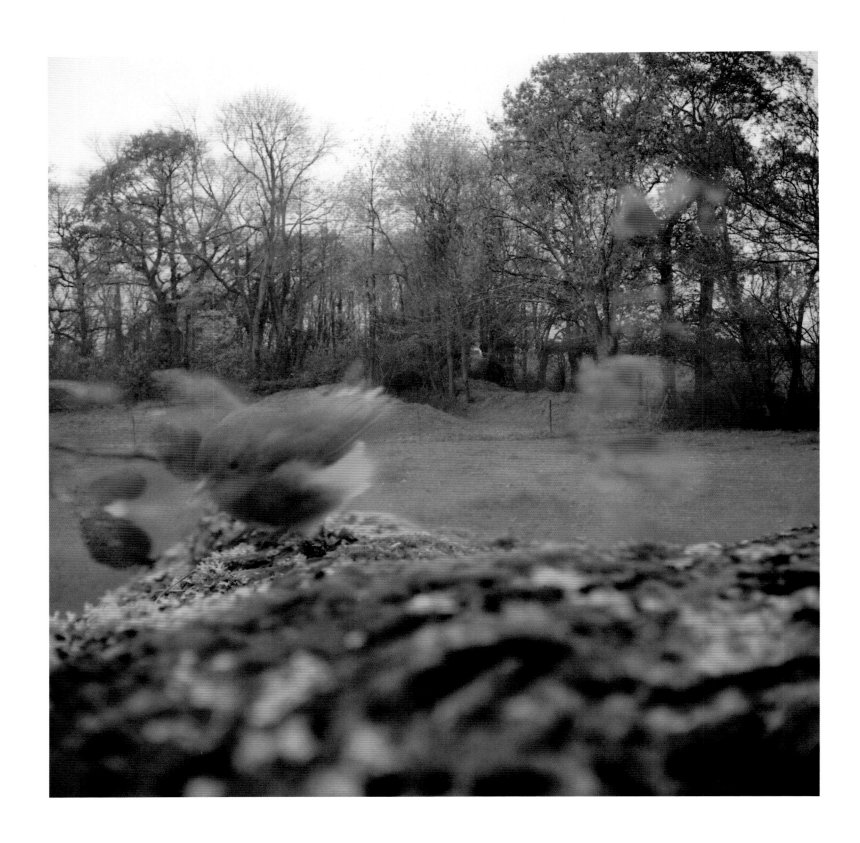

*Plate 11*. No. 9, October 1979, 40.5/40.5 in.

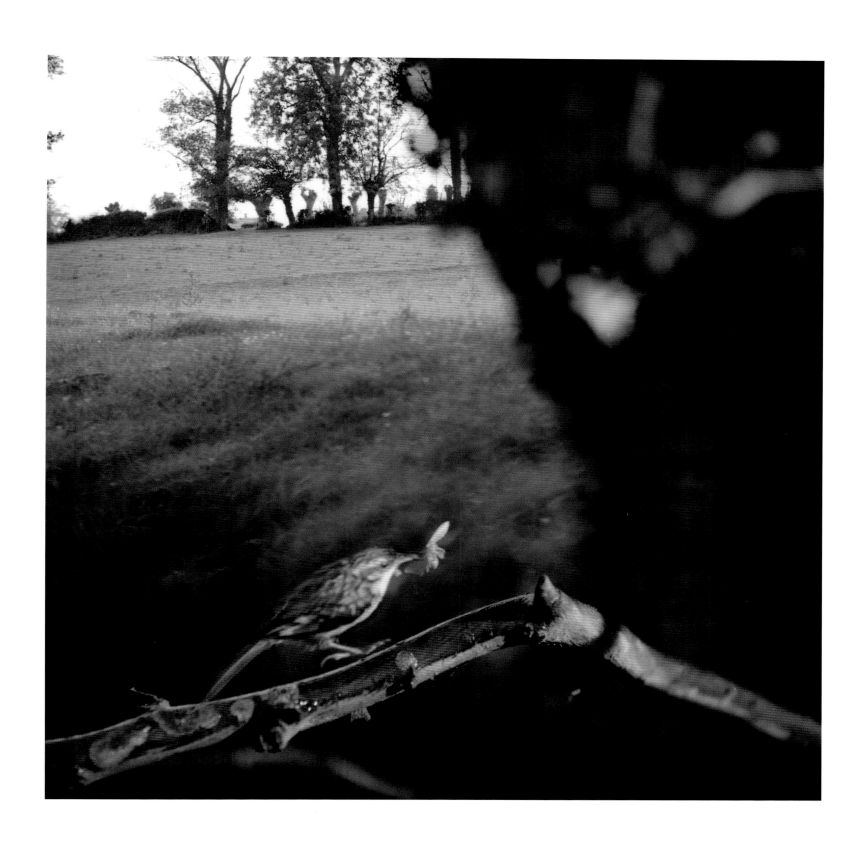

*Plate 12*. No. 16, July August 1980, 21.75/21.75 in.

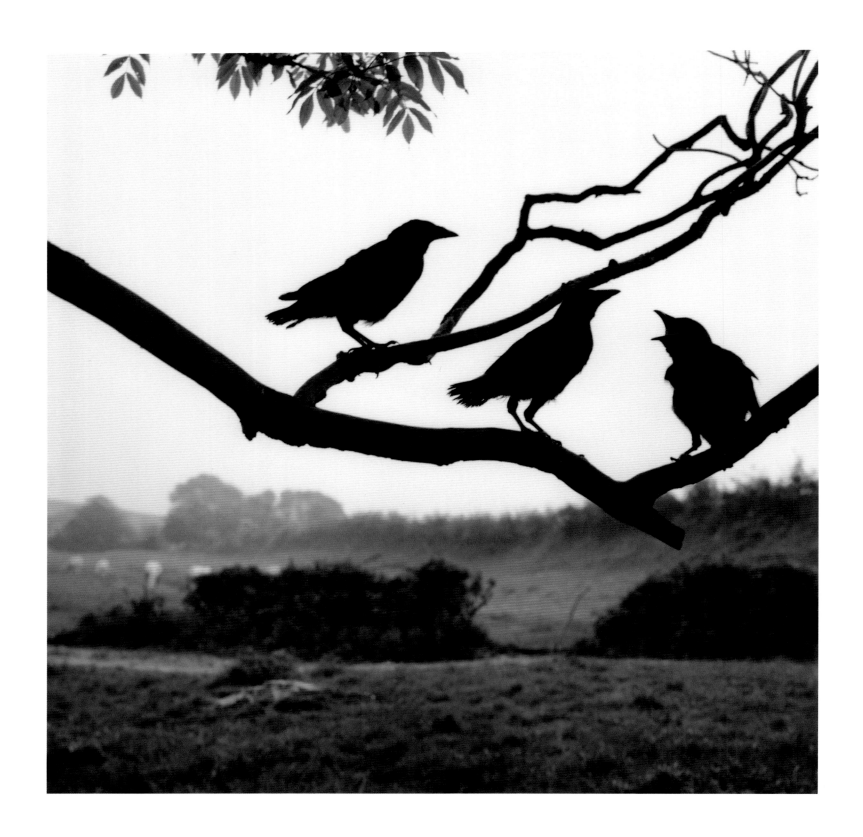

*Plate 13.* No. 11, December 1979–March 1980, 40.5/40.5 in.

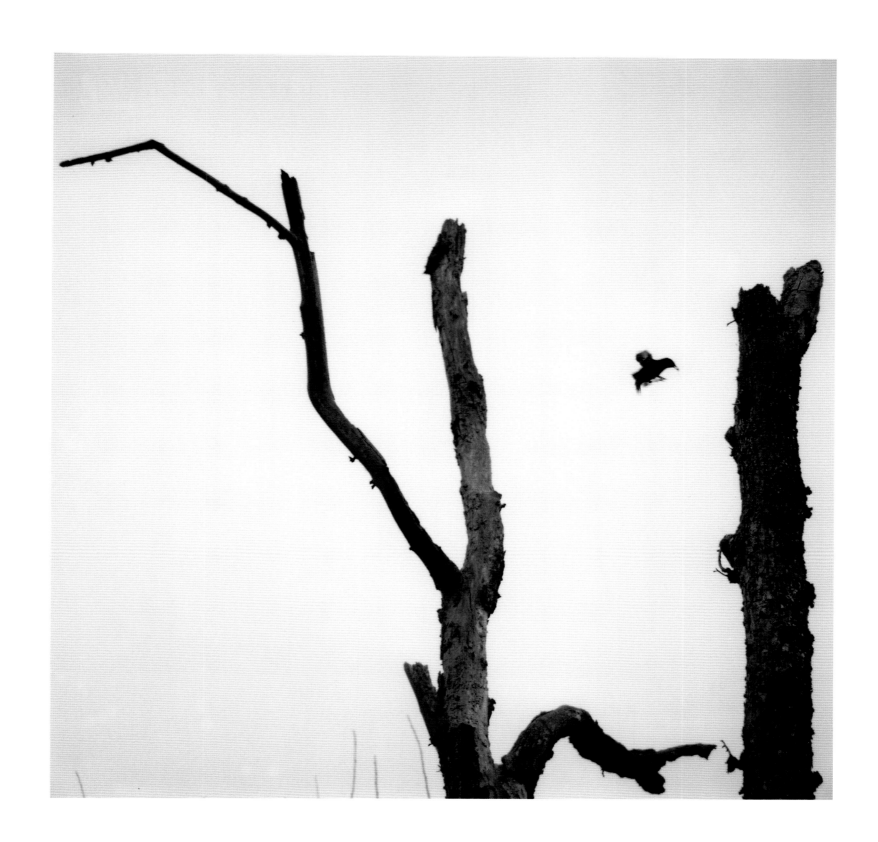

*Plate 14.* No. 79, June July 1987, 60.25/60.25 in.

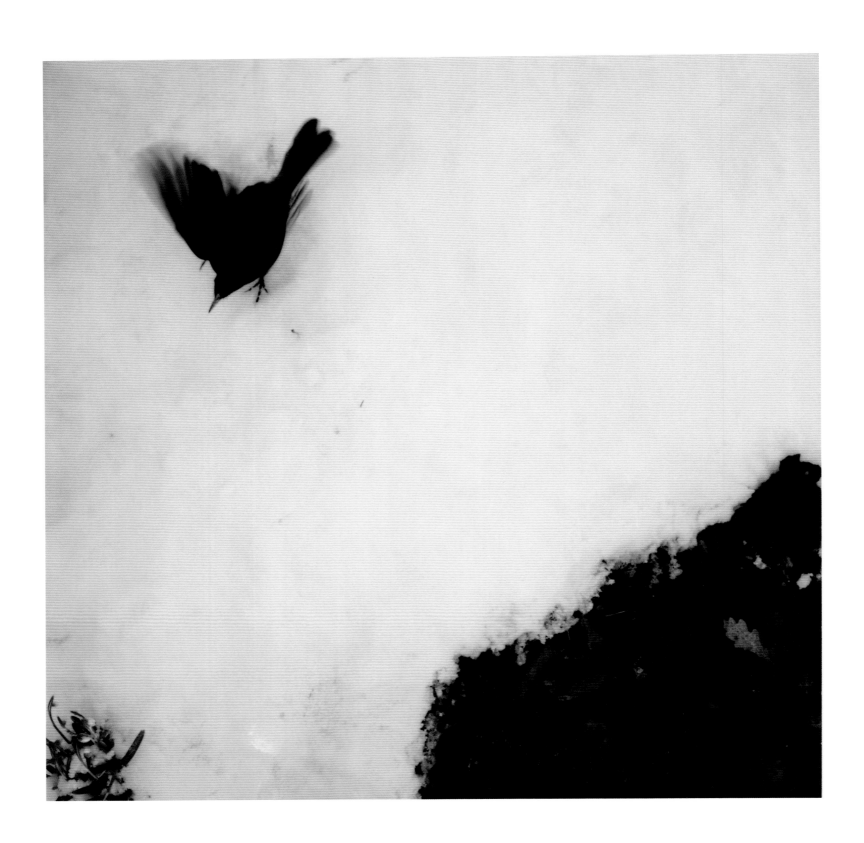

*Plate 15.* No. 60, January February 1987, 34.75/34.75 in.

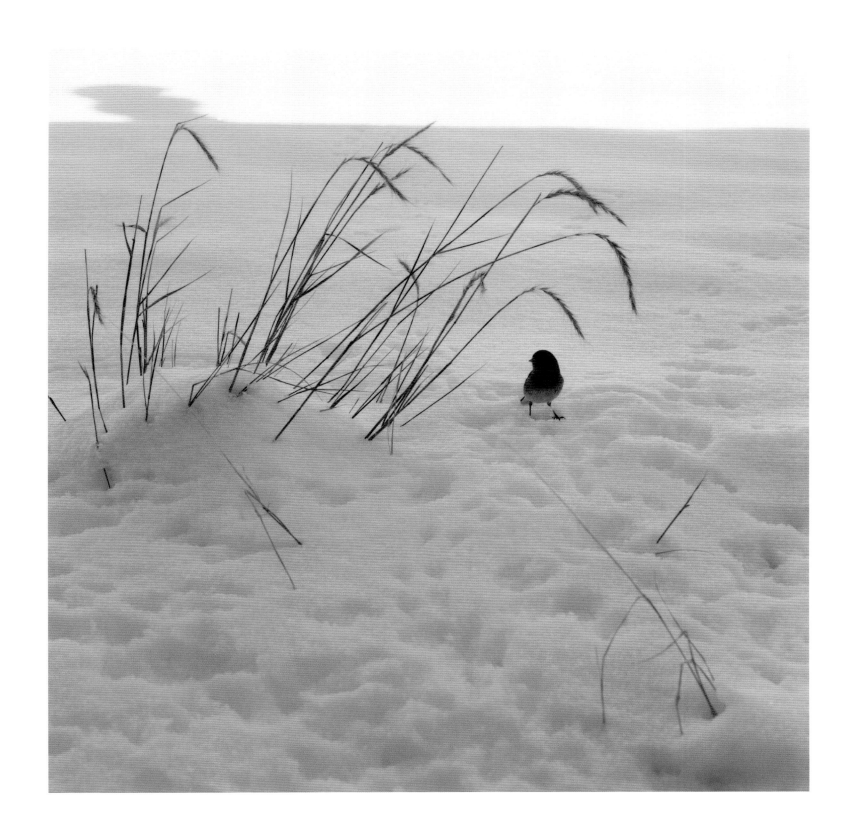

*Plate 16.* No. 212, January February 2004, 48.5/48.5 in.

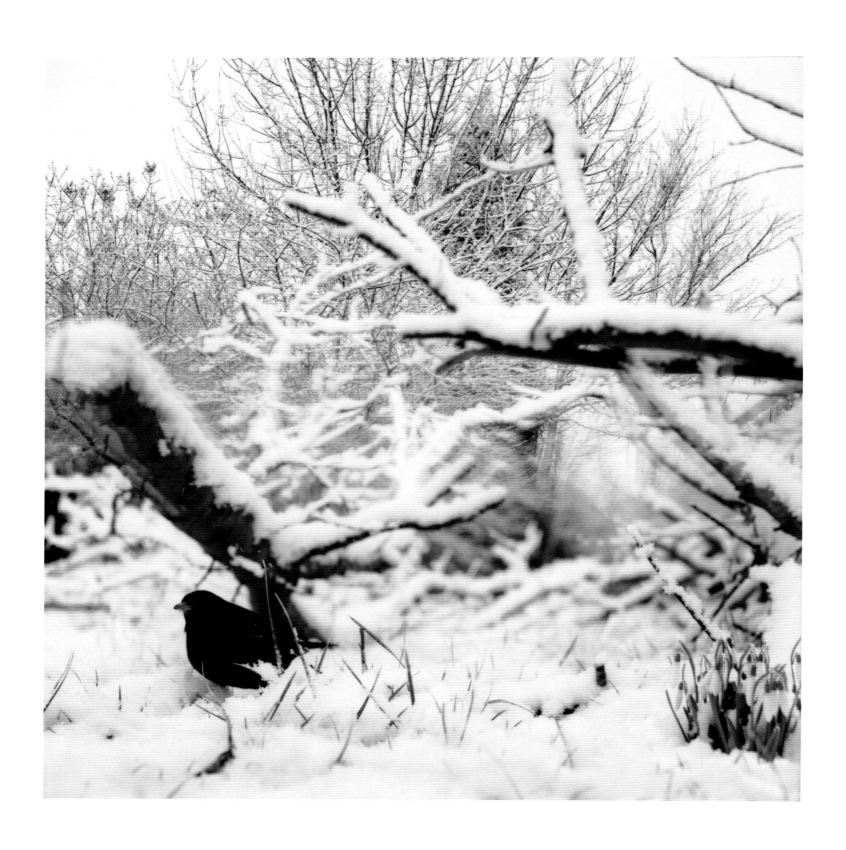

*Plate 17.* No. 58, January February 1987, 40.5/40.5 in.

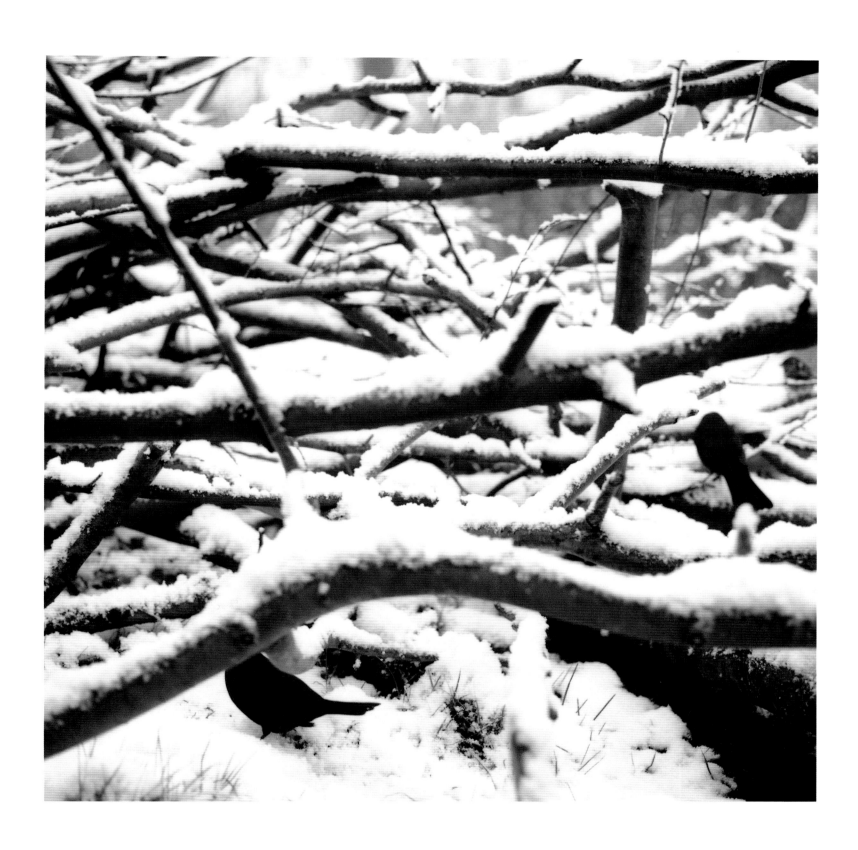

*Plate 18.* No. 57, January February 1987, 40.5/40.5 in.

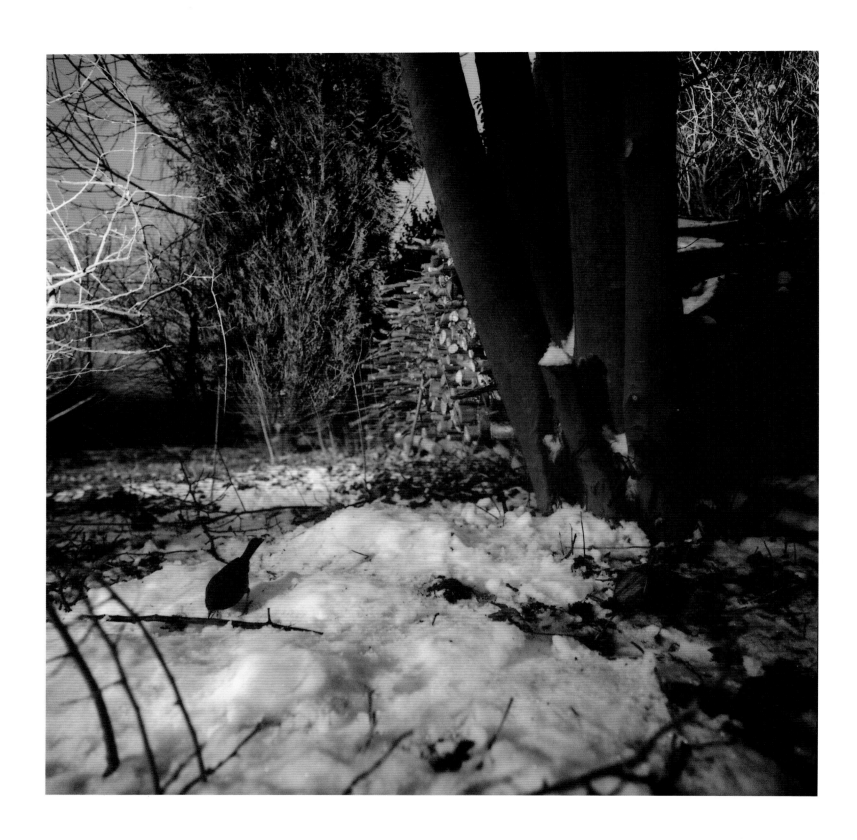

*Plate 19.* No. 55, January February 1987, 28.75/28.75 in.

*Plate 20.* No. 245, January February 2004, 48.5/48.5 in.

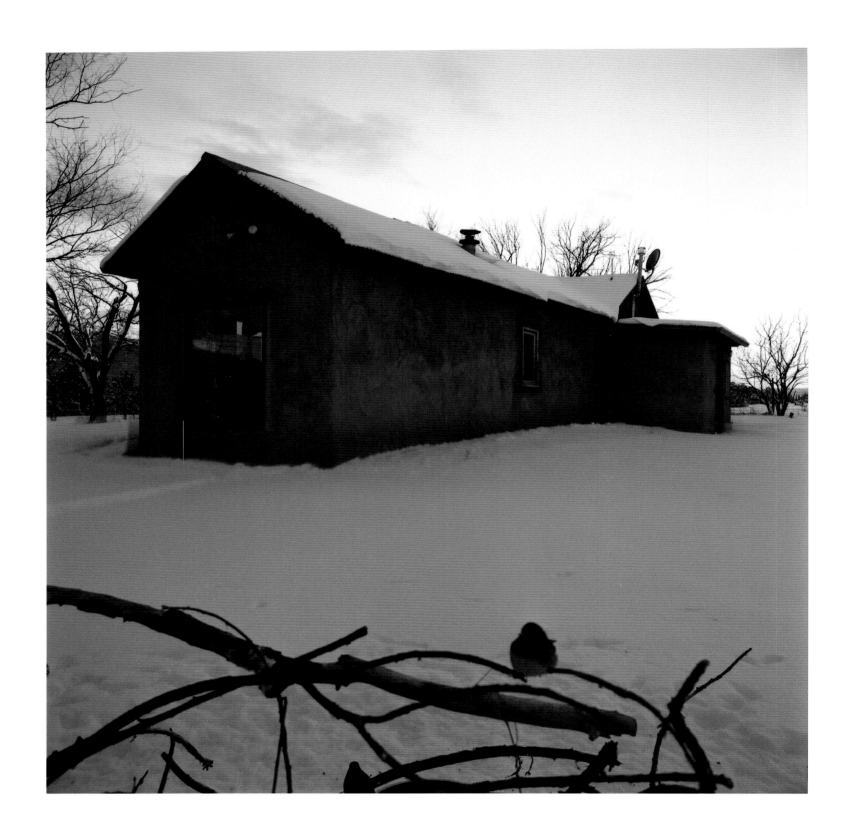

*Plate 21.* No. 226, January February 2004, 48.5/48.5 in.

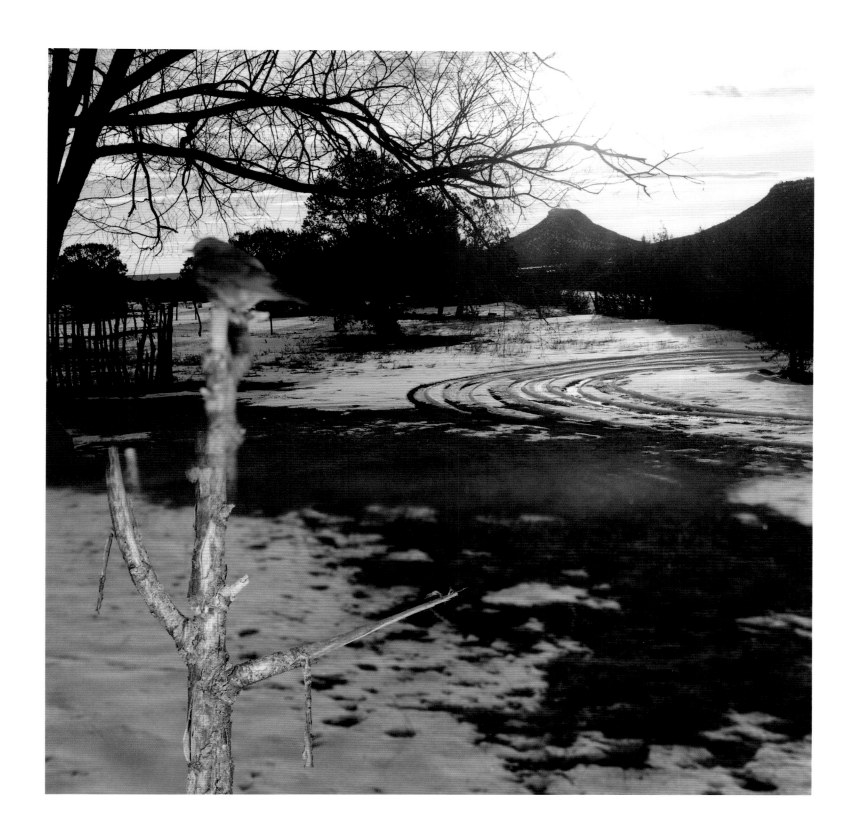

*Plate 22.* No. SP16, December 2003–January 2004, 40.5/40.5 in.

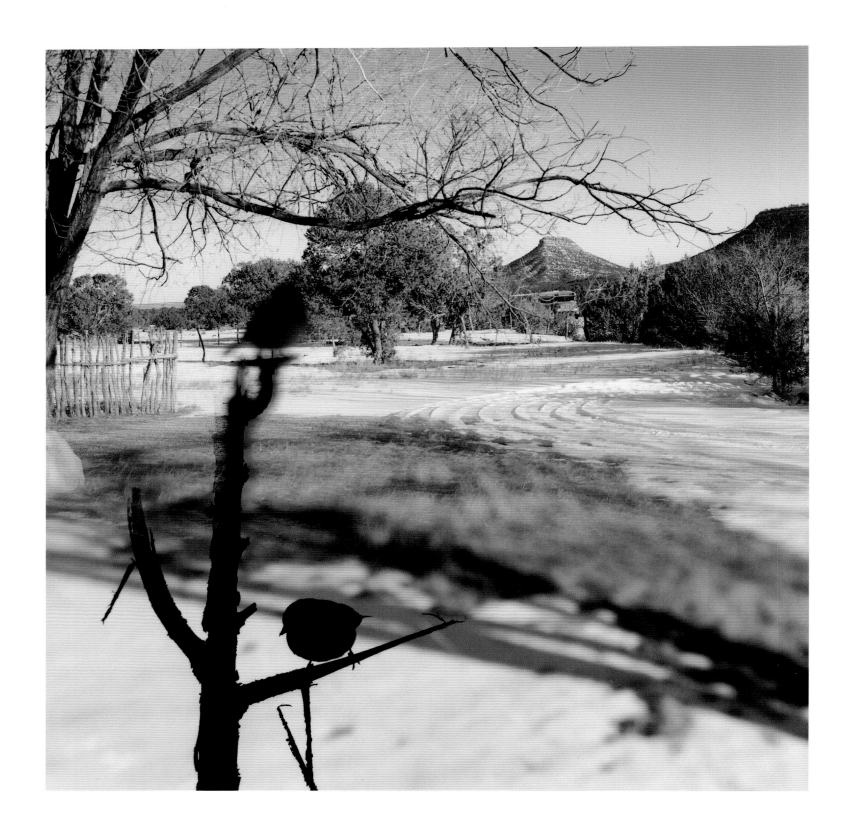

*Plate 23.* No. P120, December 2003–January February 2004, 40.5/40.5 in.

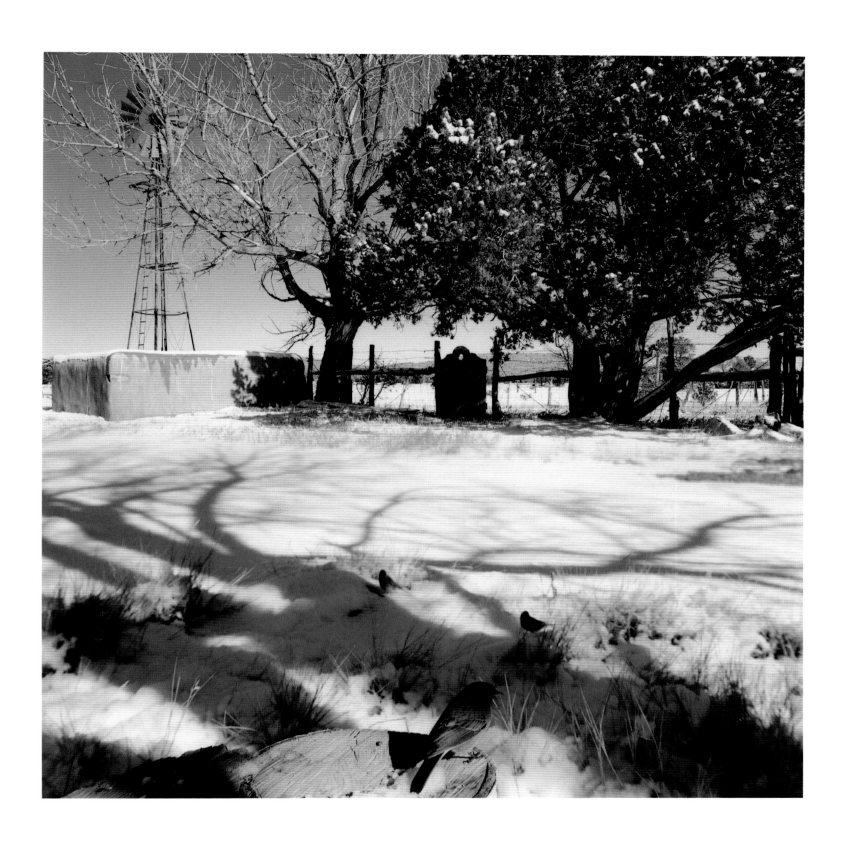

*Plate 24.* No. 164, December 2003–January 2004, 40.5/40.5 in.

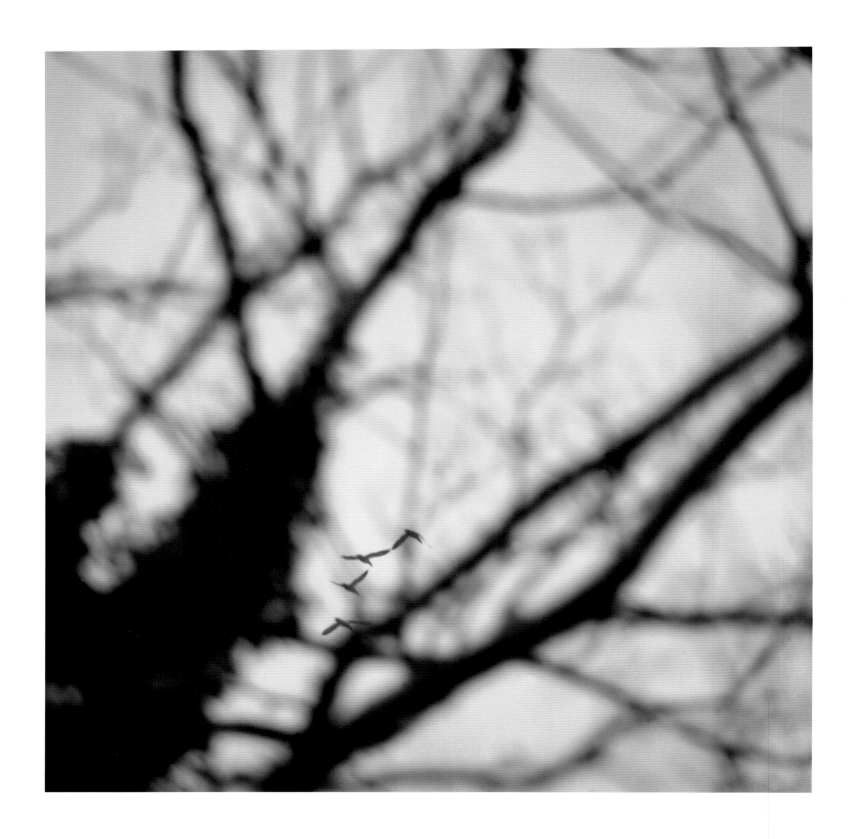

*Plate 25.* No. 24, June July 1981, 17/17 in.

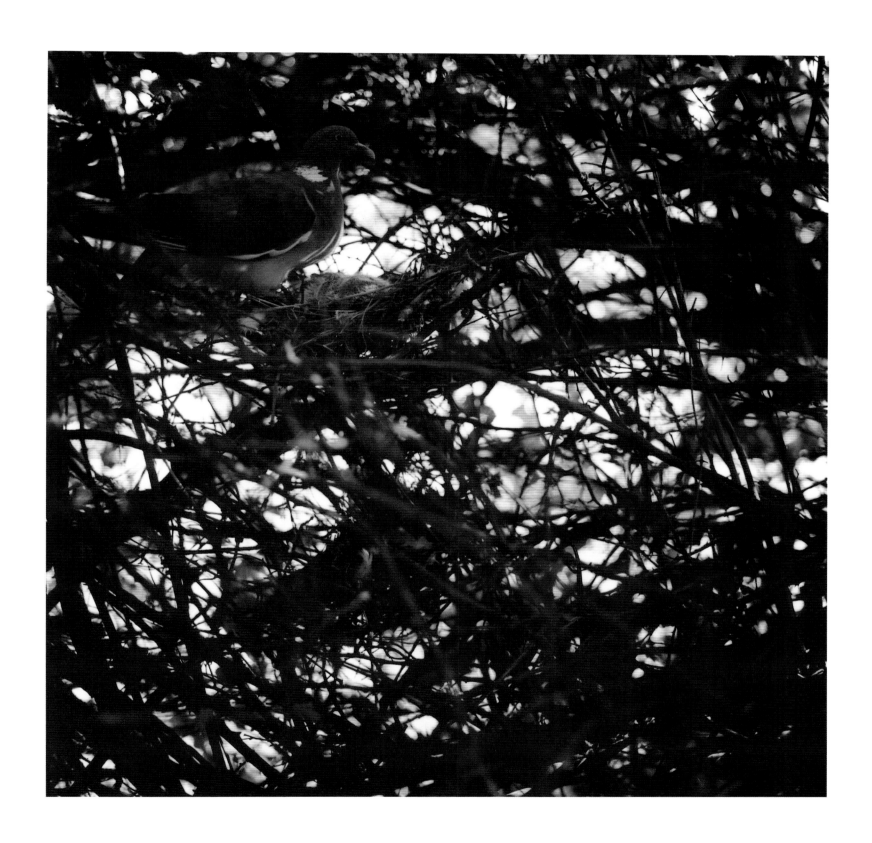

*Plate 26*. No. 30², August September 1981, 72/72 in.

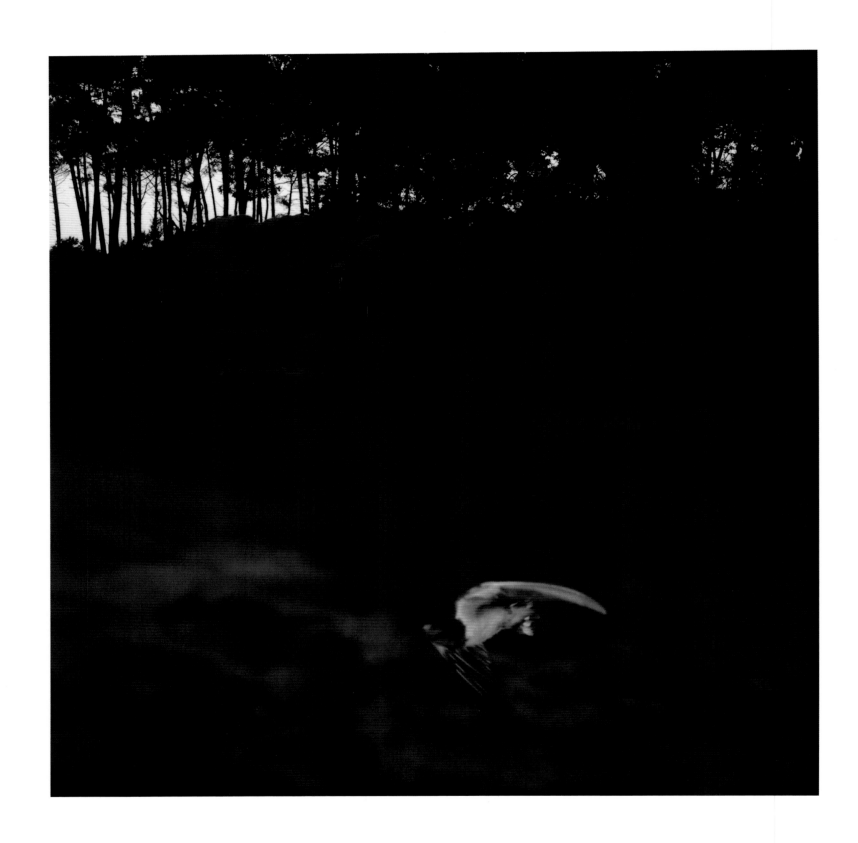

*Plate* 27. No. 121, August September 1992, 24.75/24.75 in.

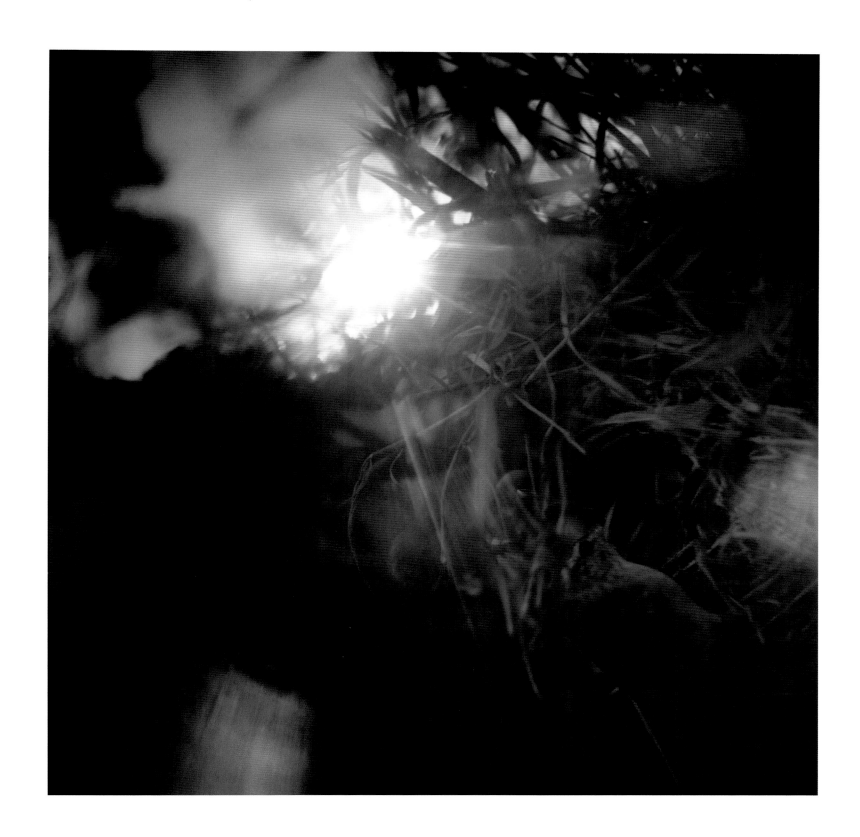

*Plate 28.* No. 32, June July 1982, 48.5/48.5 in.

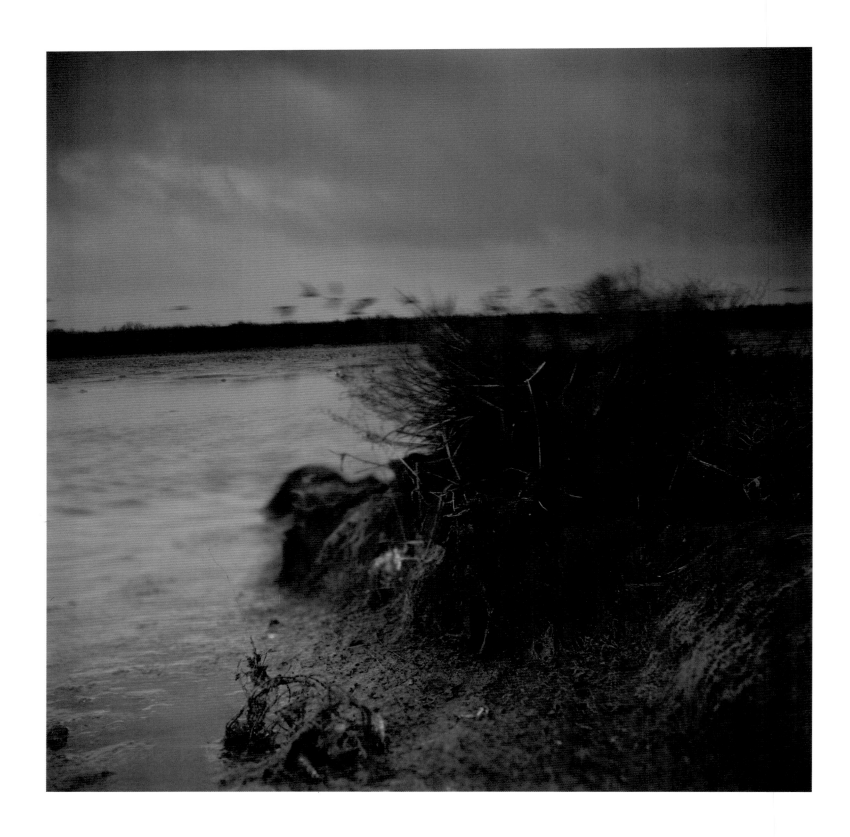

*Plate 29.* No. 106, January 1992, 60.25/60.25 in.

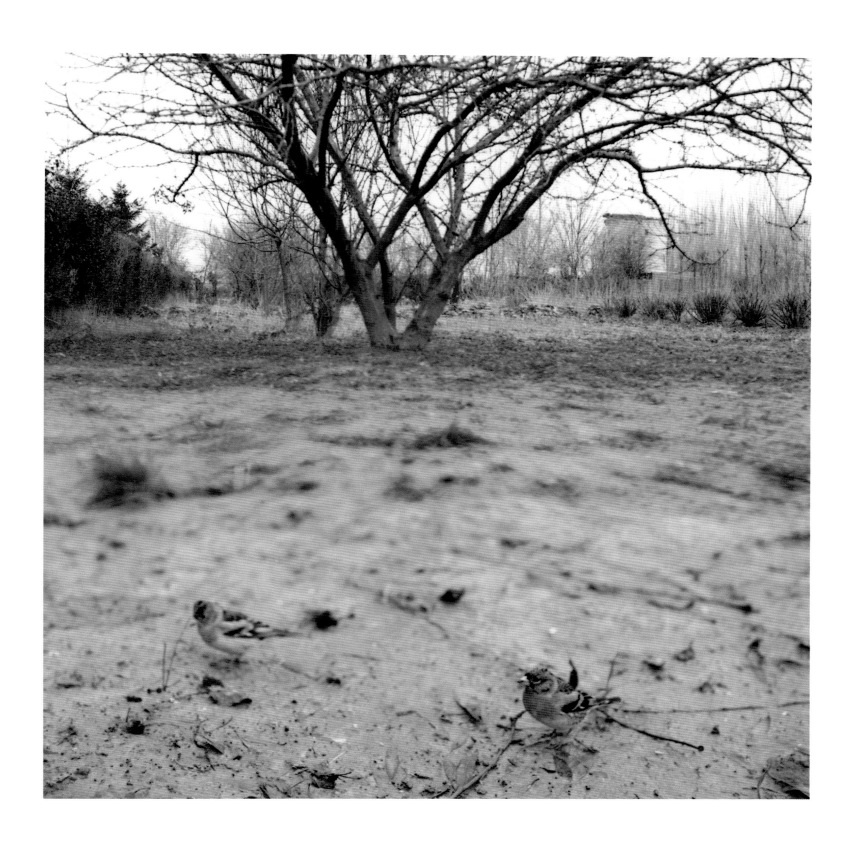

*Plate 30.* No. 66, January February March 1987, 34.75/34.75 in.

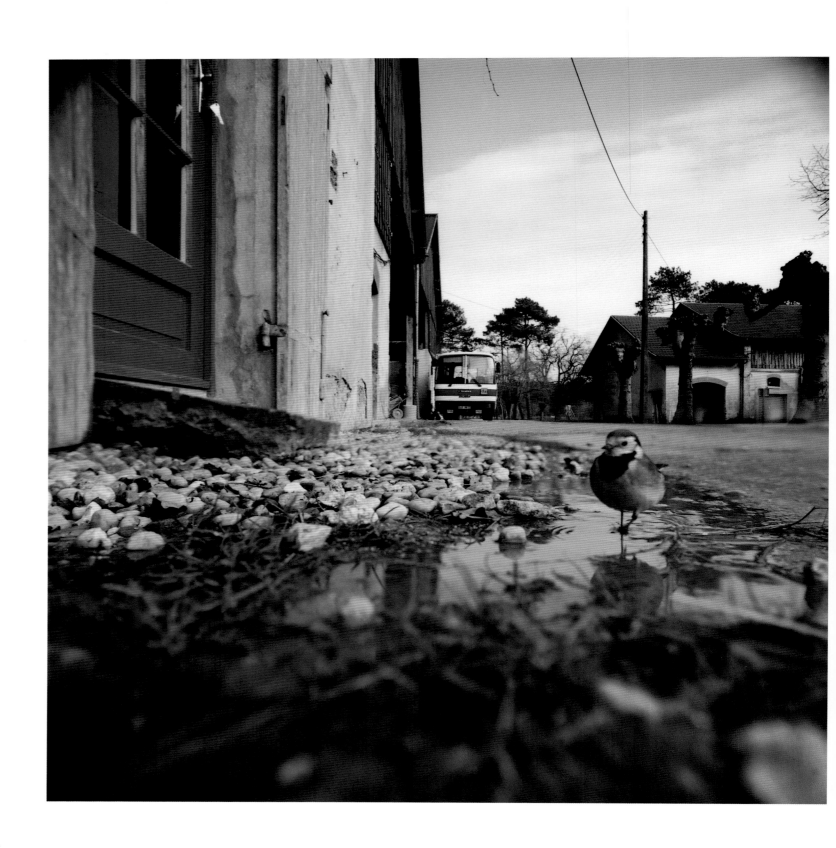

*Plate 31.* No. 91, November December 1990, 28.75/60.25 in.

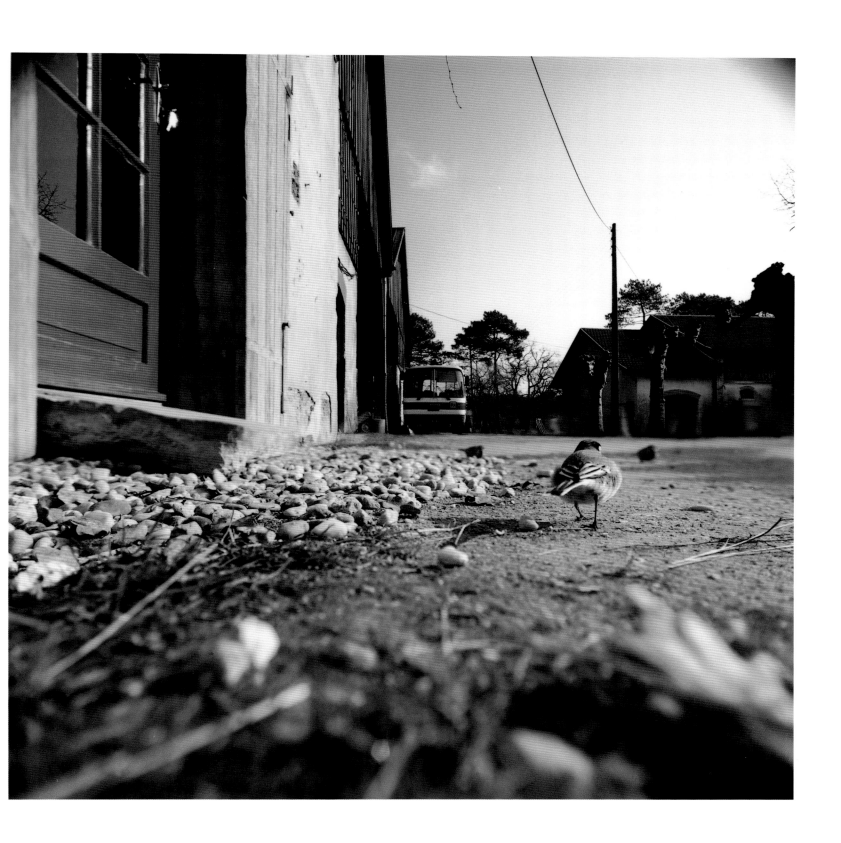

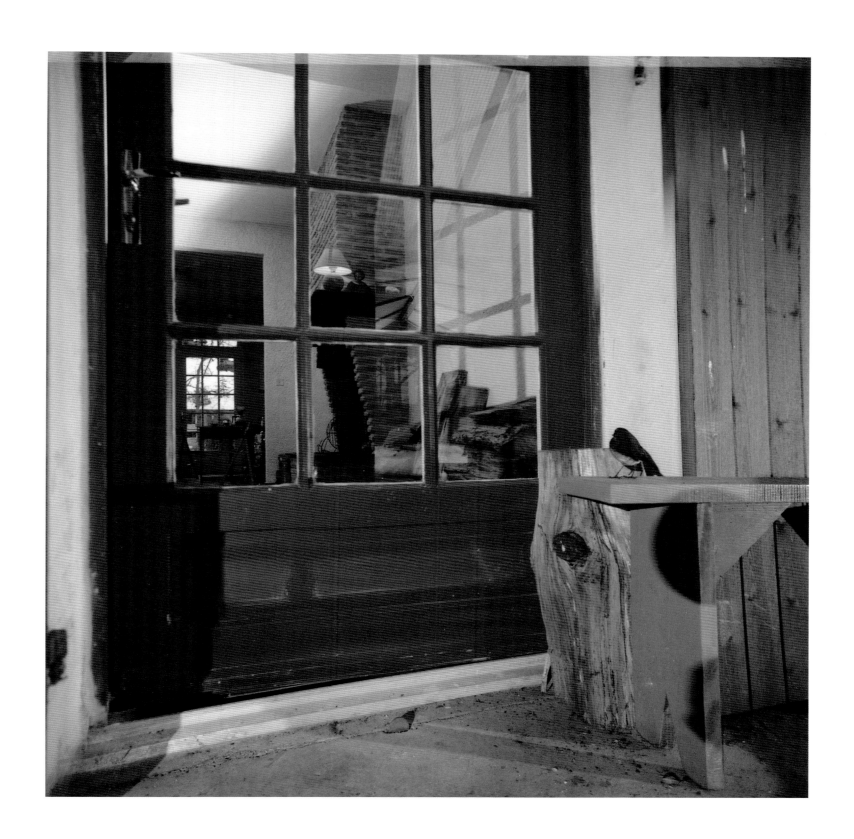

*Plate 32.* No. 125, January 1991–February 1993 (detail), 85.75/111.5 in.

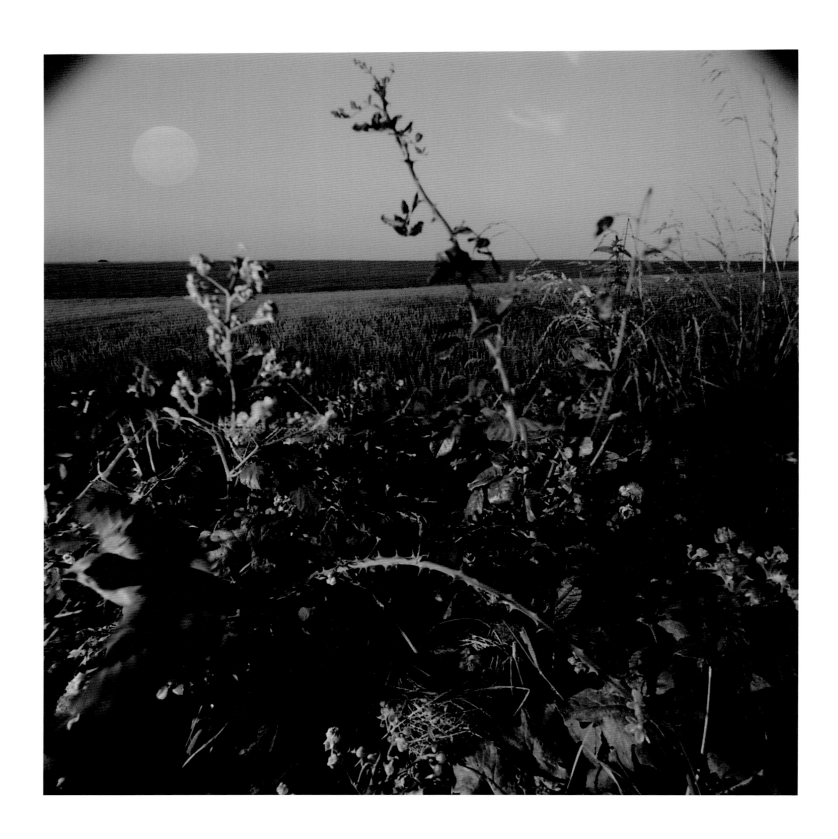

*Plate 33*. No. SIP, July August 1982, 49.5/49.5 in.

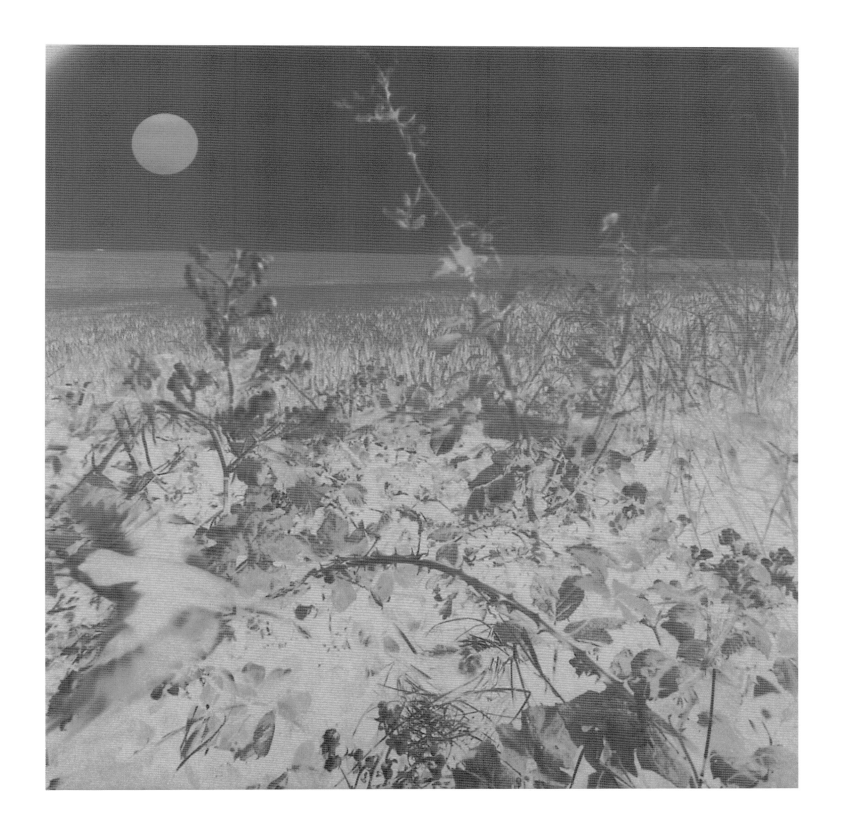

*Plate 34.* No. SIN, July August 1982, 49.5/49.5 in.

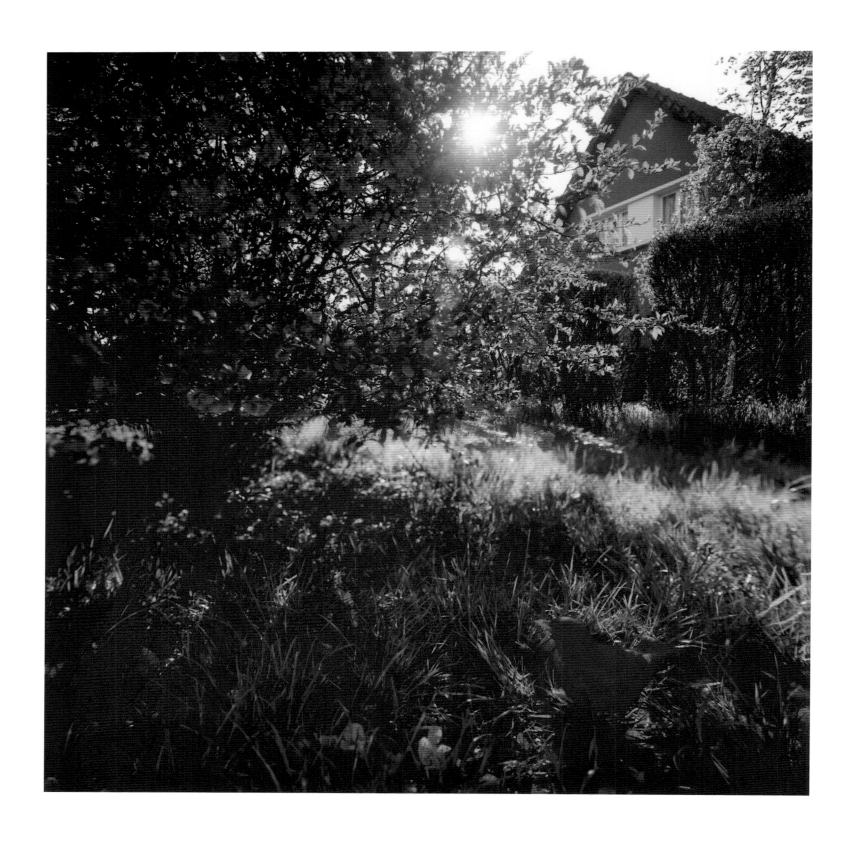

*Plate* 35. No. 40, April May 1986, 40.5/40.5 in.

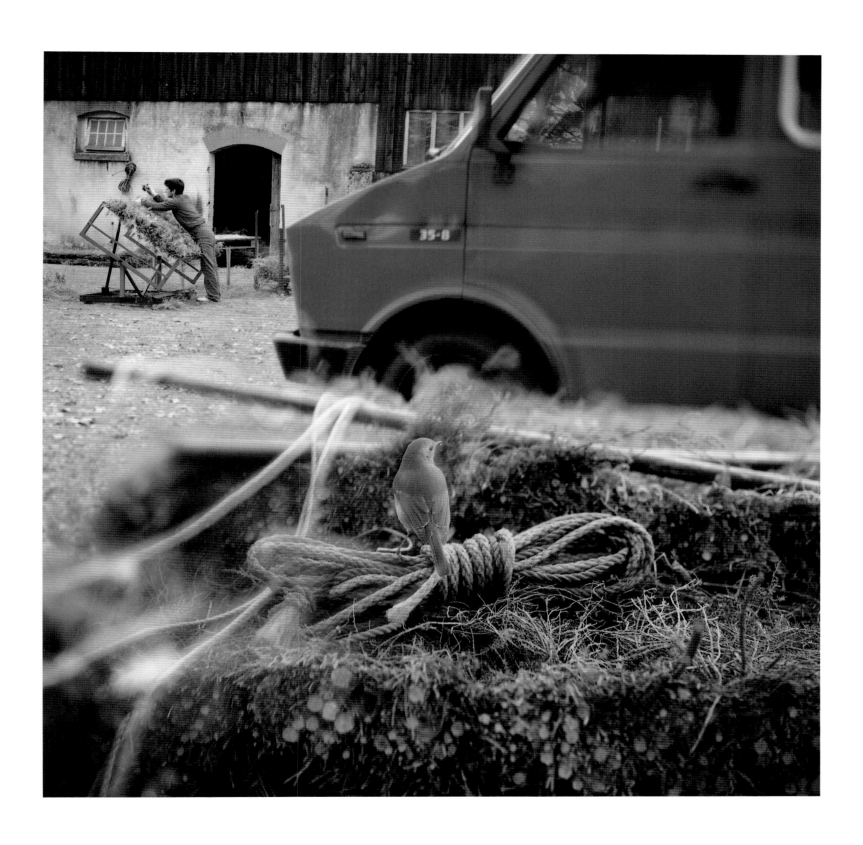

*Plate 36.* No. 100 D6, October 1990–February 1993, 40.5/40.5 in.

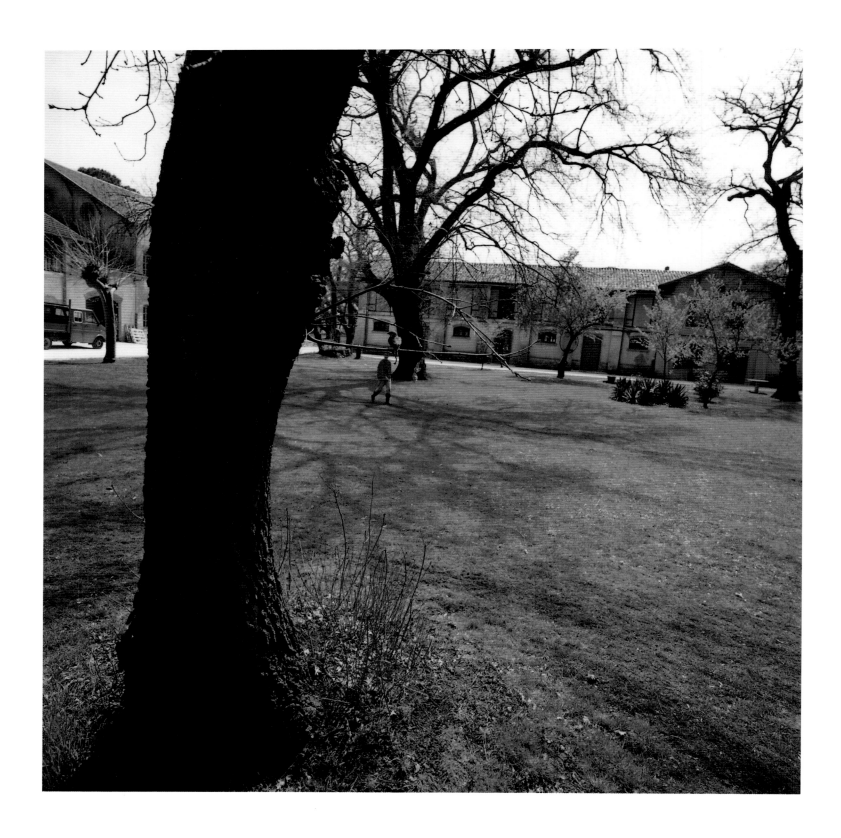

*Plate 37.* No. 112, March April May 1992, 40.5/40.5 in.

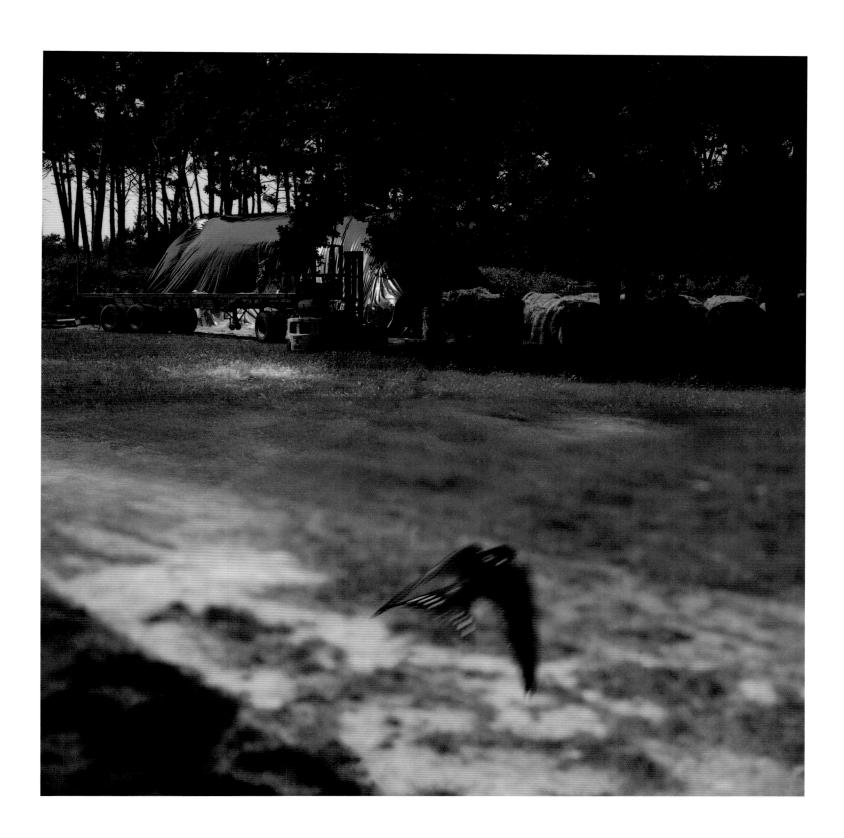

*Plate 38.* No. 118, August September 1992, 40.5/40.5 in.

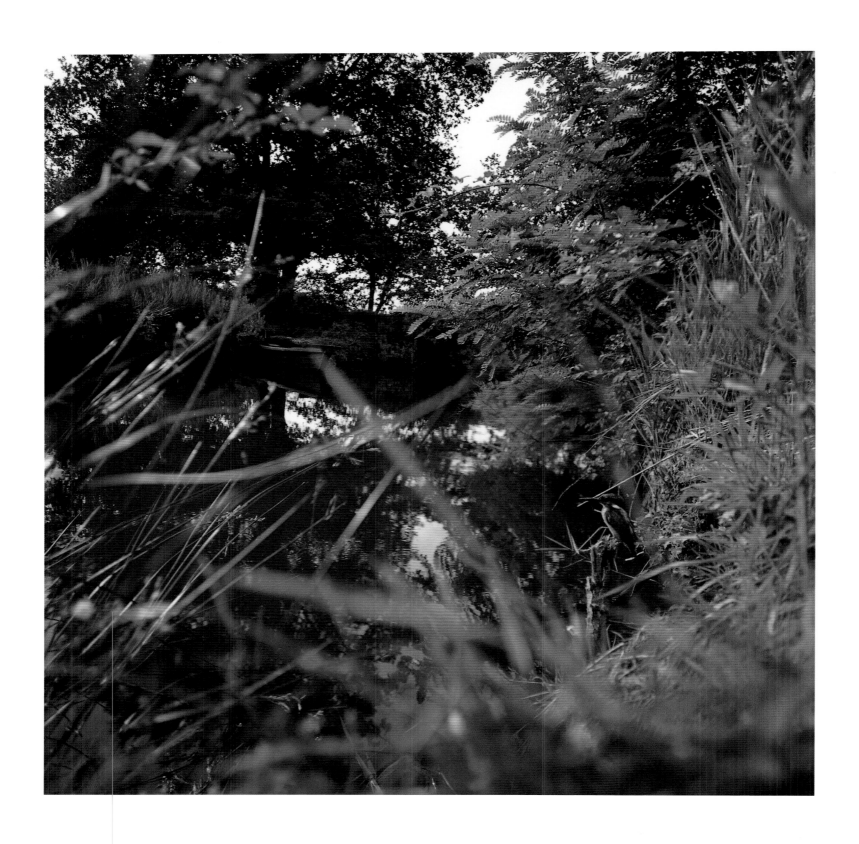

*Plate 39.* No. 117E, June 1991–August 1992, 50.5/50.5 in.

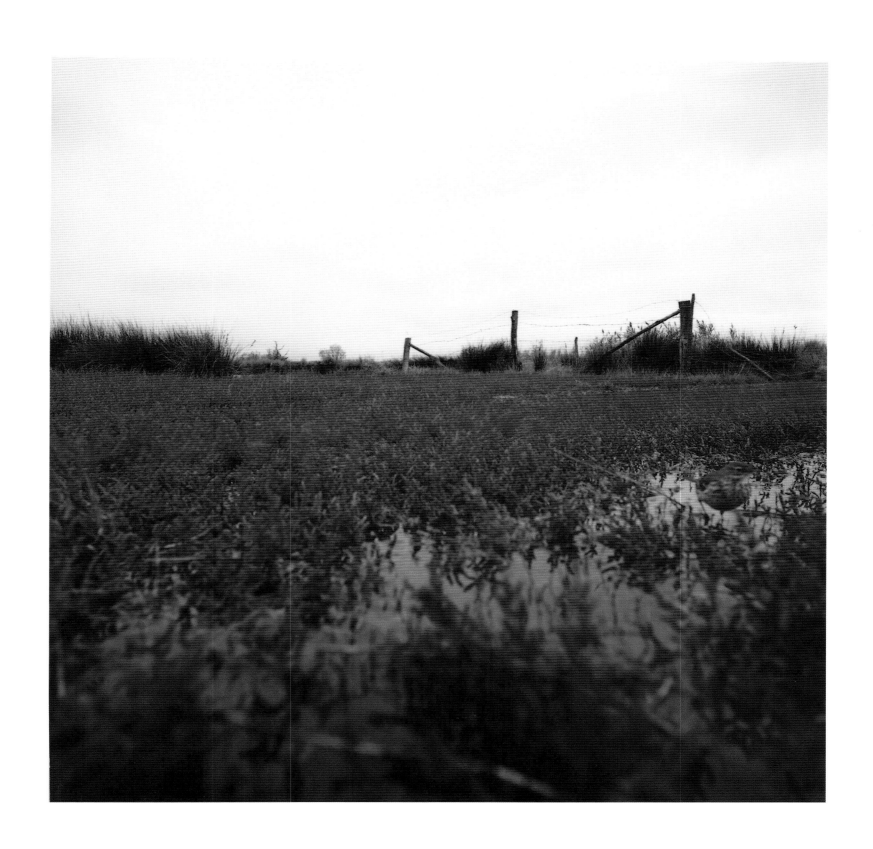

*Plate 40.* No. 102, September October November December 1991, 40.5/40.5 in.

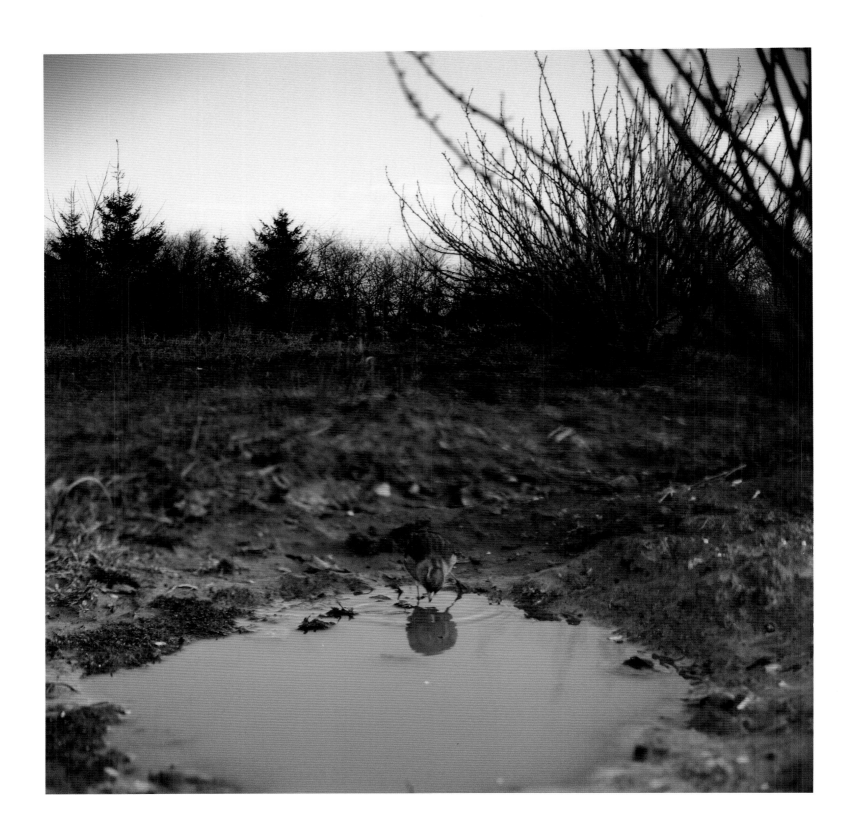

*Plate 41*. No. 65, January February March 1987, 28.75/28.75 in.

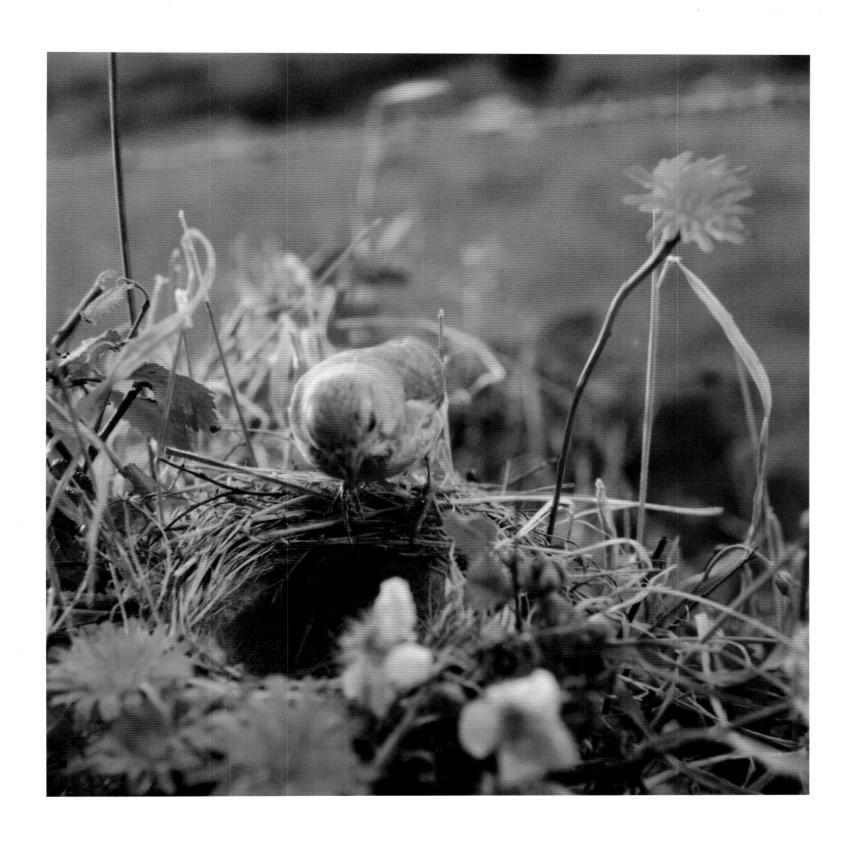

*Plate 42.* No. C4, July August 1982, 40.5/40.5 in.

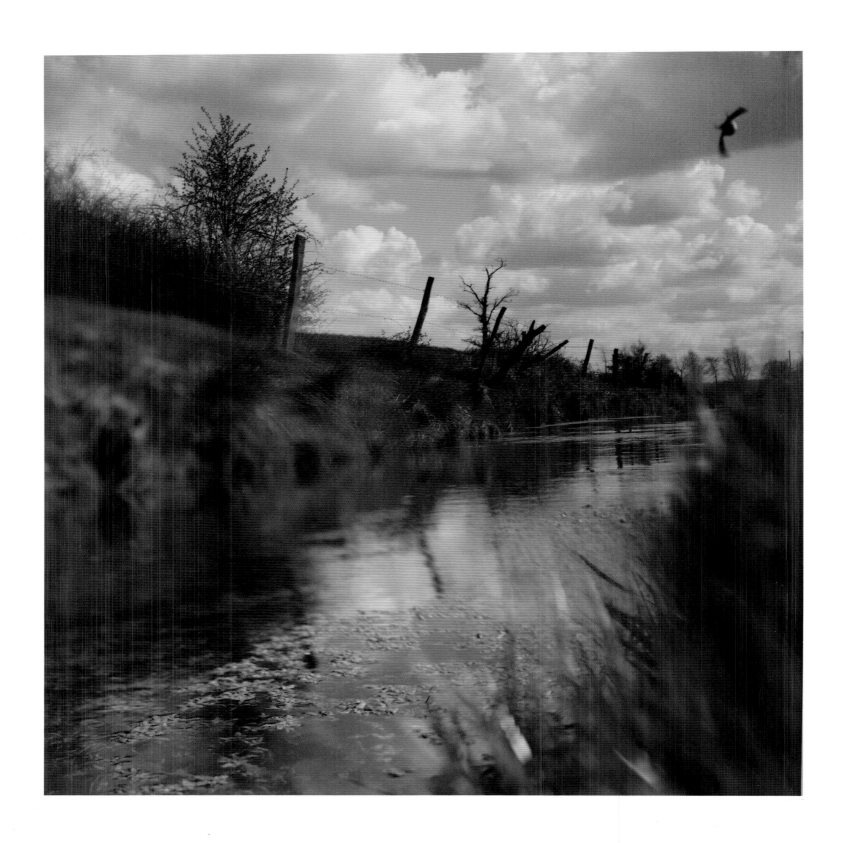

*Plate 43.* No. 52, April 1980, 50.5/50.5 in.

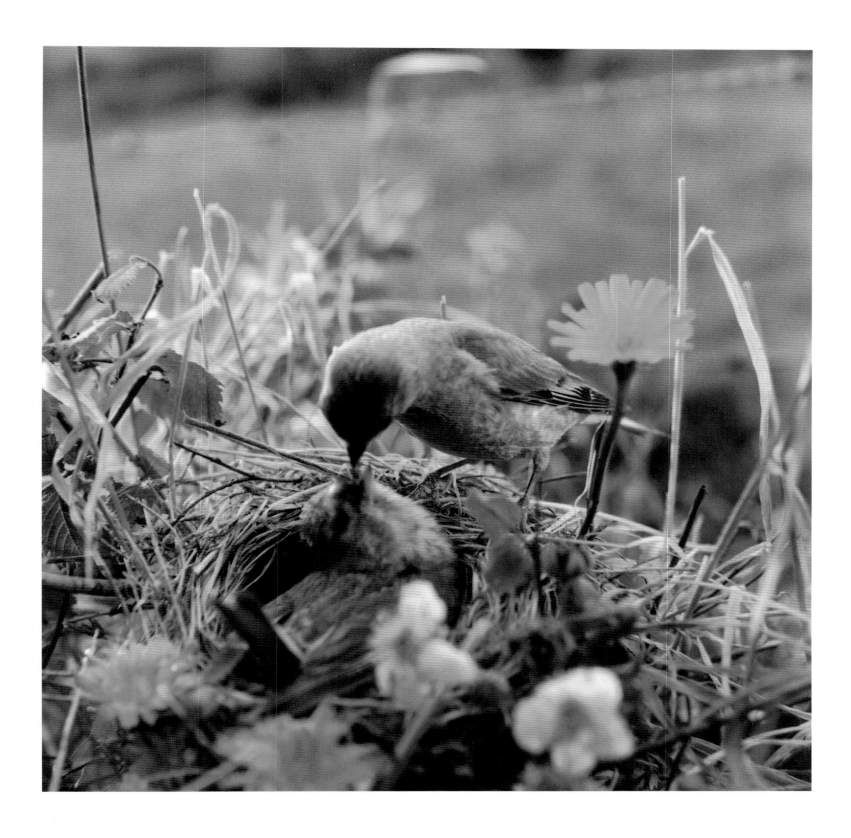

*Plate 44.* No. 34, July August 1982, 40.5/40.5 in.

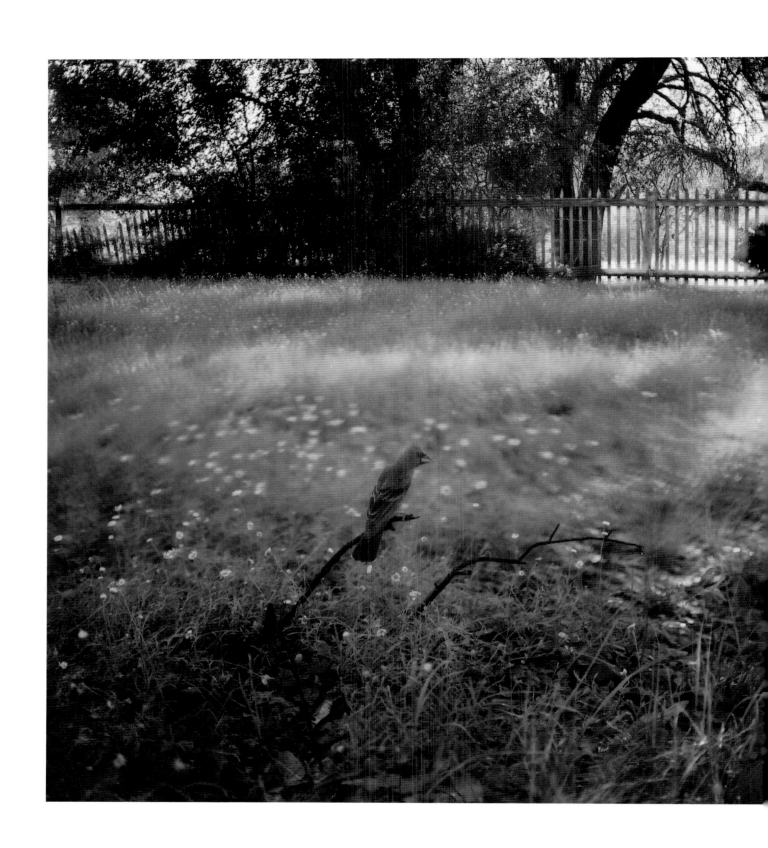

*Plate 45*. No. 407, April May 2006, 60.25/119.25 in.

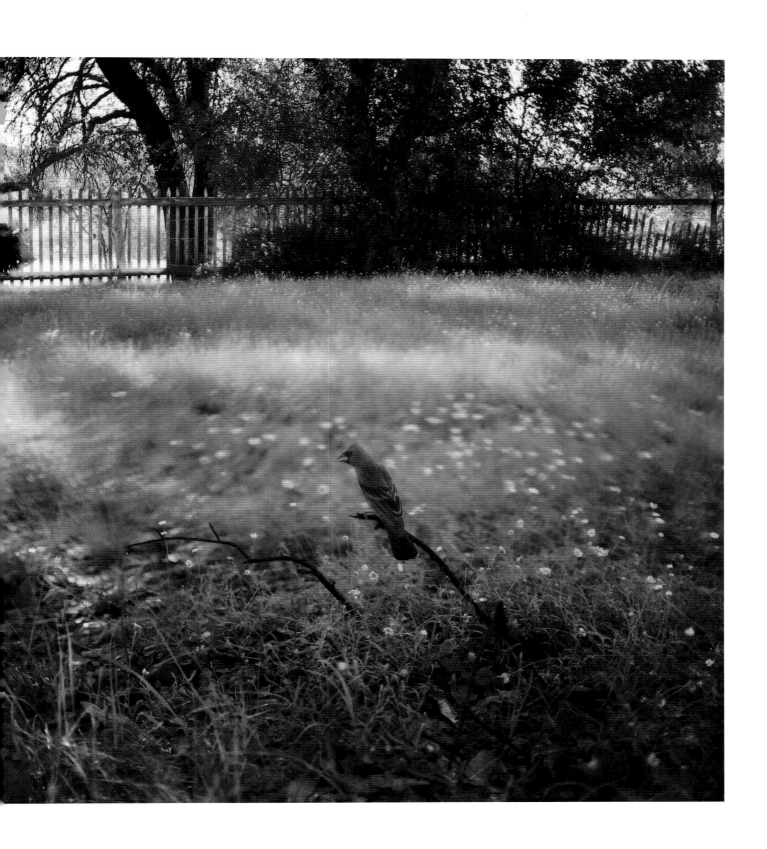

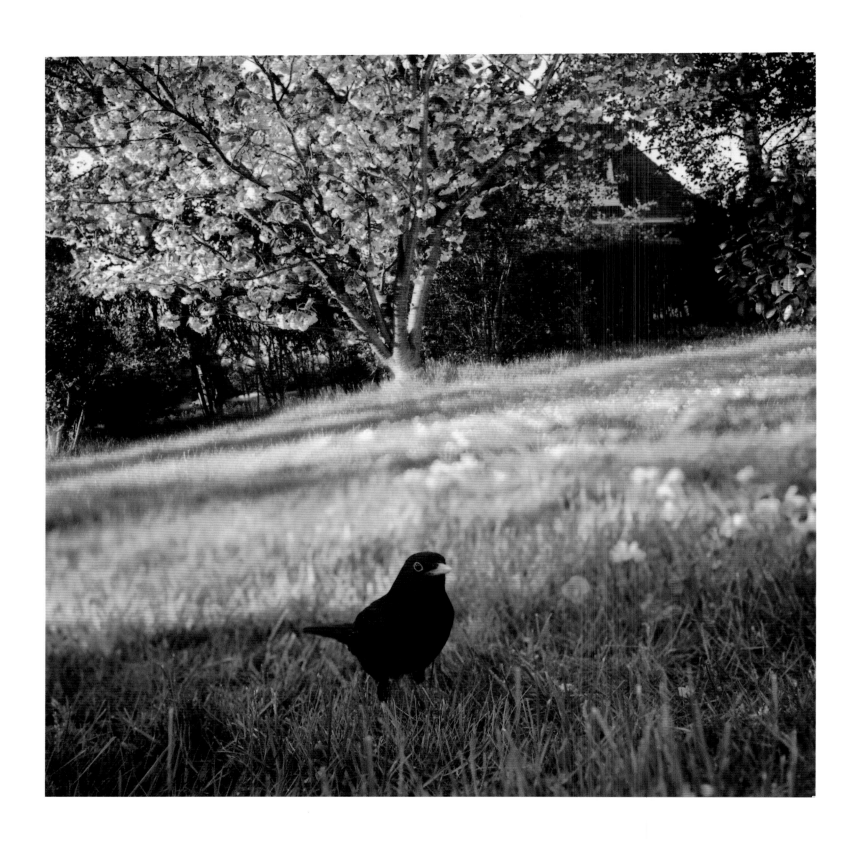

*Plate 46.* No. 74, March April May 1987, 34.75/34.75 in.

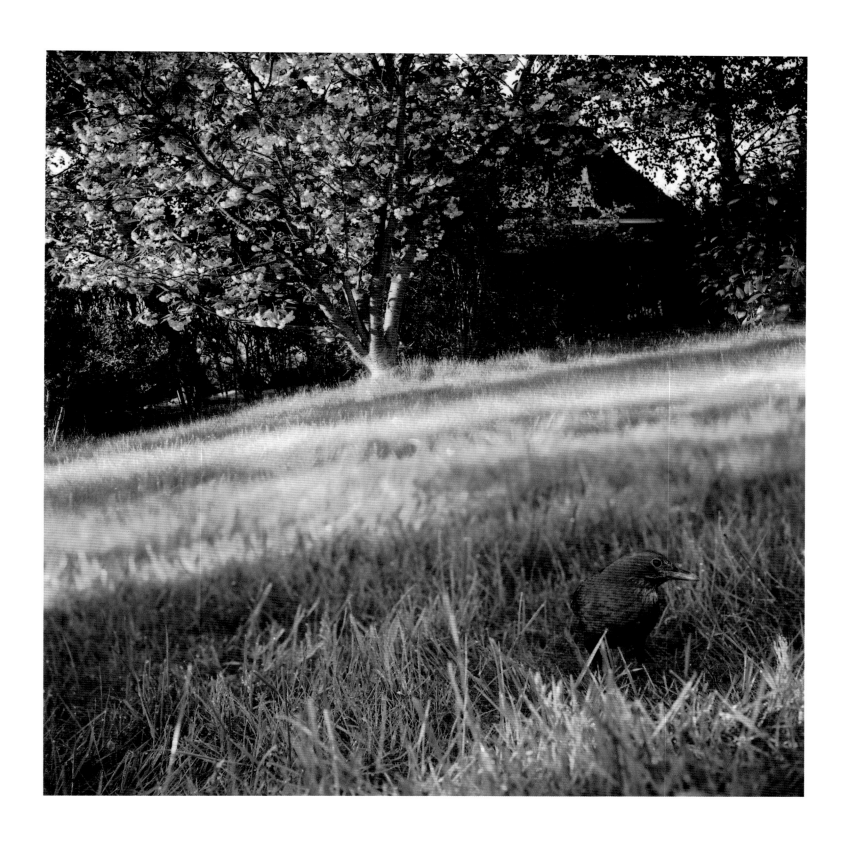

*Plate 47*. No. 75, March April May 1987, 43.25/43.25 in.

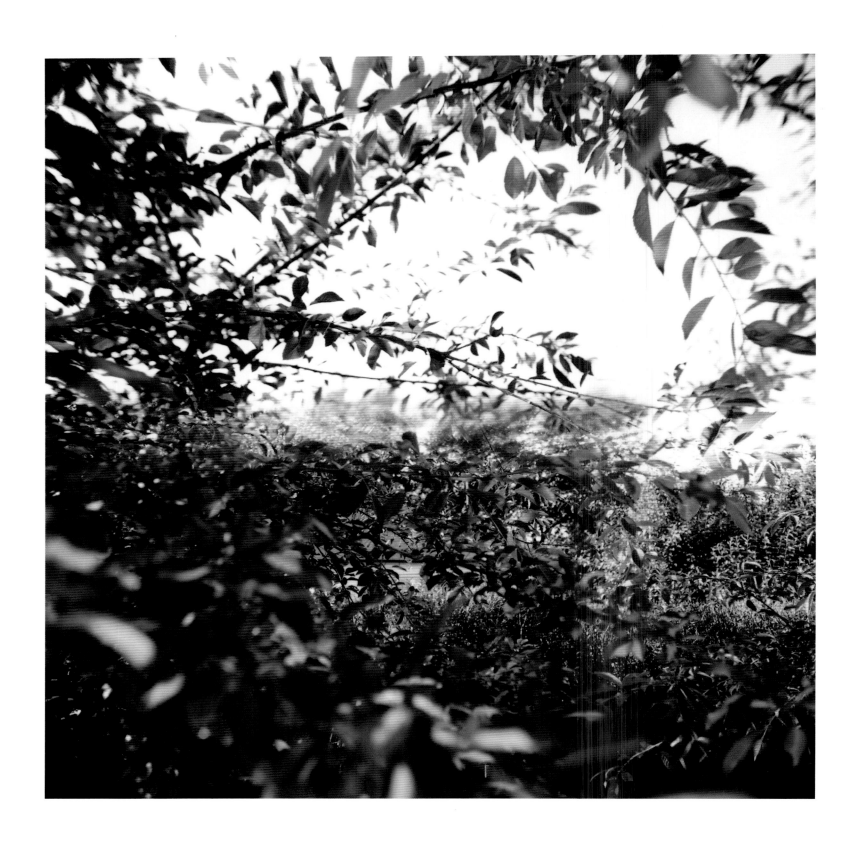

*Plate 48.* No. 45, July August 1986, 40.5/40.5 in.

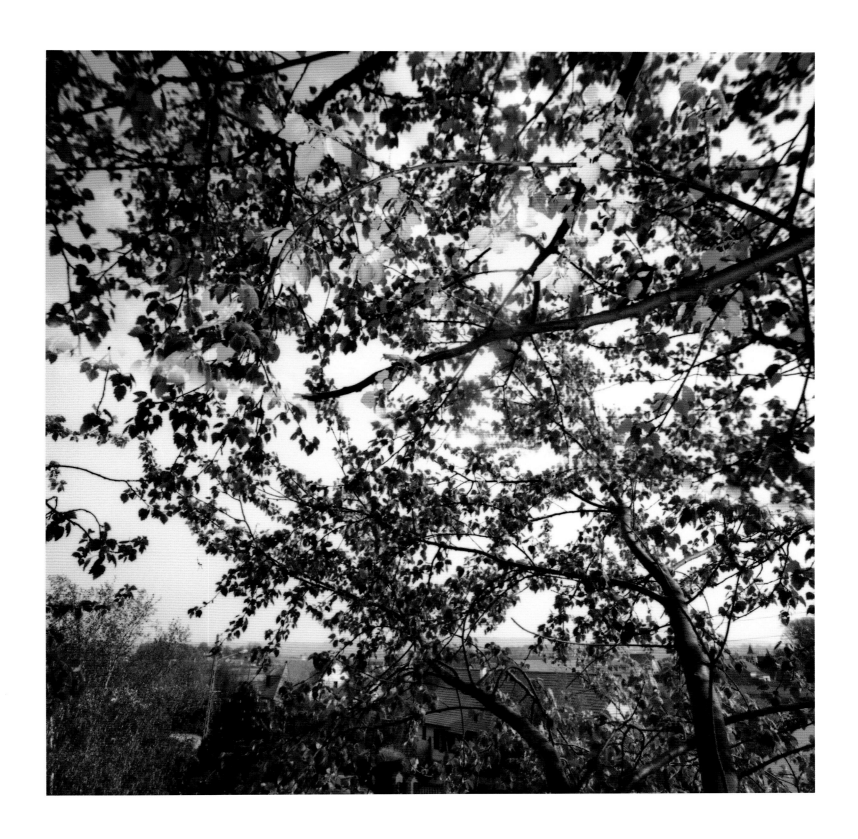

*Plate 49*. No. 76, May June 1987, 40.5/40.5 in.

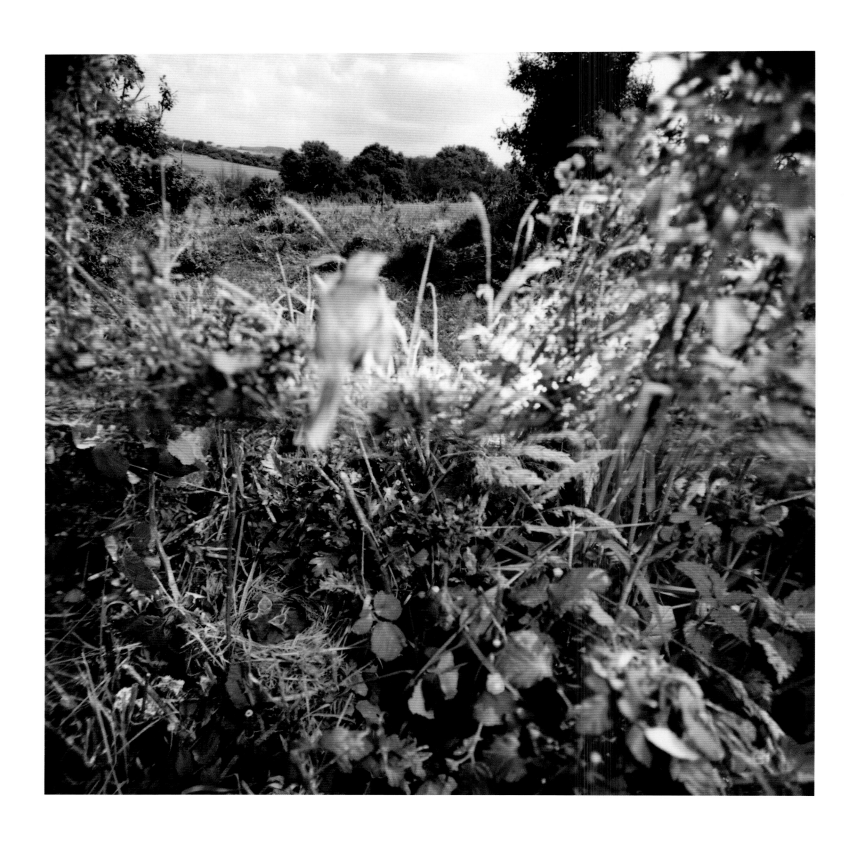

*Plate 50.* No. 36, August 1982, 17/17 in.

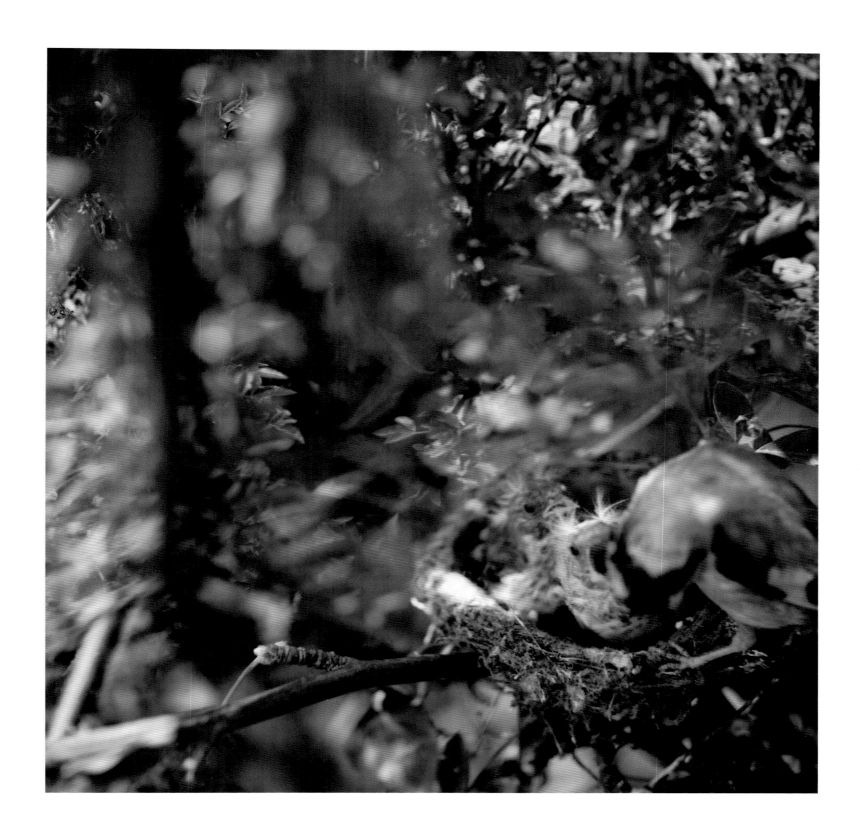

*Plate 51.* No. C3, June July 1981, 72/72 in.

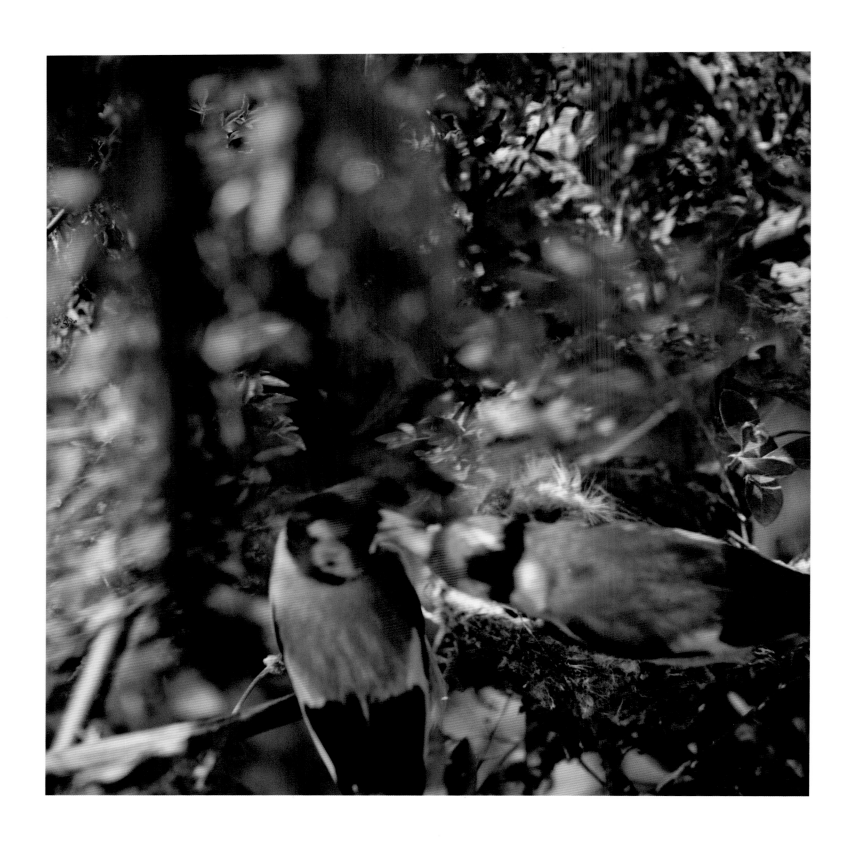

Plate 52. No. C2, June July 1981, 72/72 in.

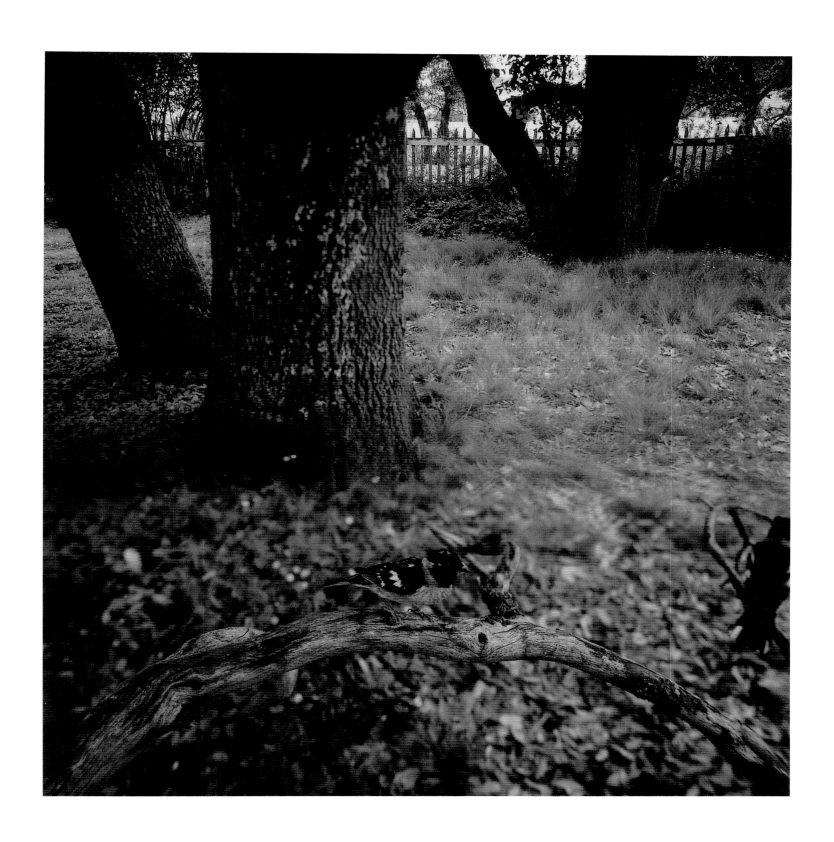

*Plate 53.* No. 395, April May 2006, 60.25/60.25 in.

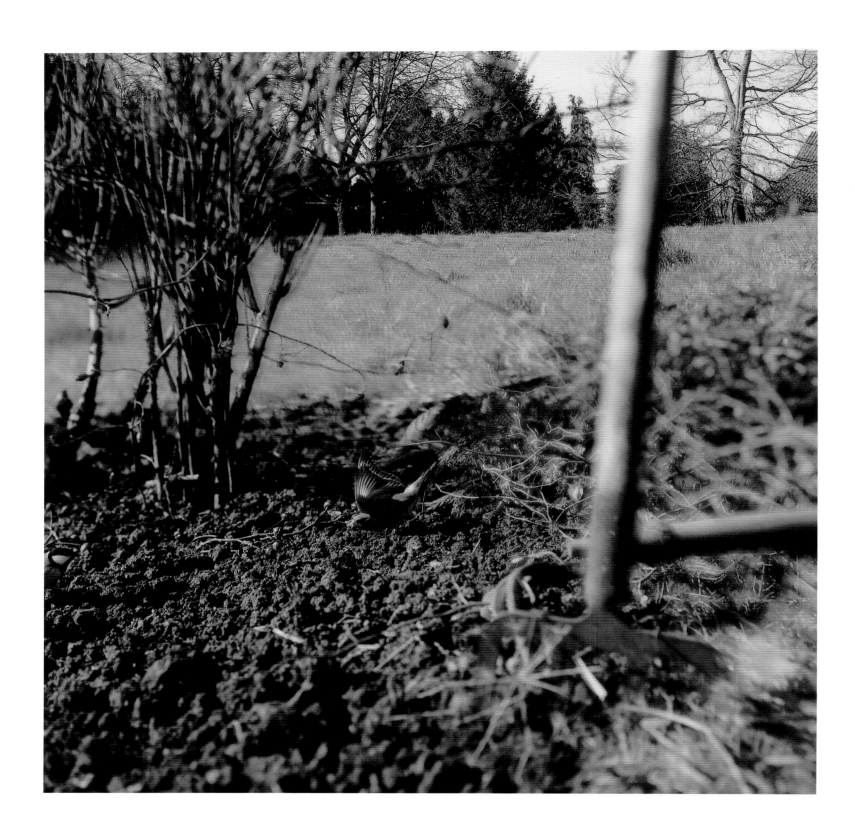

*Plate 54*. No. 141, February March April 2001, 40.5/40.5 in.

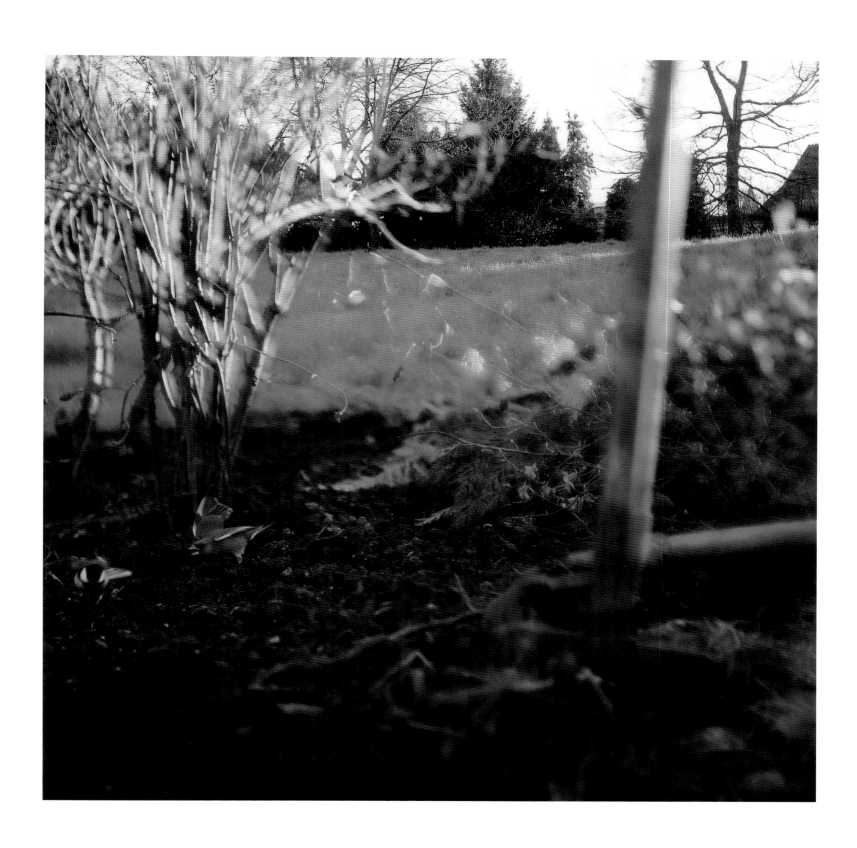

*Plate* 55. No. 142, February March April 2001, 40.5/40.5 in.

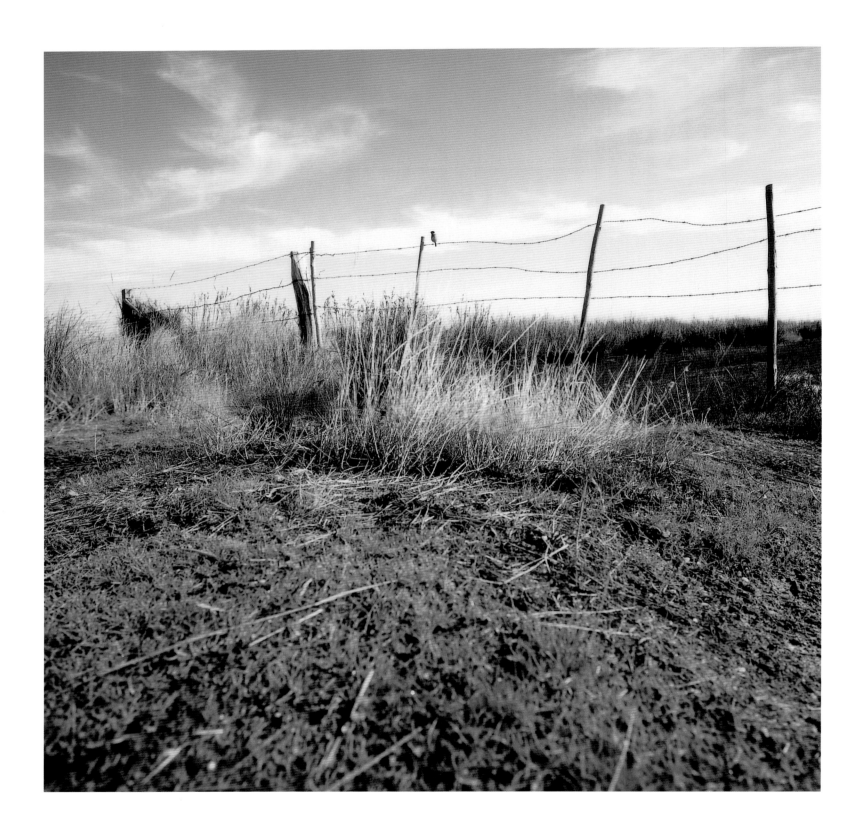

*Plate 56.* No. 101, September October November December 1991, 17/17 in.

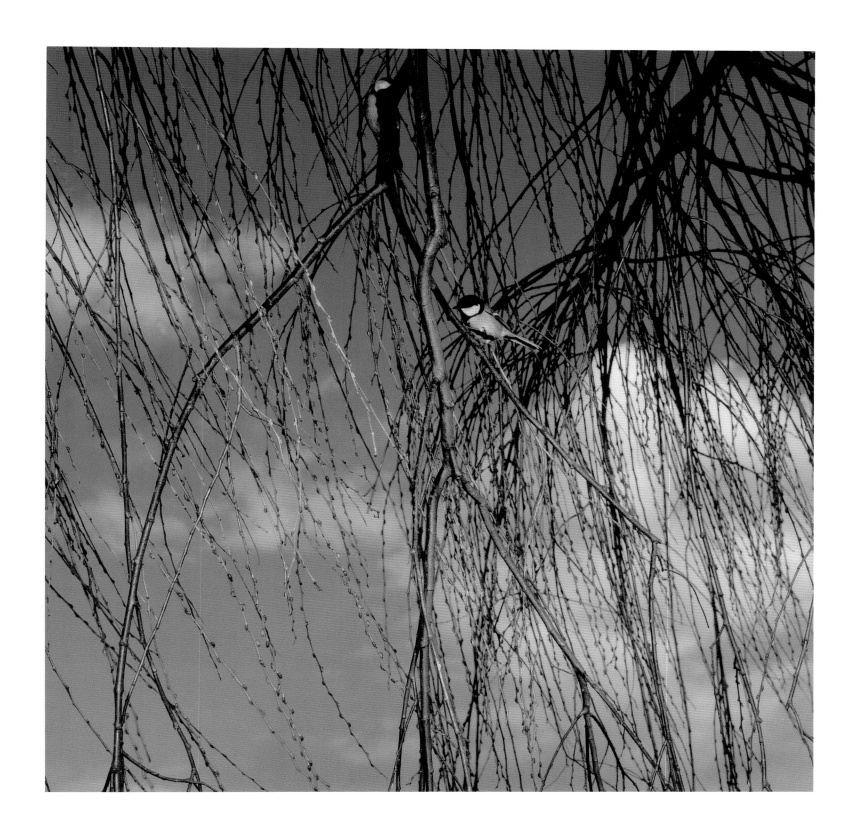

*Plate 57.* No. 78, November December 1987, 60.25/60.25 in.

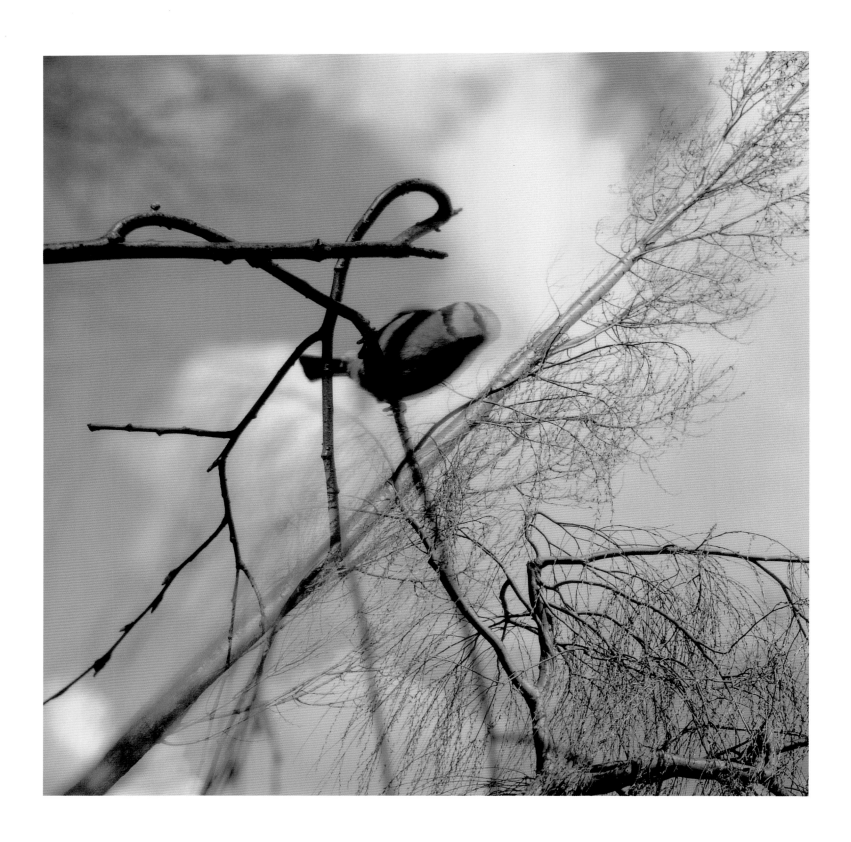

*Plate 58.* No. C14, January February March April 1987, 50.5/50.5 in.

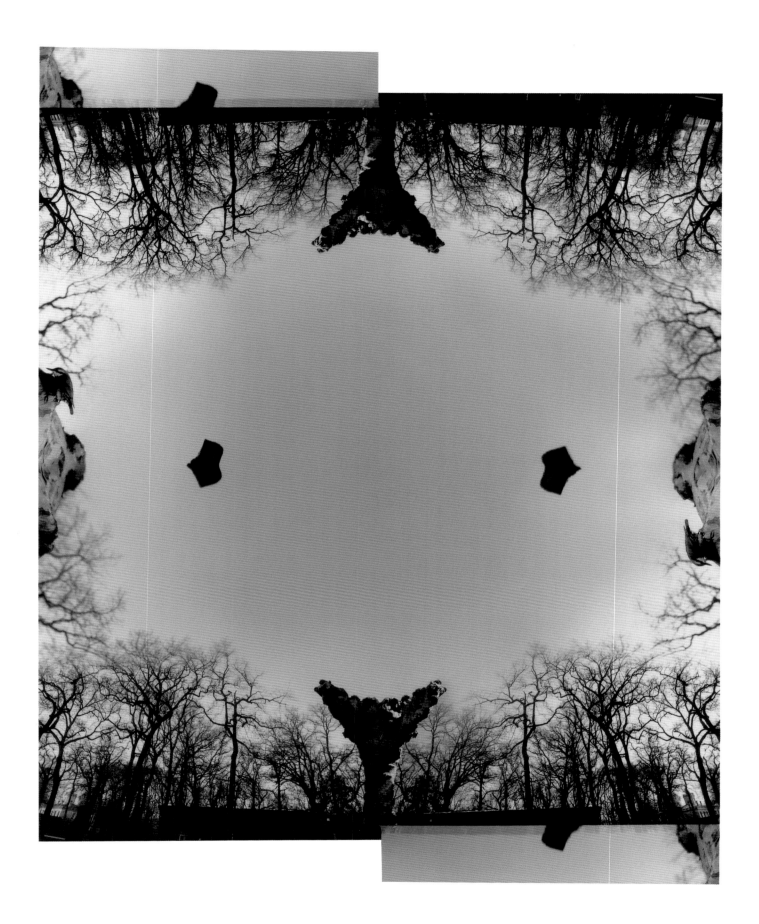

*Plate 59.* No. 94, August 1990—March 1991, 80/72 in.

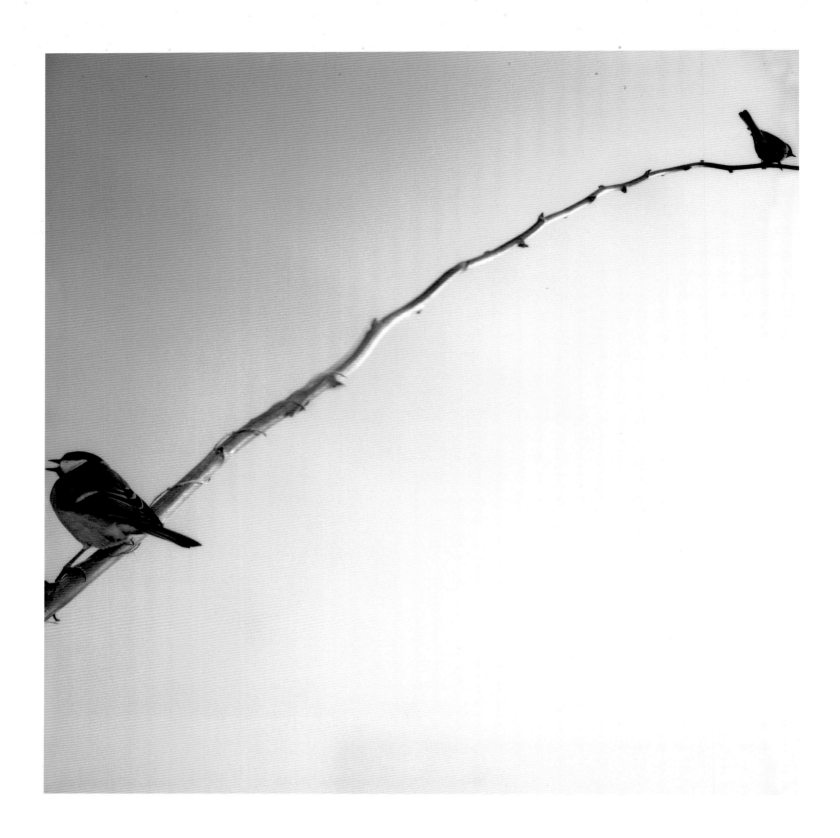

*Plate 60.* No. 70, January February March April 1987, 72/72 in.

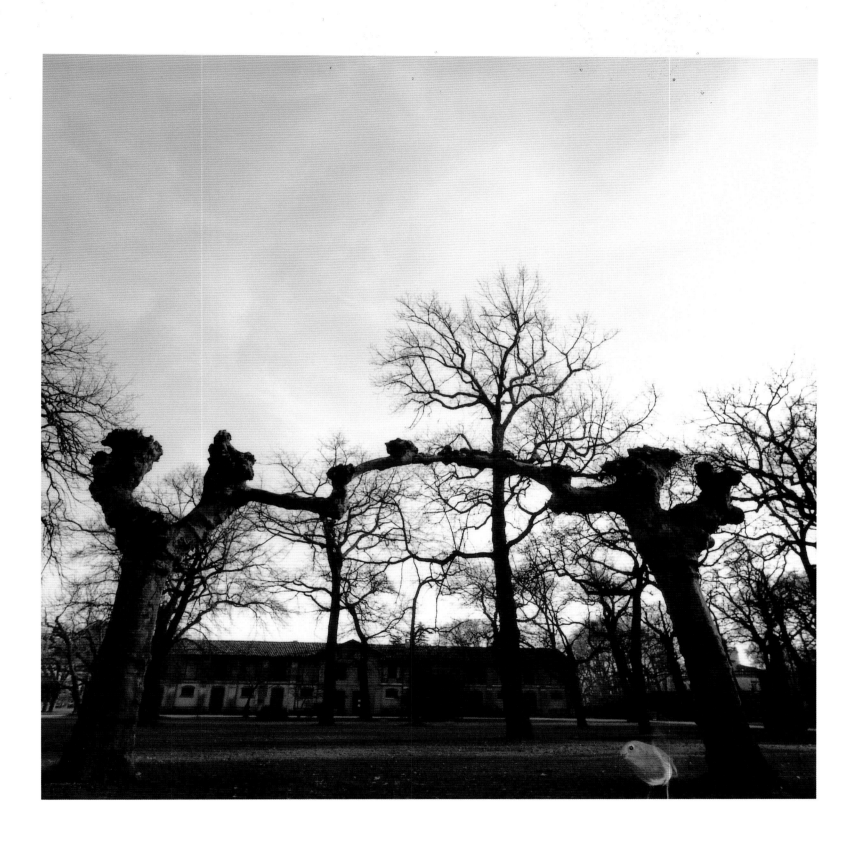

*Plate 61.* No. 100 D7, October 1990–February 1993, 60.25/60.25 in.

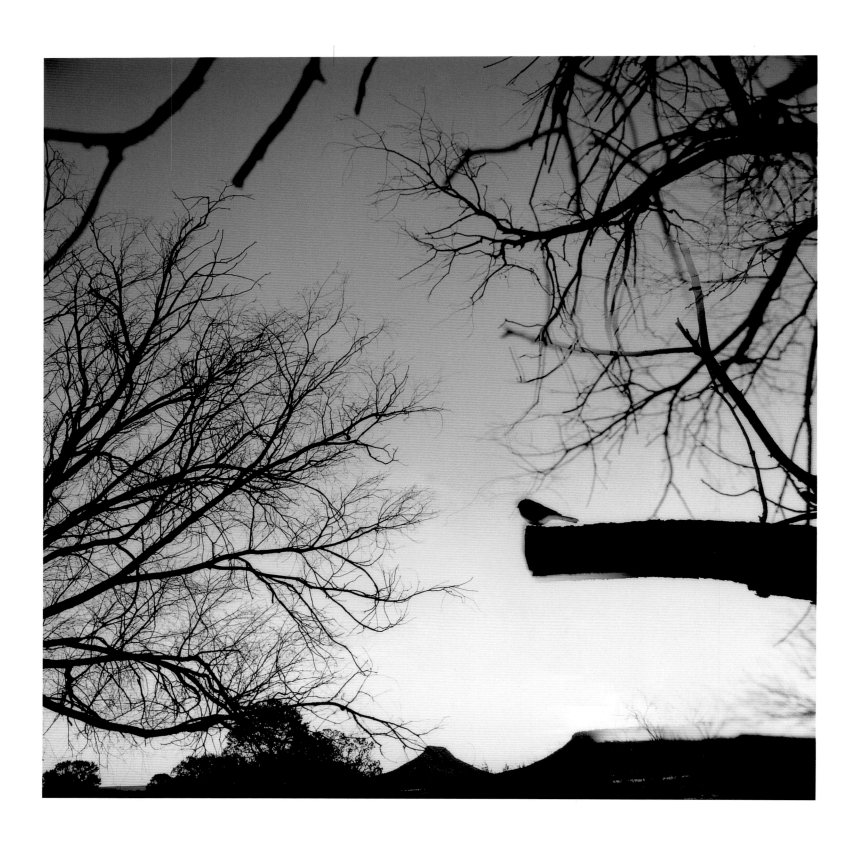

*Plate 62.* No. 172, December 2003–January 2004, 48.5/48.5 in.

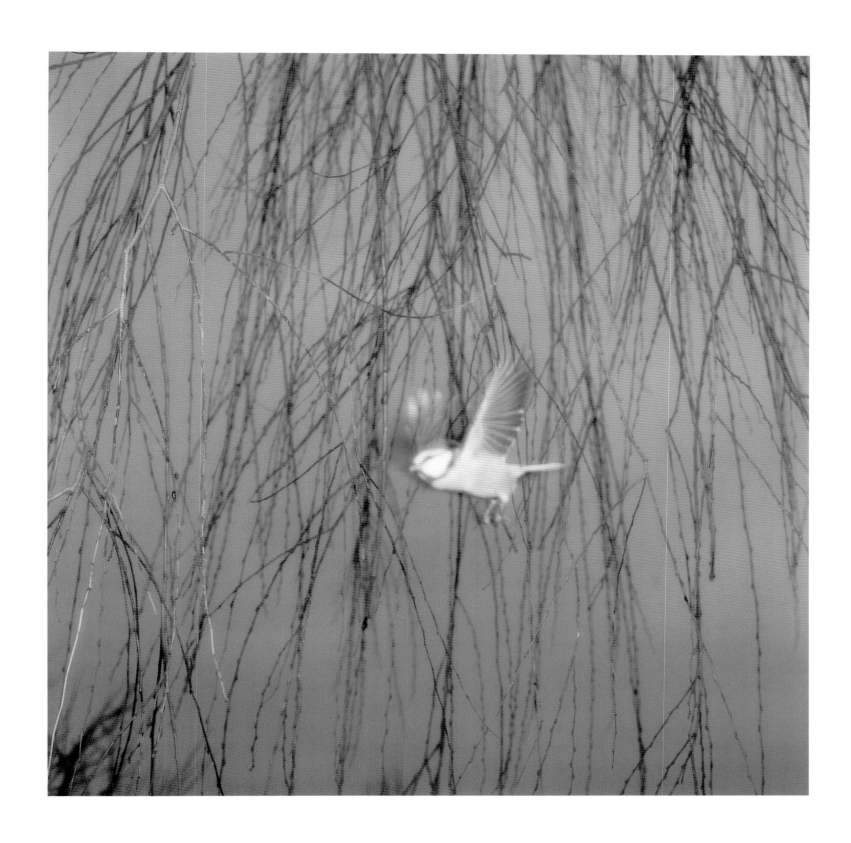

*Plate 63.* No. 63, January February 1987, 72/72 in.

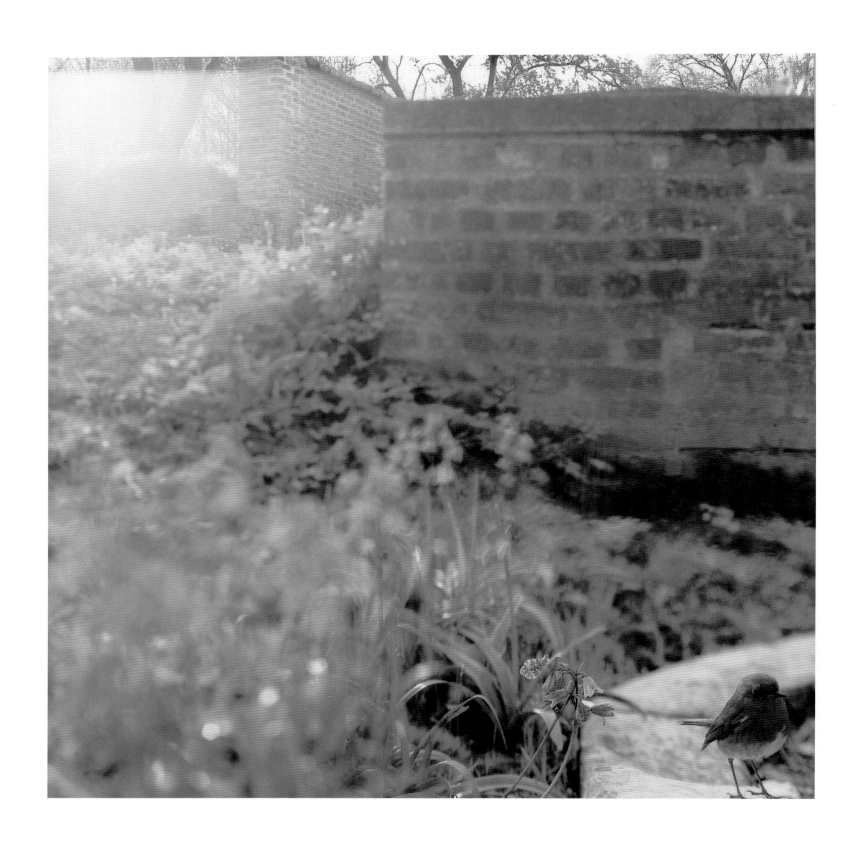

*Plate 64.* No. J9, February March April May 2001, 48.5/48.5 in.

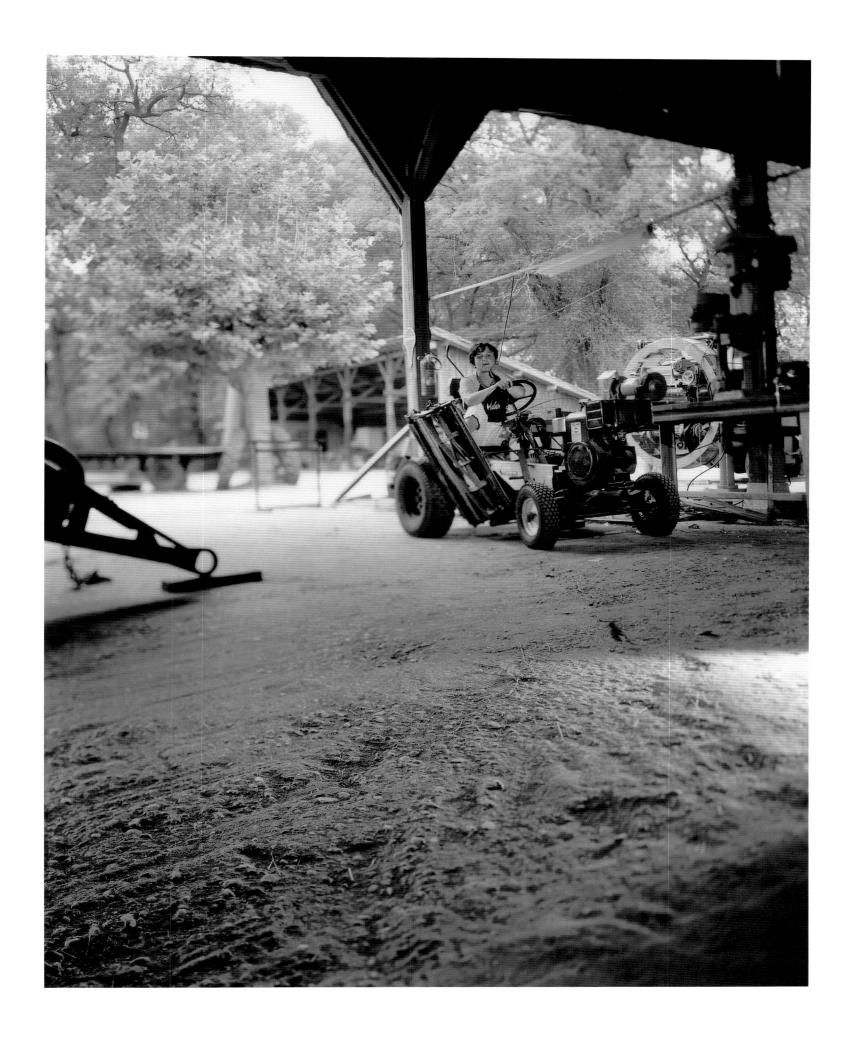

*Plate 65.* No. 115, May June 1992, 60.25/48.5 in.

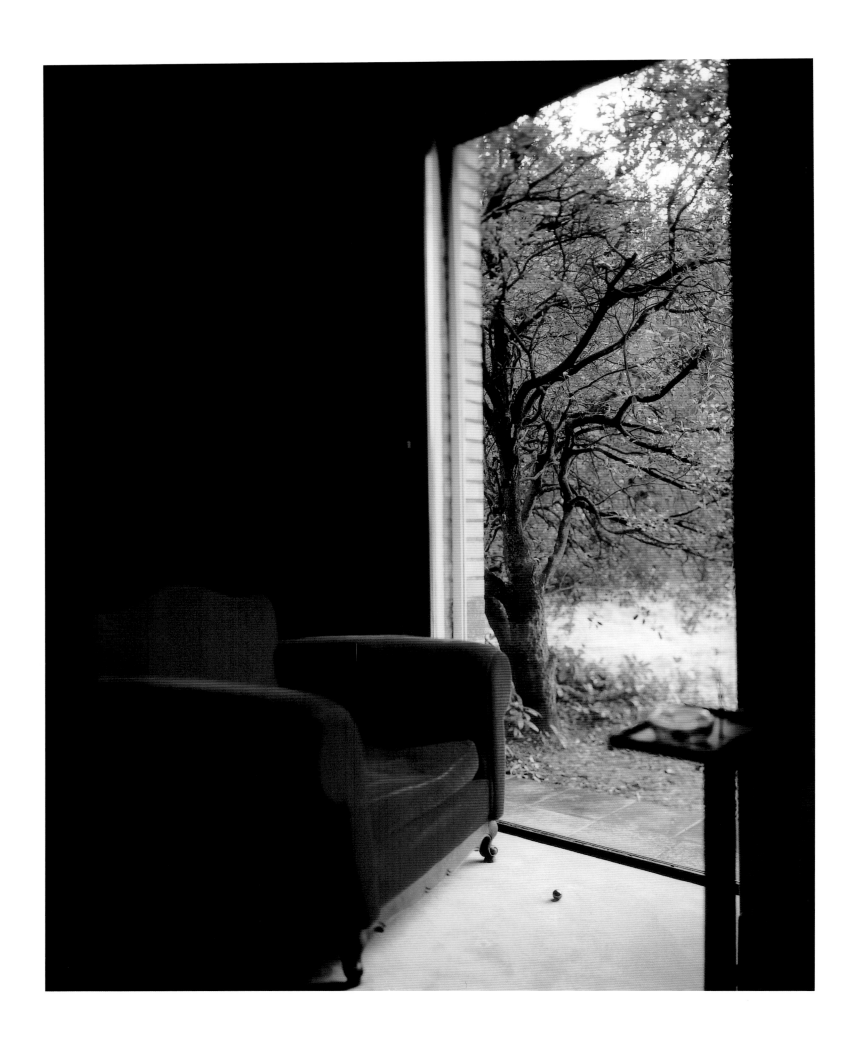

*Plate 66*. No. B4, November December 2000–January 2001, 60.25/48.5 in.

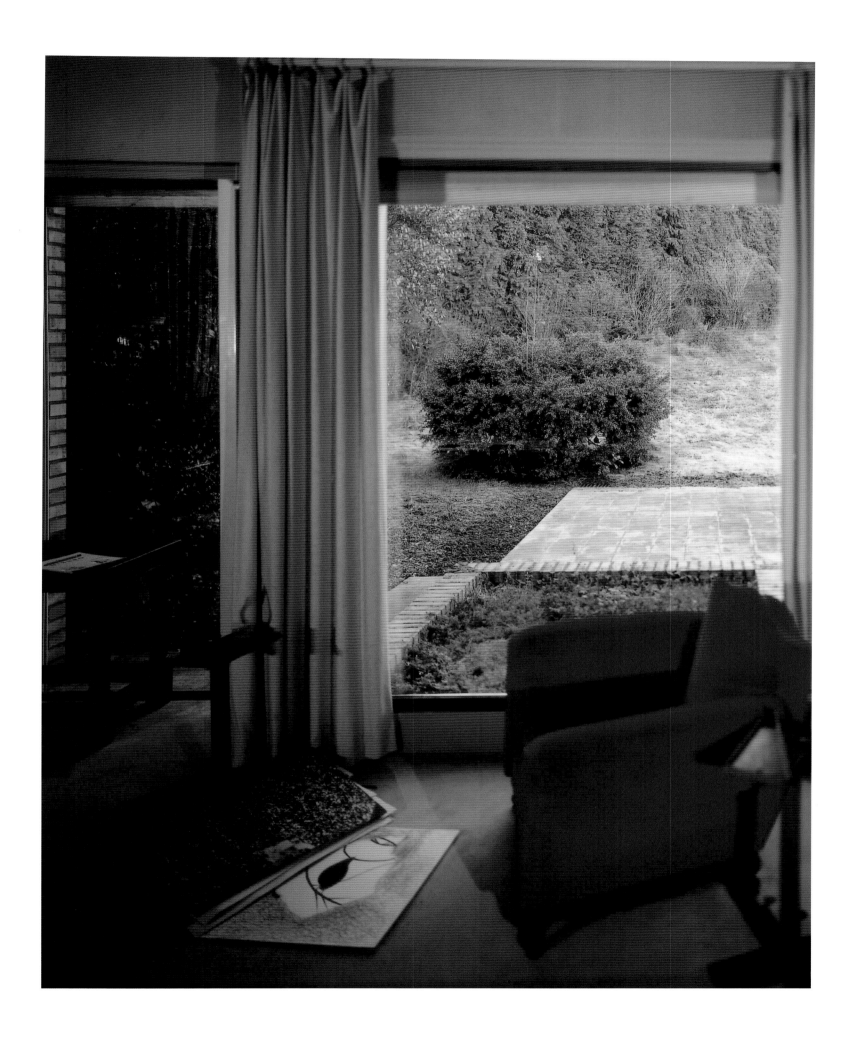

*Plate 67*. No. B2, November December 2000–January 2001, 60.25/48.5 in.

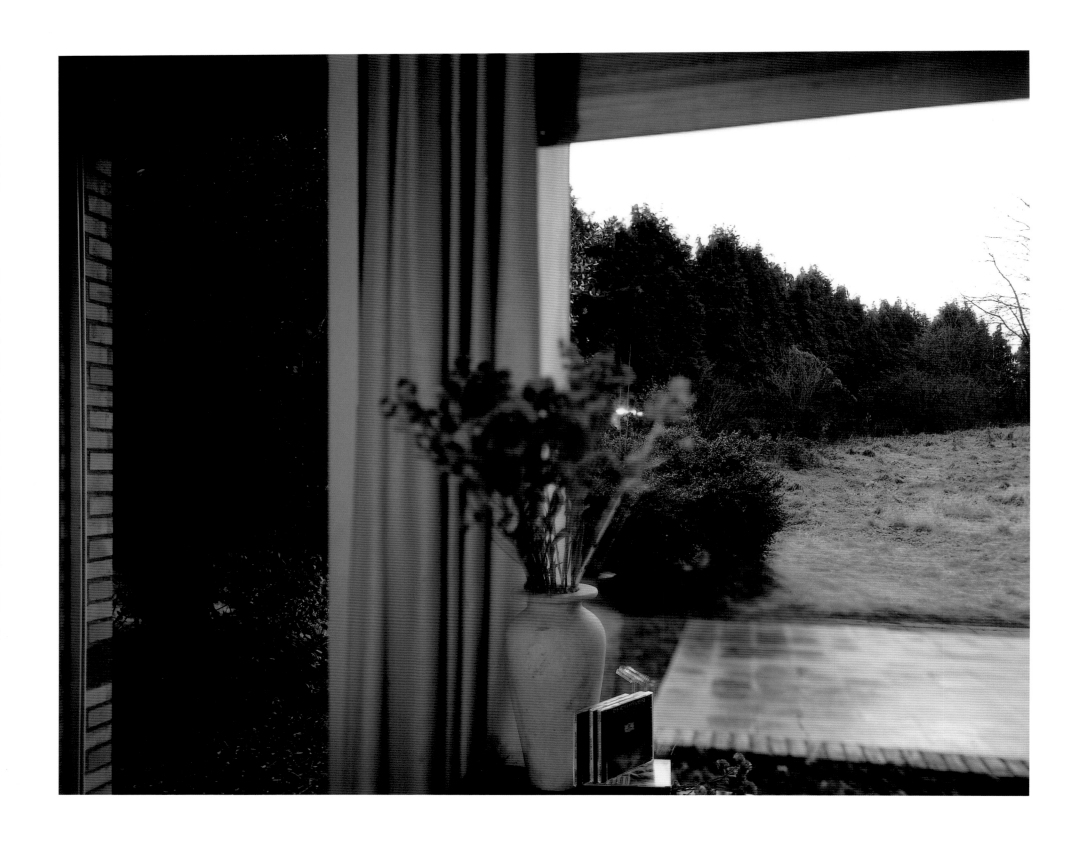

*Plate 68.* No. B3, November December 2000–January 2001, 48.5 / 60.25 in.

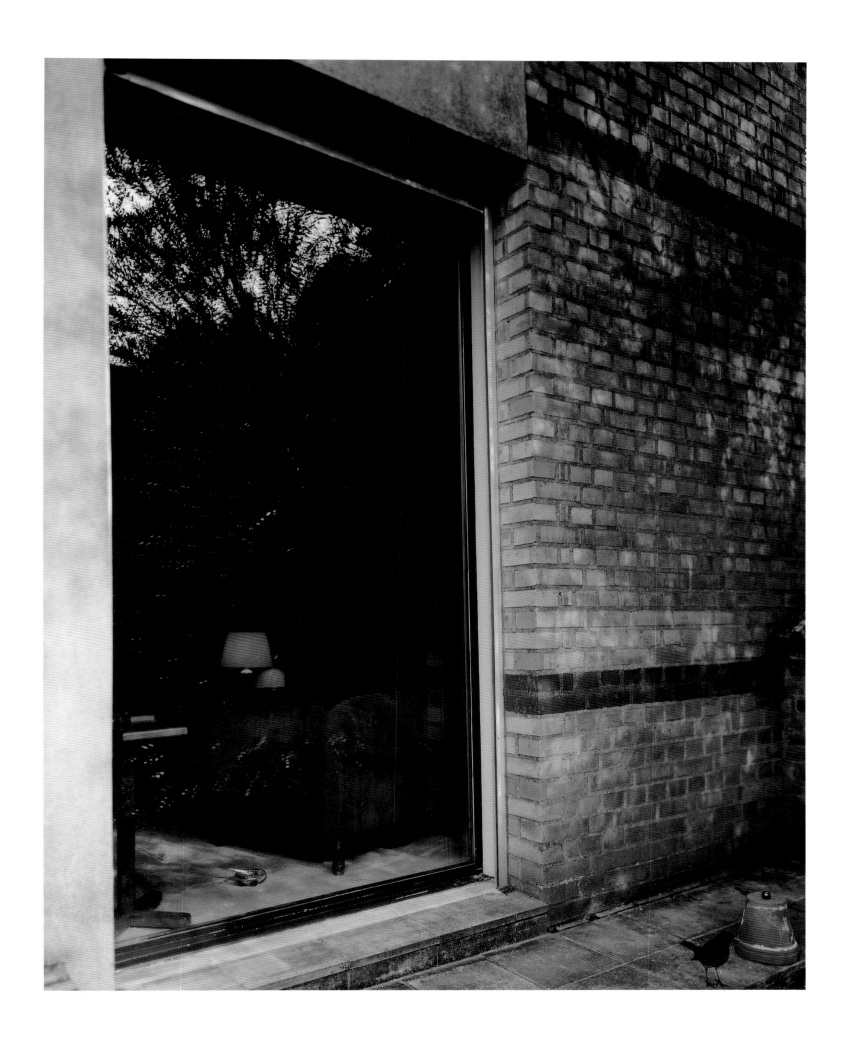

*Plate 69.* No. B7, November December 2000–January 2001, 60.25/48.5 in.

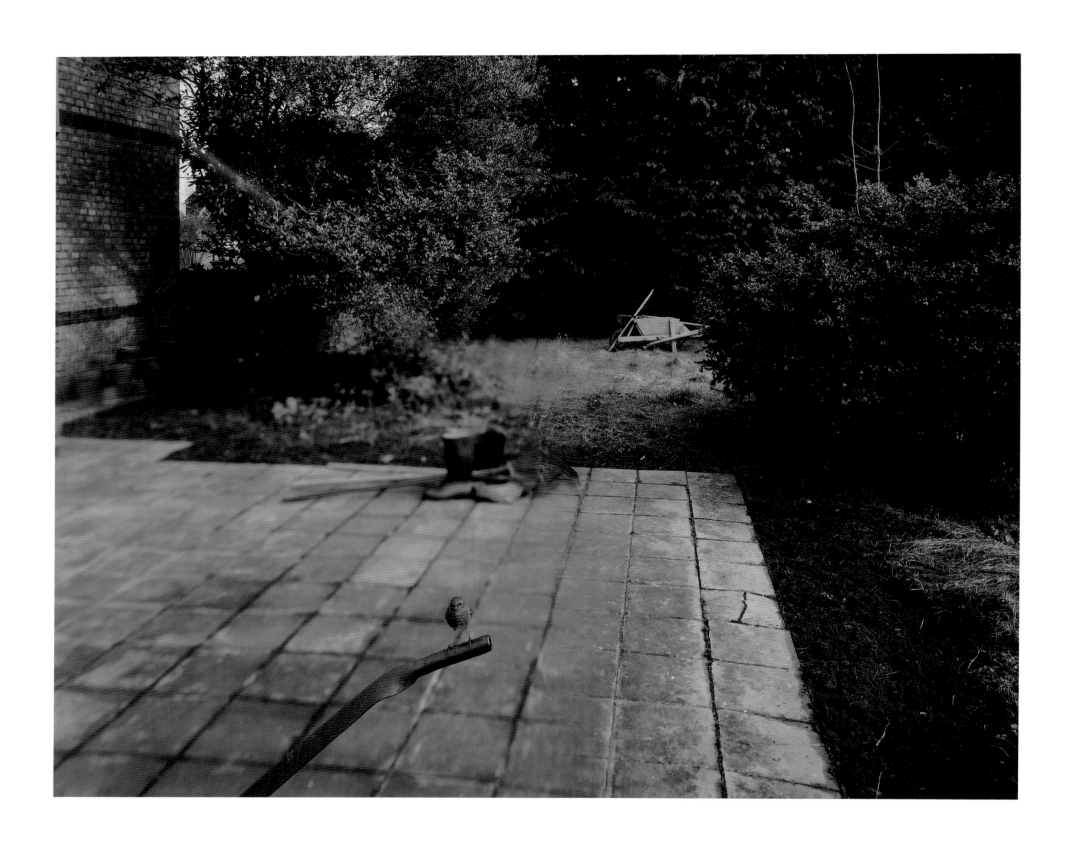

Plate 70. No. B9, November December 2000–January 2001, 48.5/60.25 in.

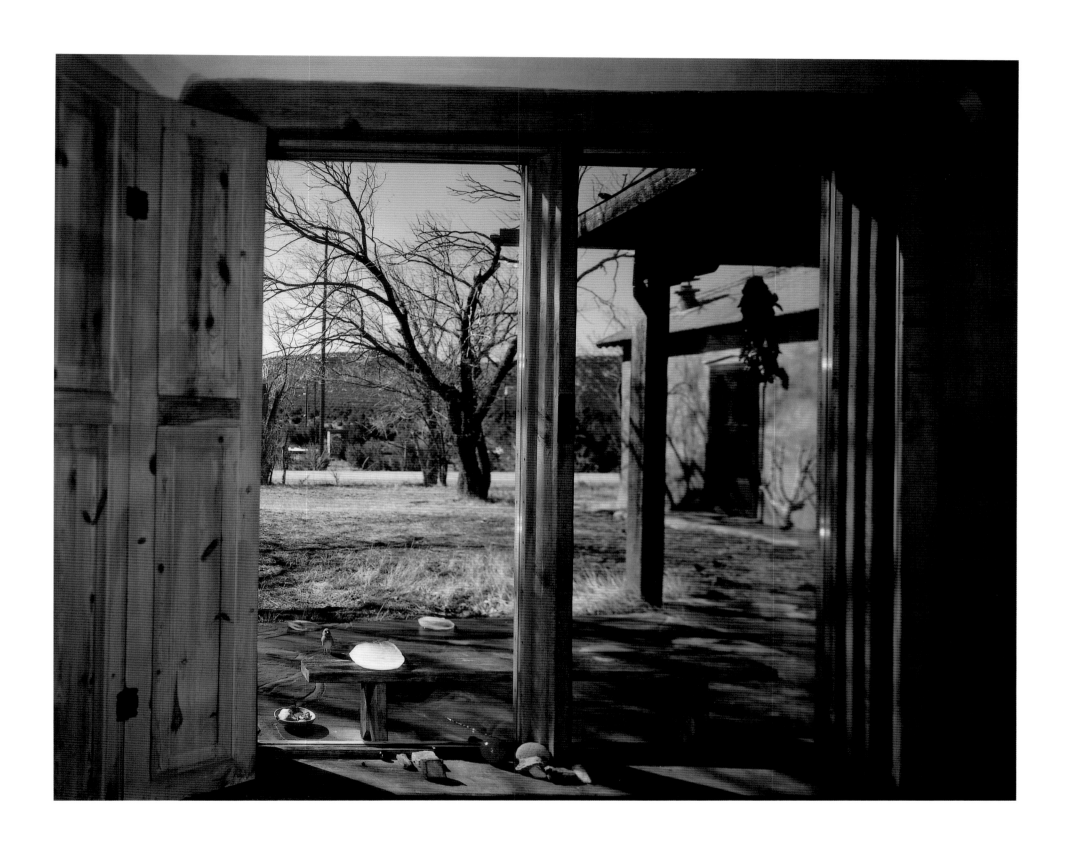

*Plate 71.* No. 250, January February March 2004, 48.5/60.25 in.

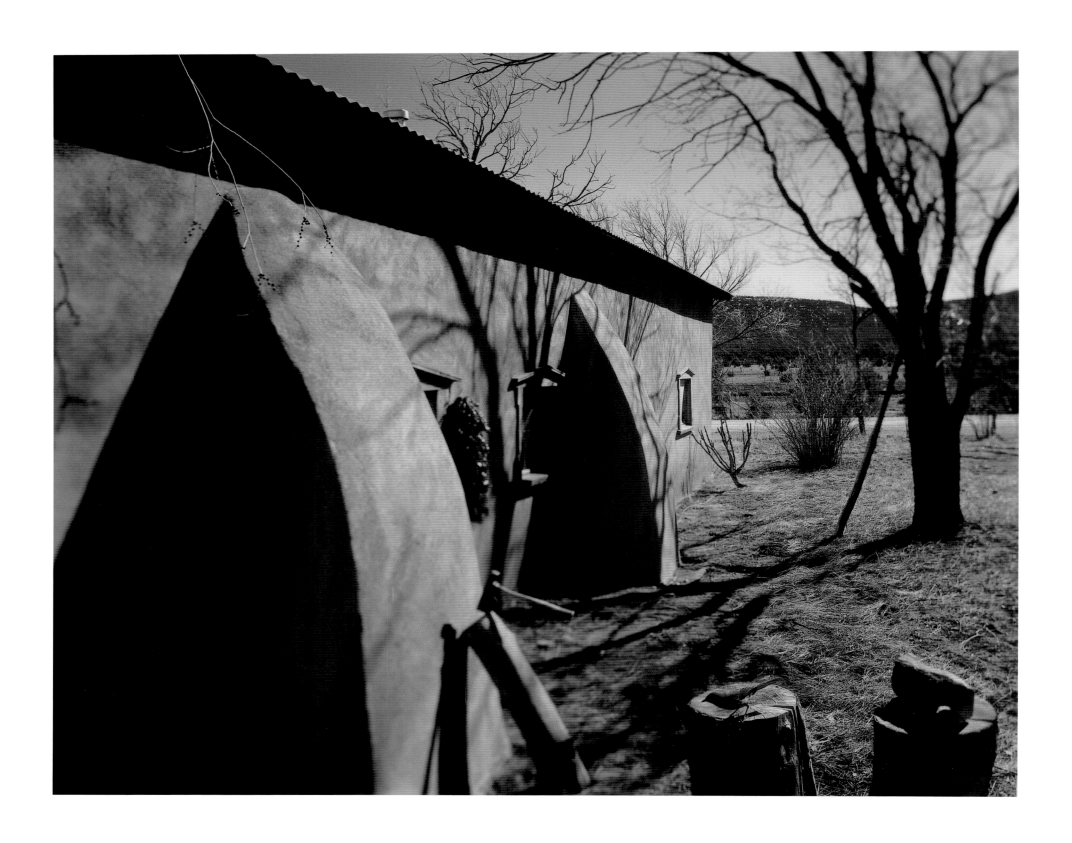

*Plate 72.* No. 258, February March 2004, 48.5/60.25 in.

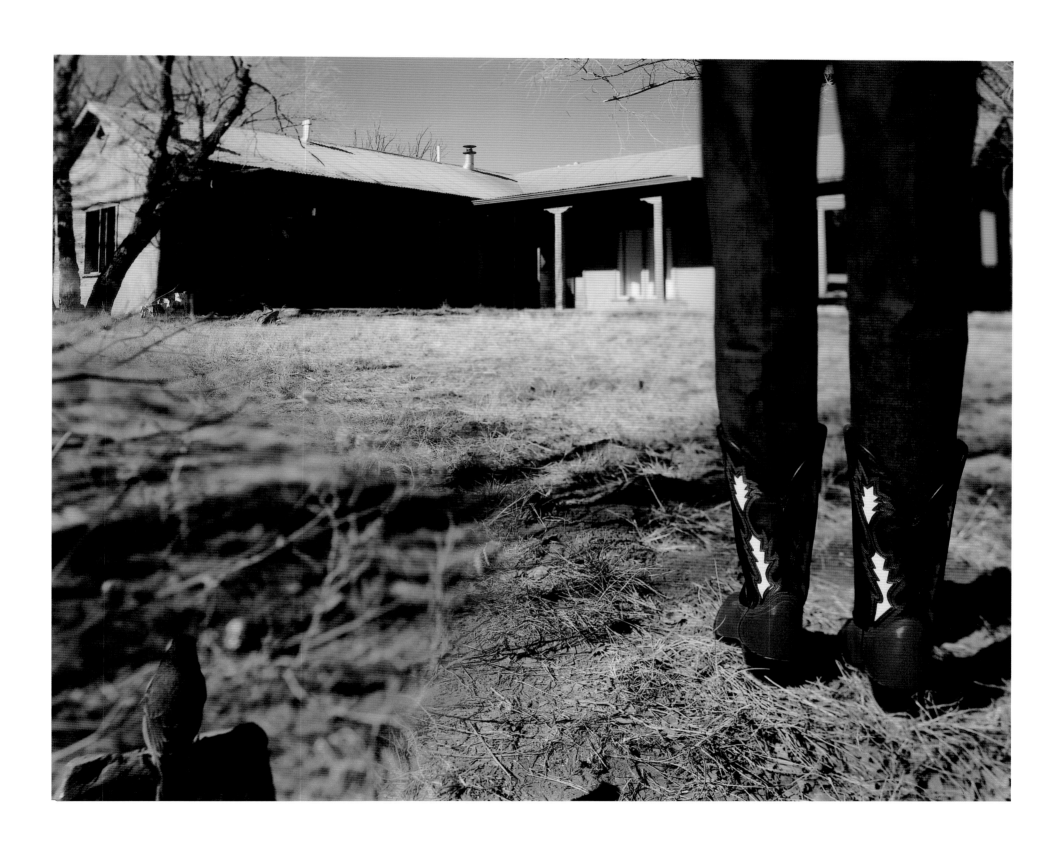

*Plate* 73. No. 186, January February 2004, 48.5/60.25 in.

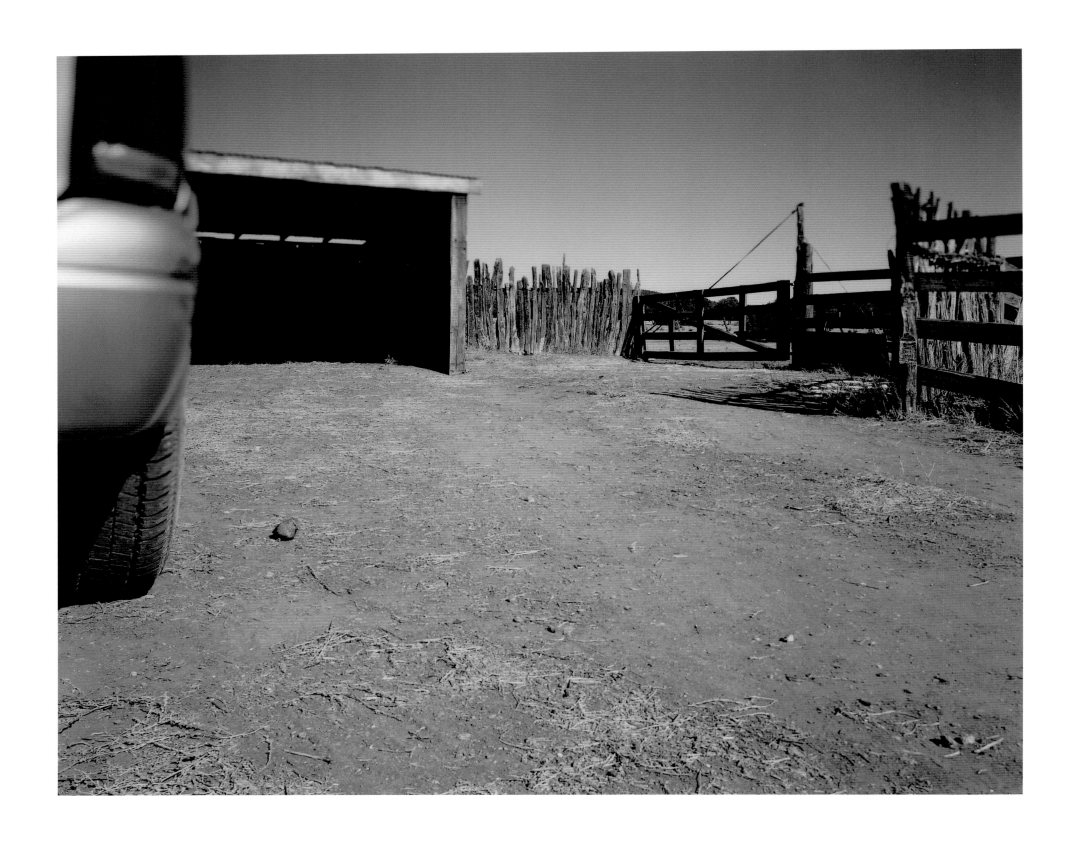

*Plate 74.* No. 198, January February 2004, 48.5/60.25 in.

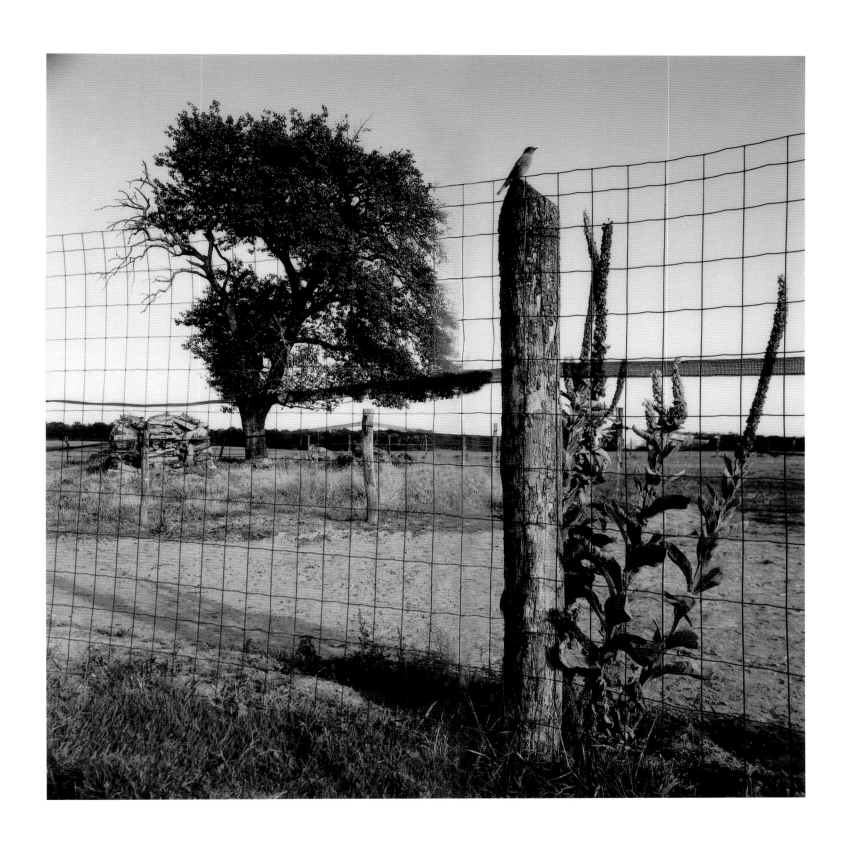

*Plate 75*. No. 160, September October 2003, 48.5/60.25 in.

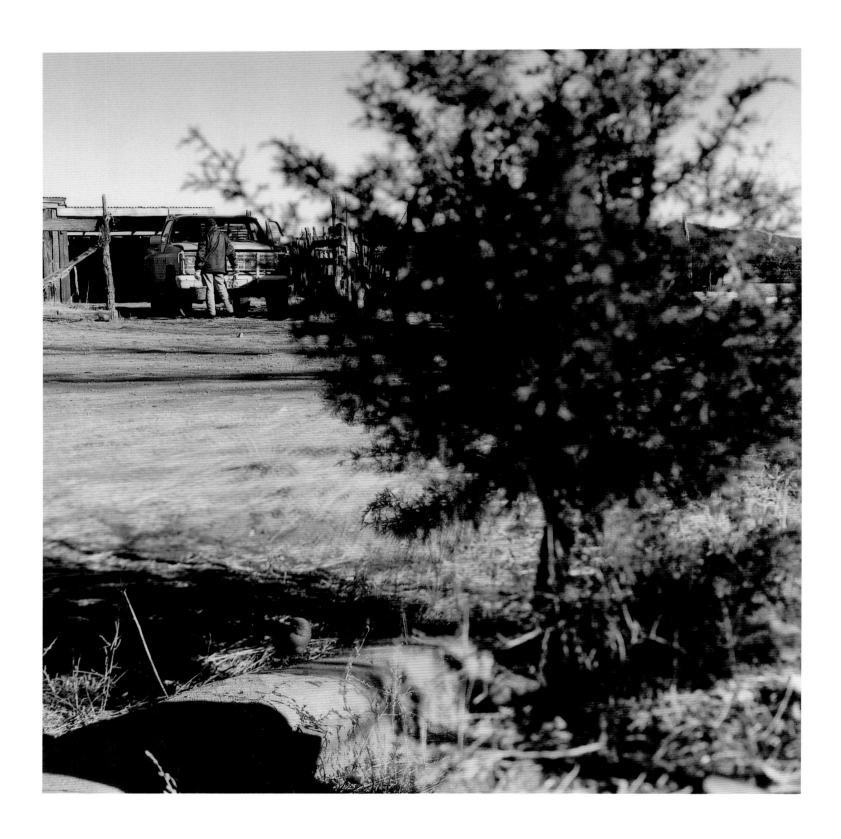

*Plate 76.* No. 183, January February 2004, 40.5/40.5 in.

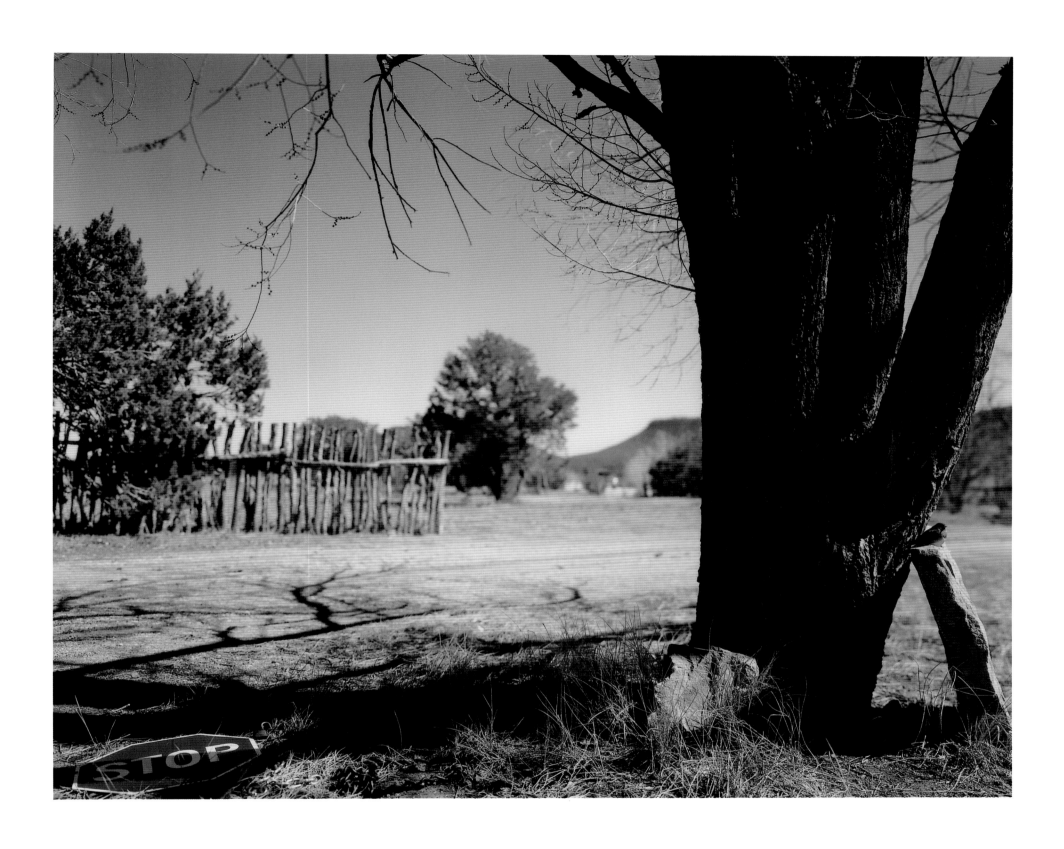

*Plate 77.* No. 253, February March 2004, 48.5/60.25 in.

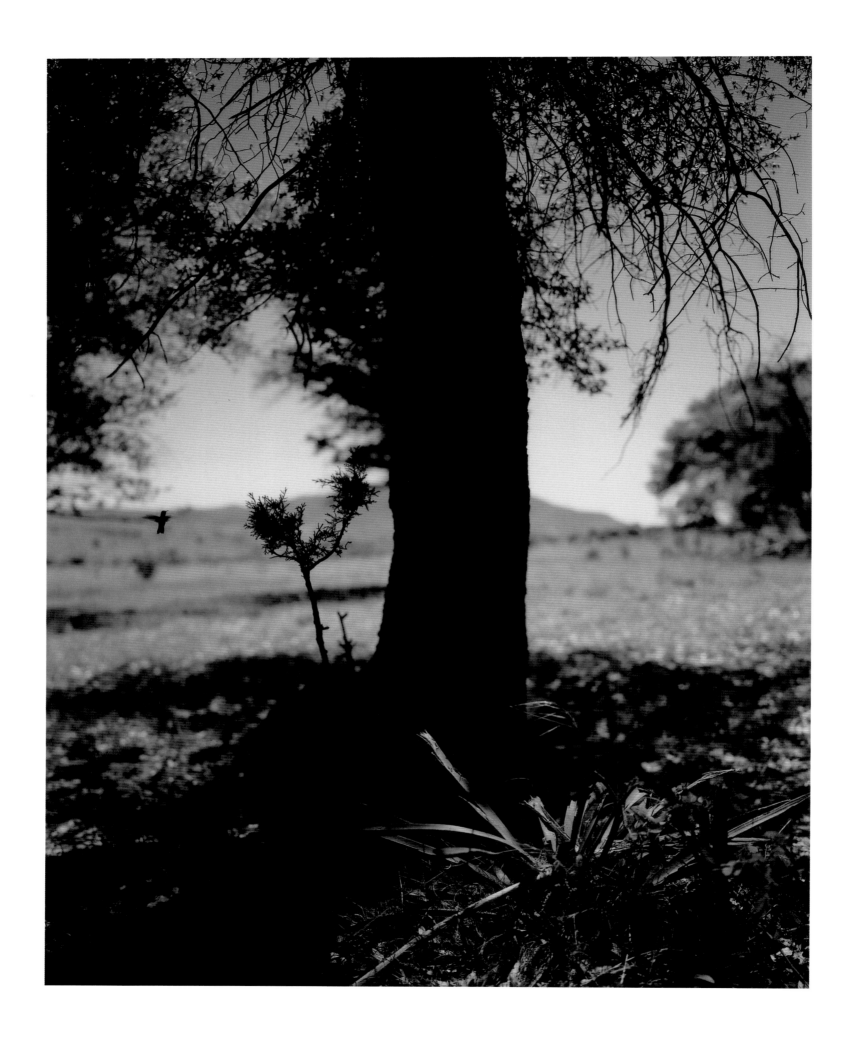

*Plate 78*. No. 319, April May 2005, 74.5/60.25 in.

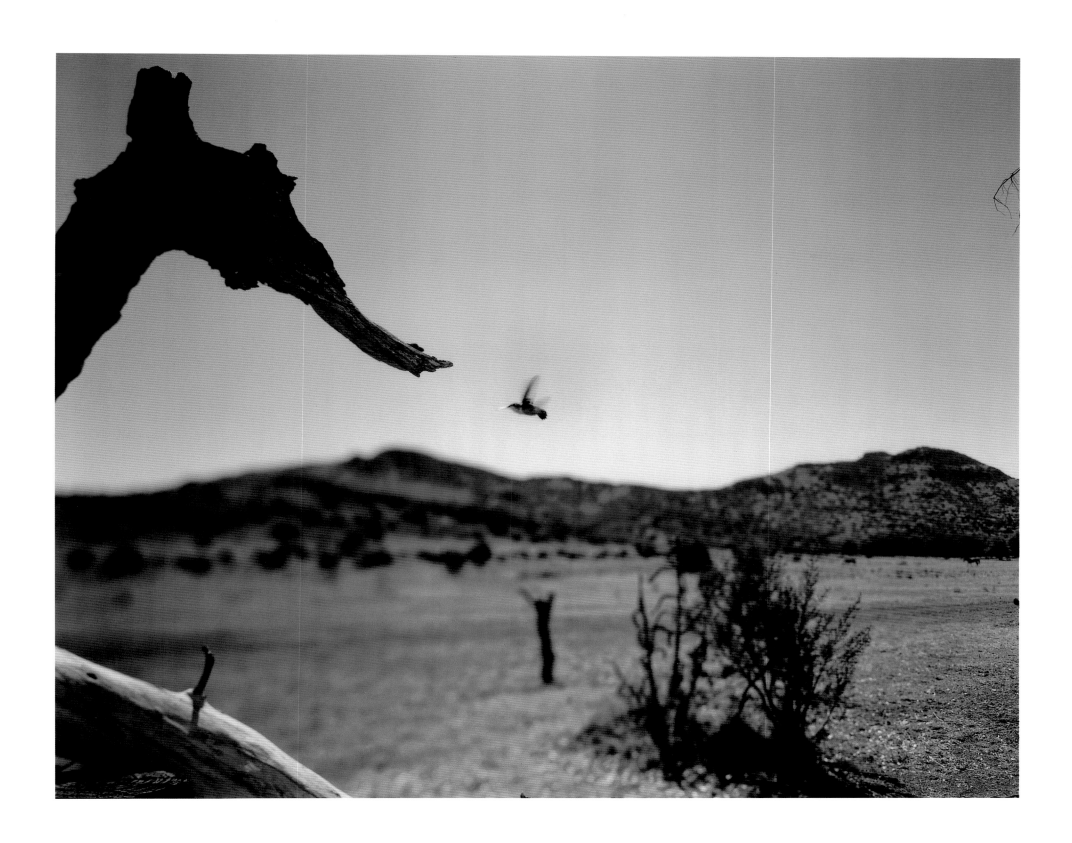

*Plate 79.* No. 368, February March 2006, 48.5/60.25 in.

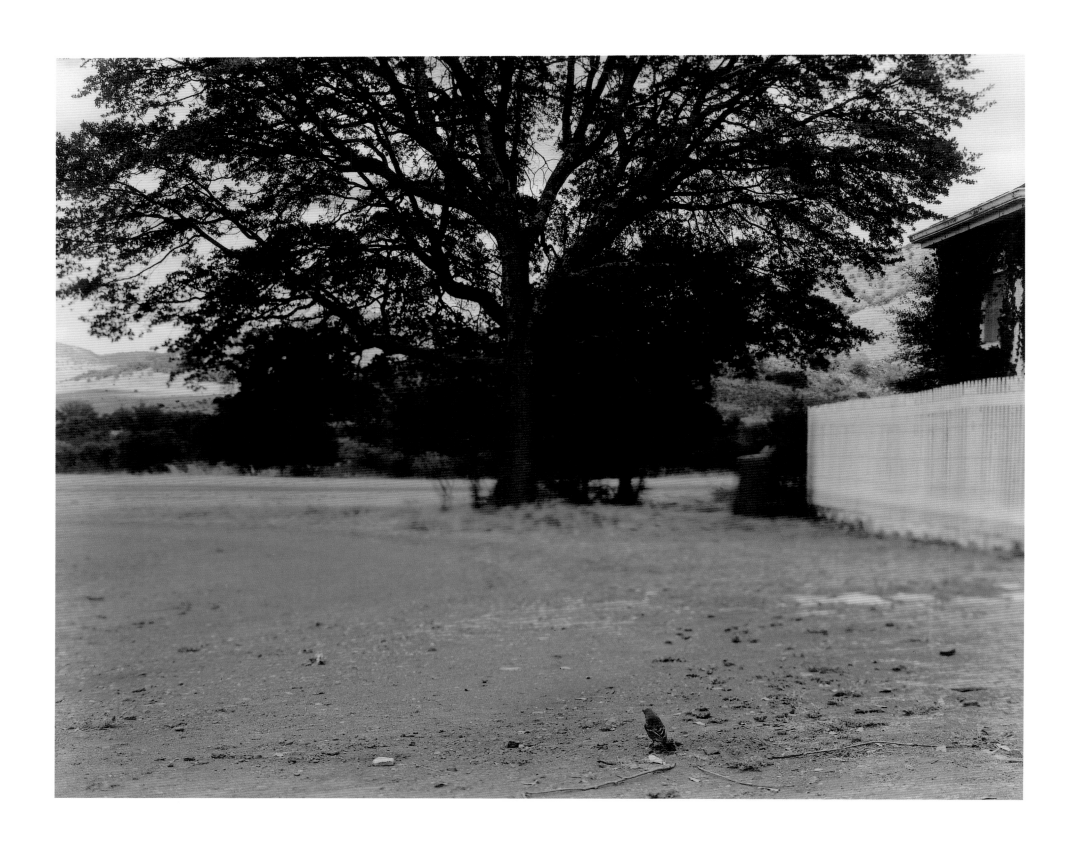

*Plate 80.* No. 373, March April 2006, 60.25/74.75 in.

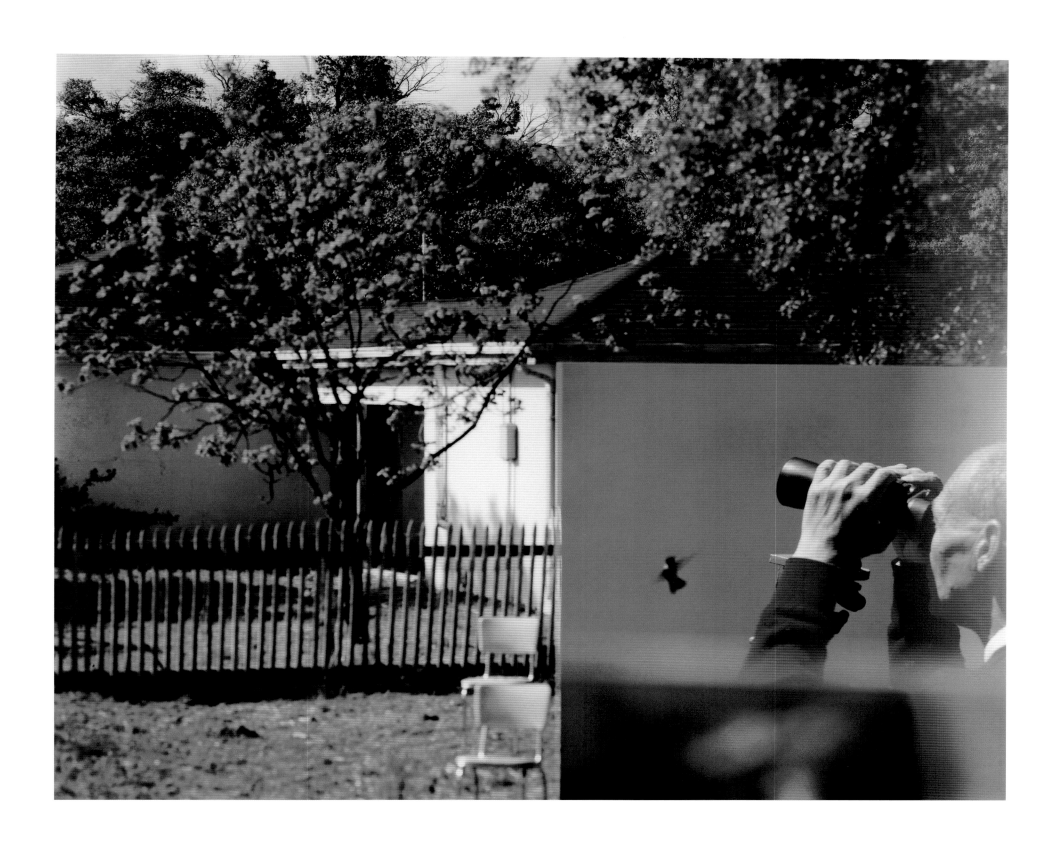

*Plate 81.* No. 320, April May 2005, 48.5/60.25 in.

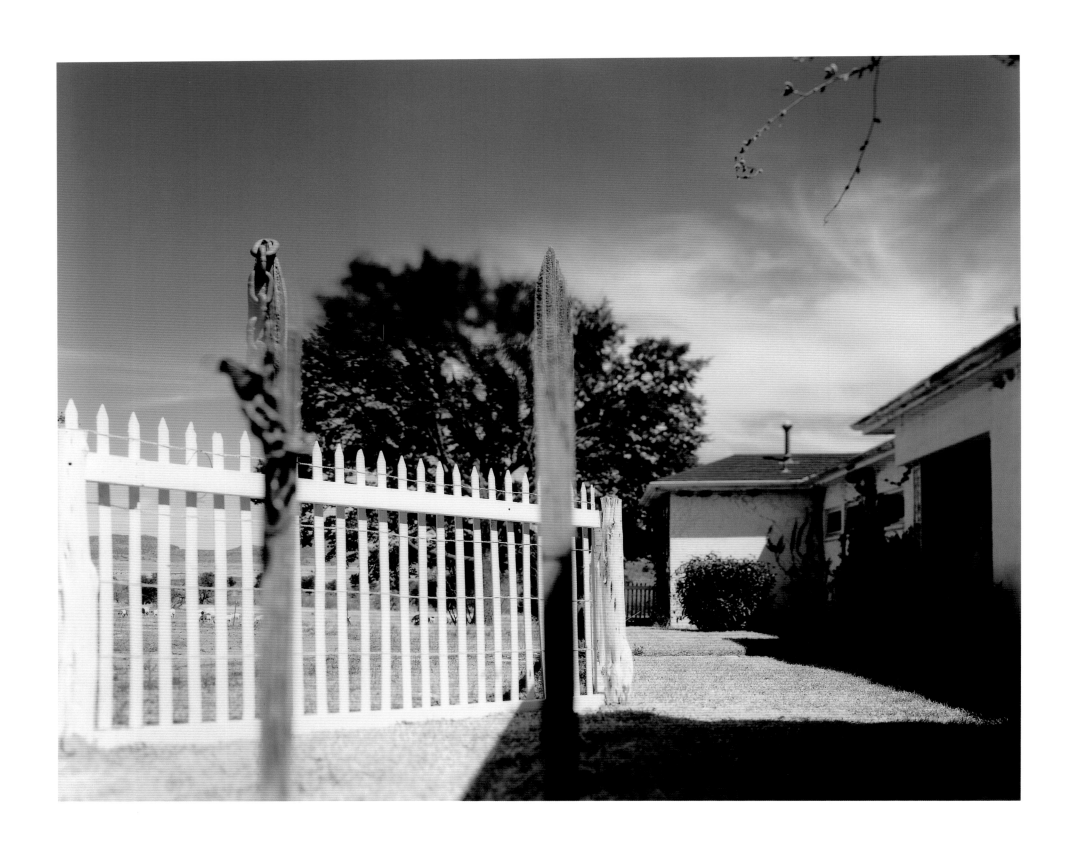

*Plate 82.* No. 290, February March 2005, 48.5/60.25 in.

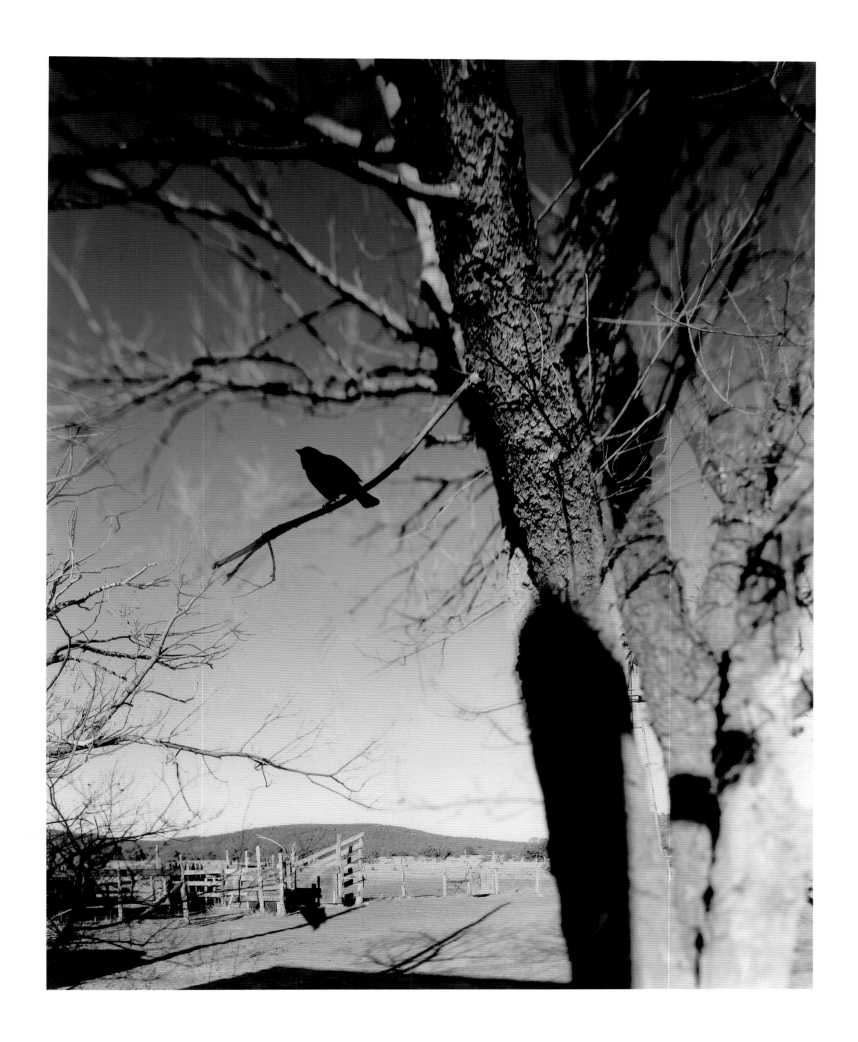

*Plate 83.* No. 269, February March 2004, 74.75/60.25 in.

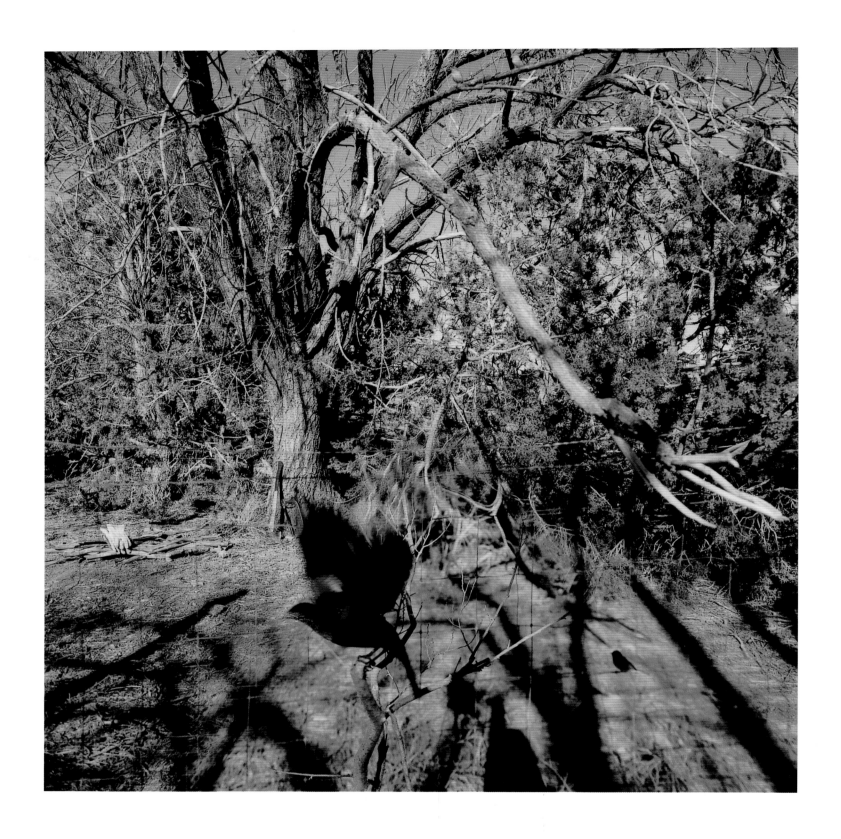

*Plate 84.* No. 284, February March 2004, 72/72 in.

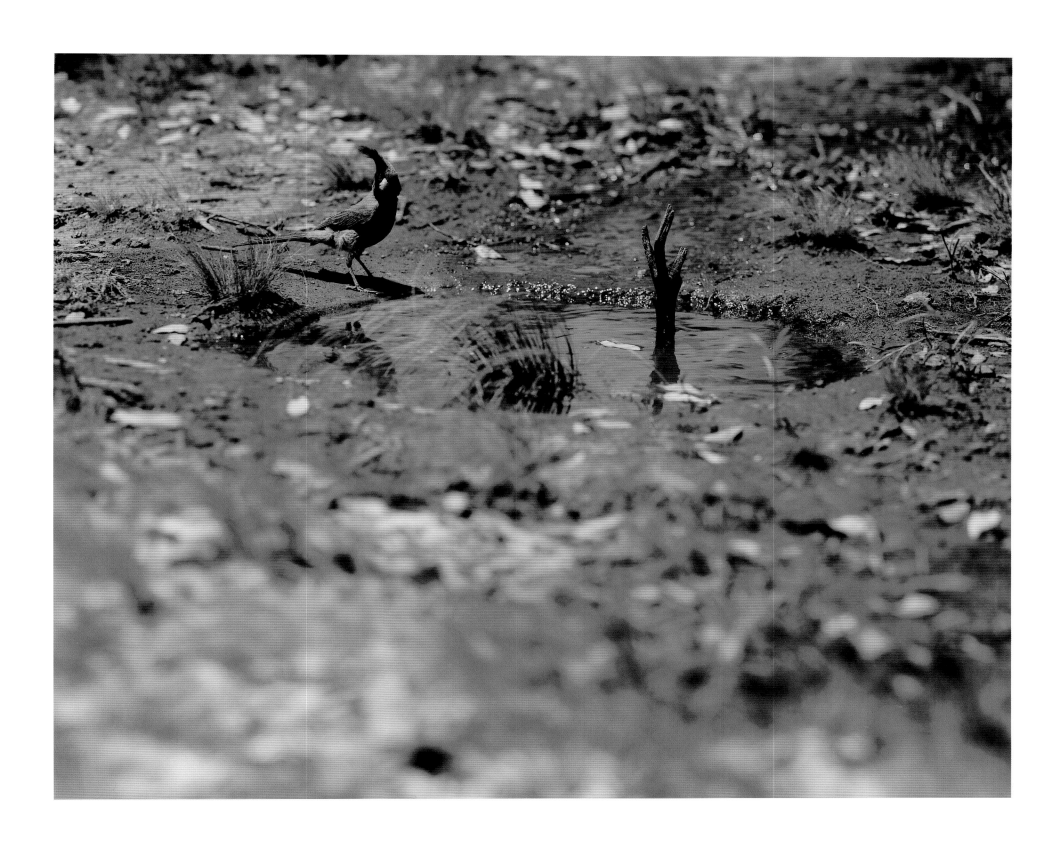

*Plate 85*. No. 394, April May 2006, 48.5/60.25 in.

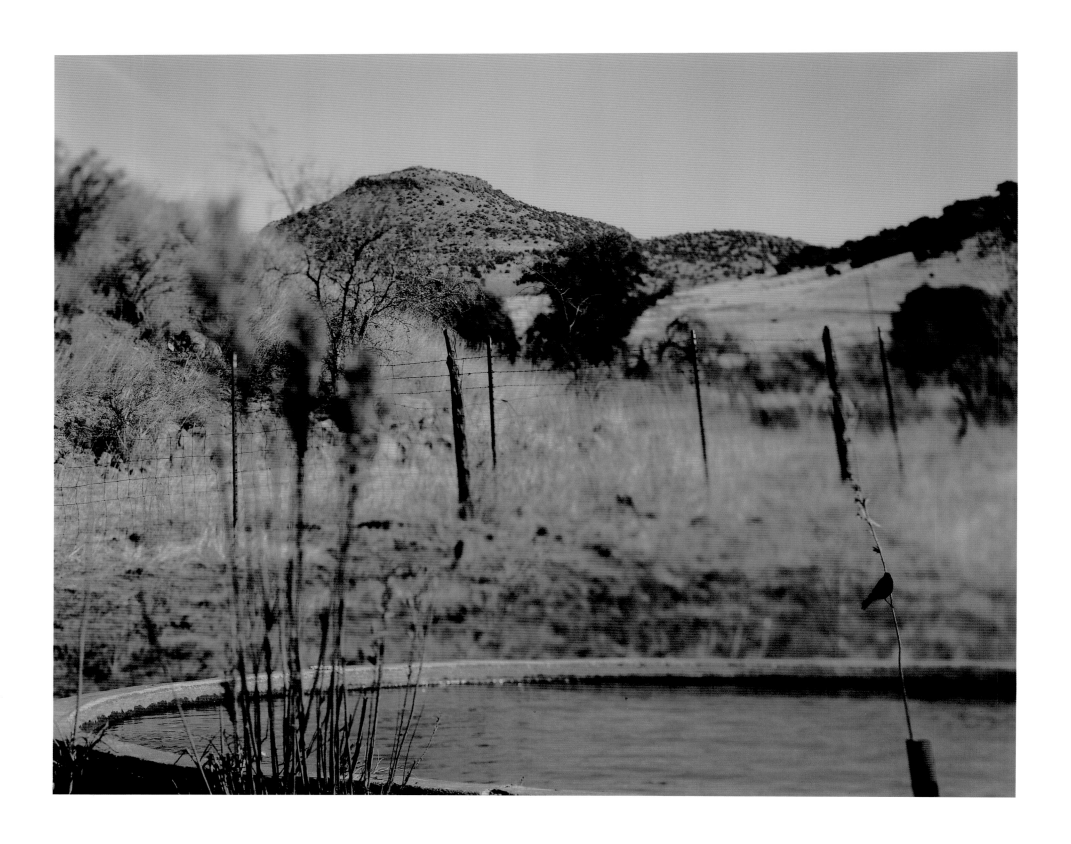

*Plate 86.* No. 356, December 2005–January 2006, 48.5 / 60.25 in.

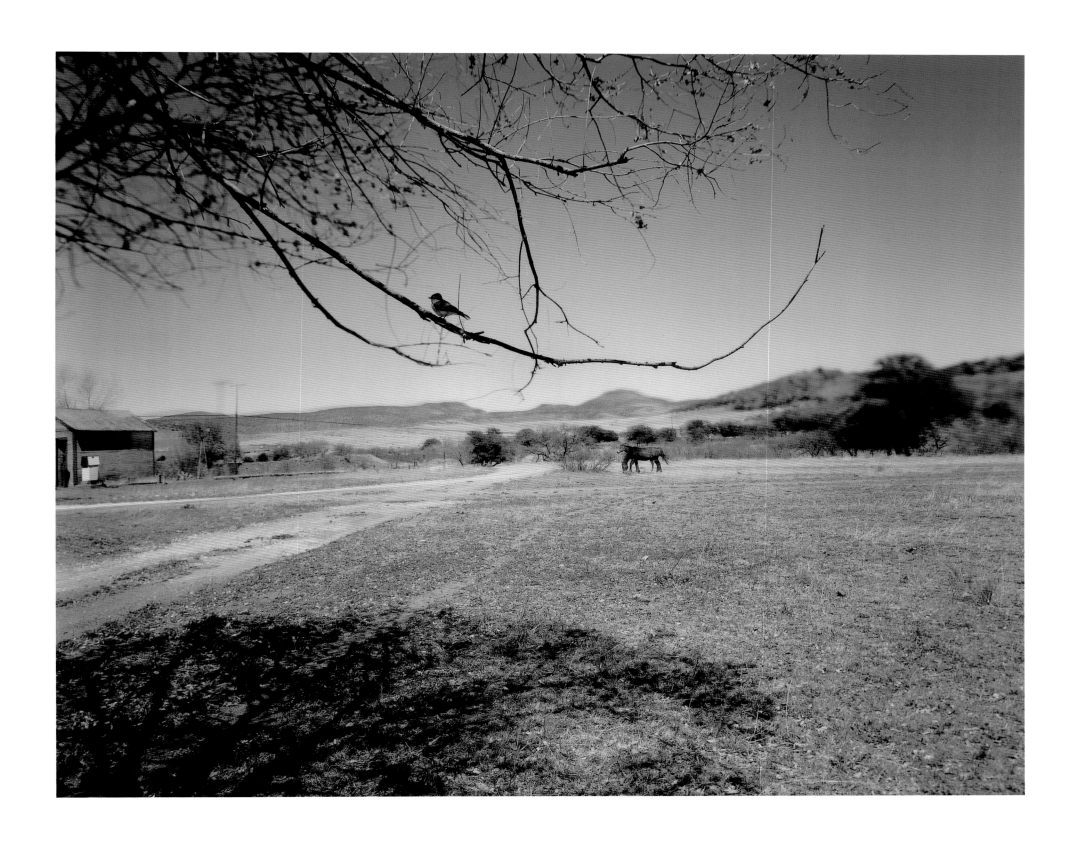

*Plate 87*. No. 305, March April 2005, 48.5/60.25 in.

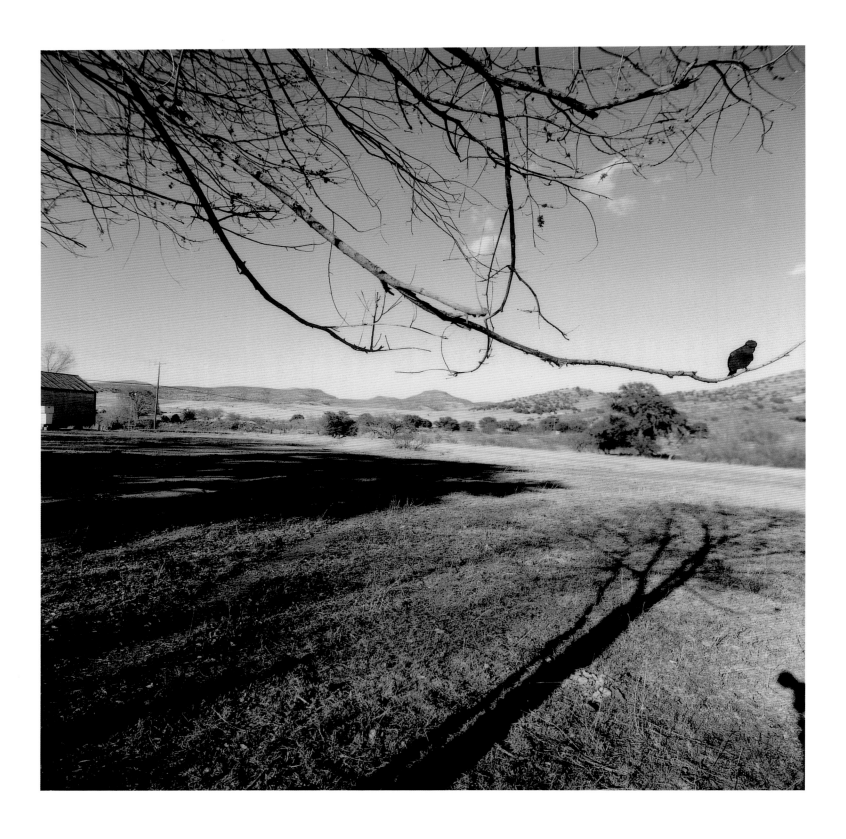

*Plate 88.* No. 300, March April 2005, 48.5/48.5 in.

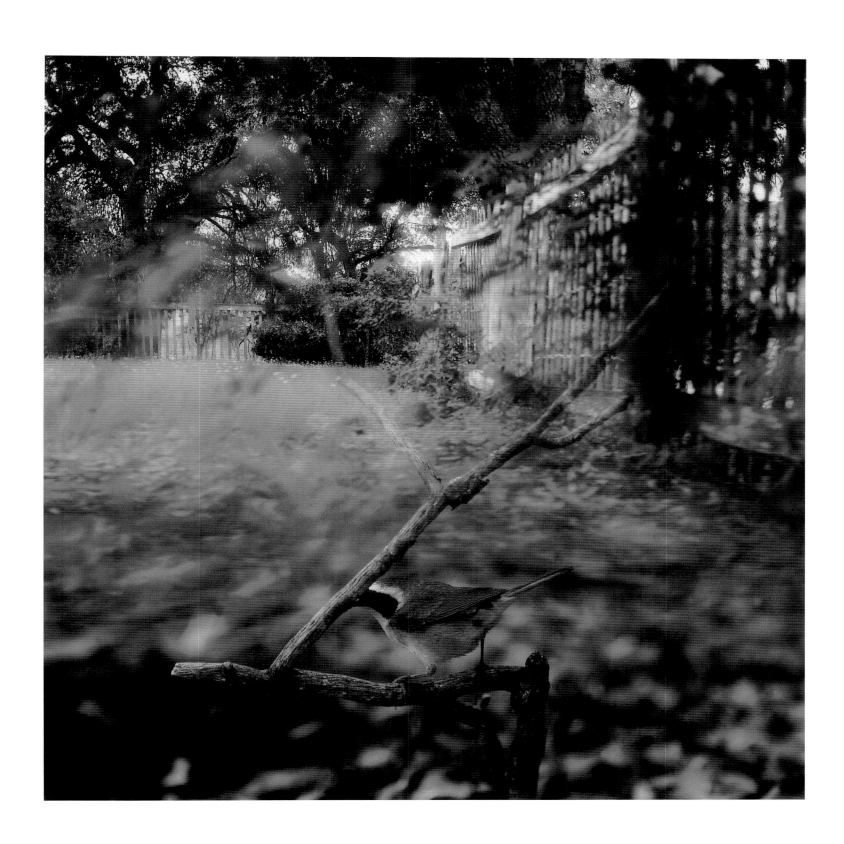

*Plate 89.* No. 406, April May 2006, 60.25/60.25 in.

*Plate 90.* No. 388, April May 2006, 72/89.75 in.

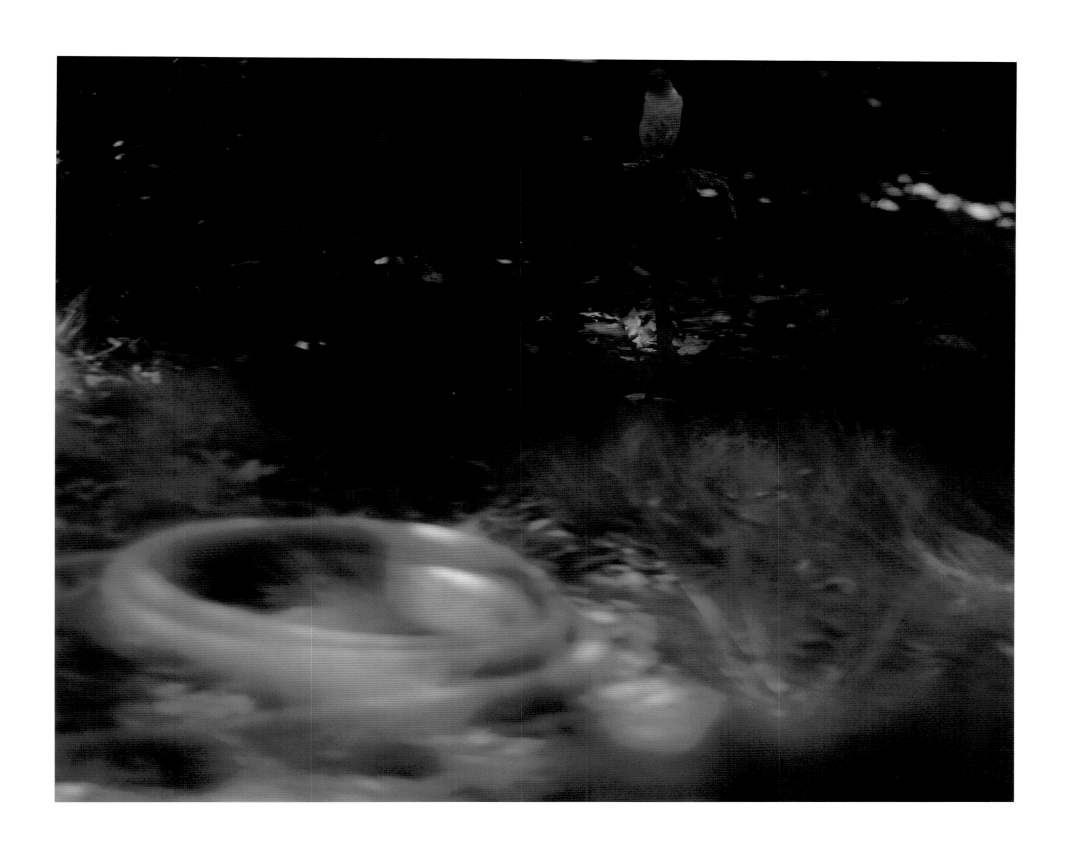

*Plate 91.* No. 399, April May 2006, 48.5/60.25 in.

*Plate 92.* No. 377, April May 2006, 89.75/72 in.

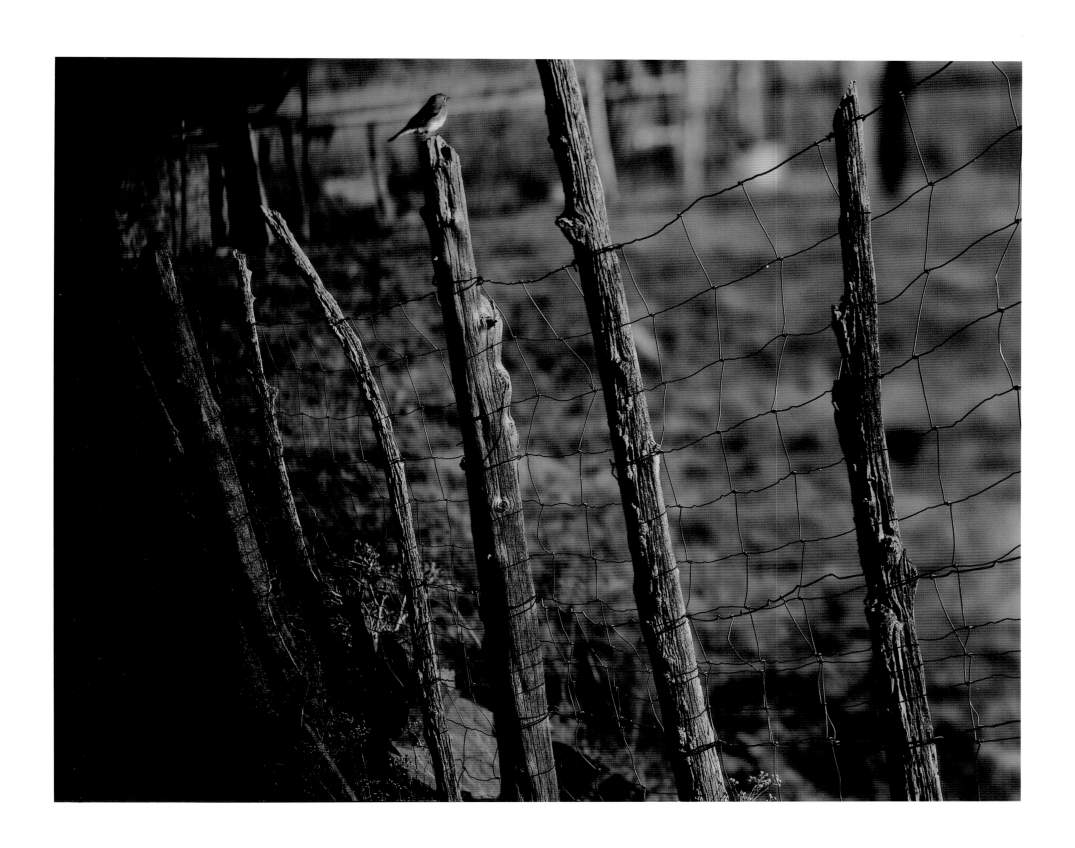

*Plate 93.* No. 355, November December 2005, 48.5/60.25 in.

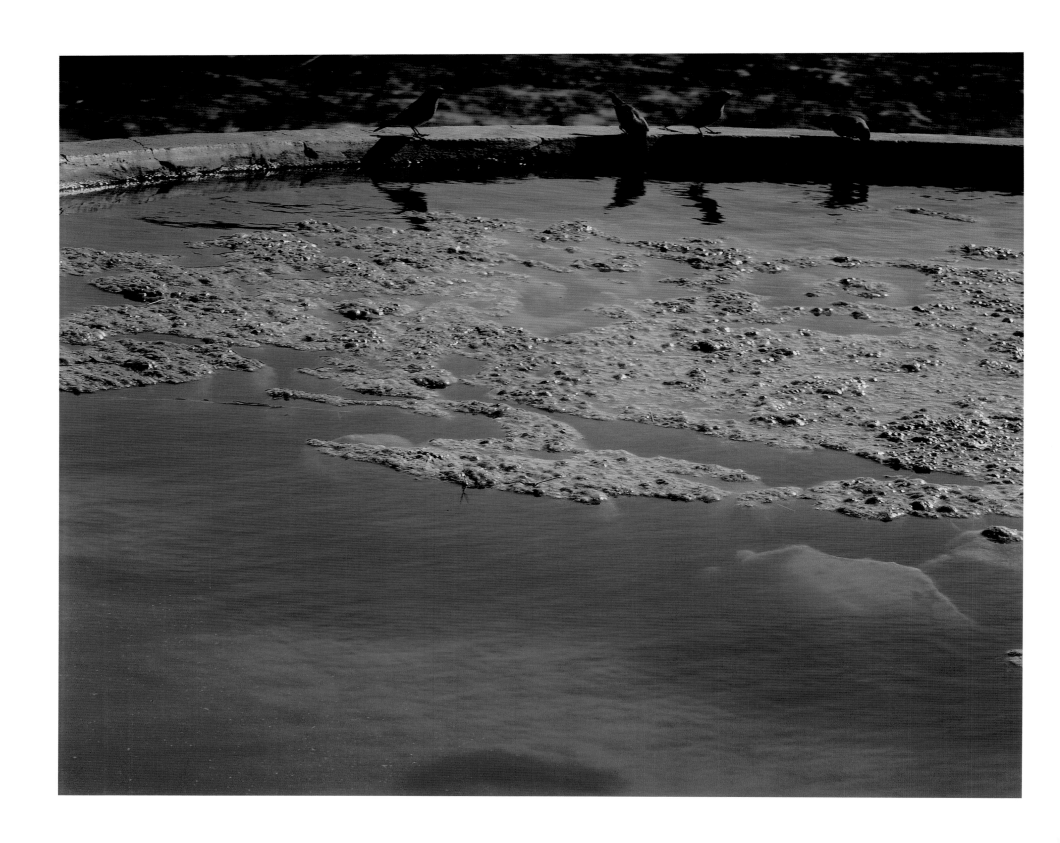

*Plate 94.* No. 357, December 2005–January 2006, 60.25/74.75 in.

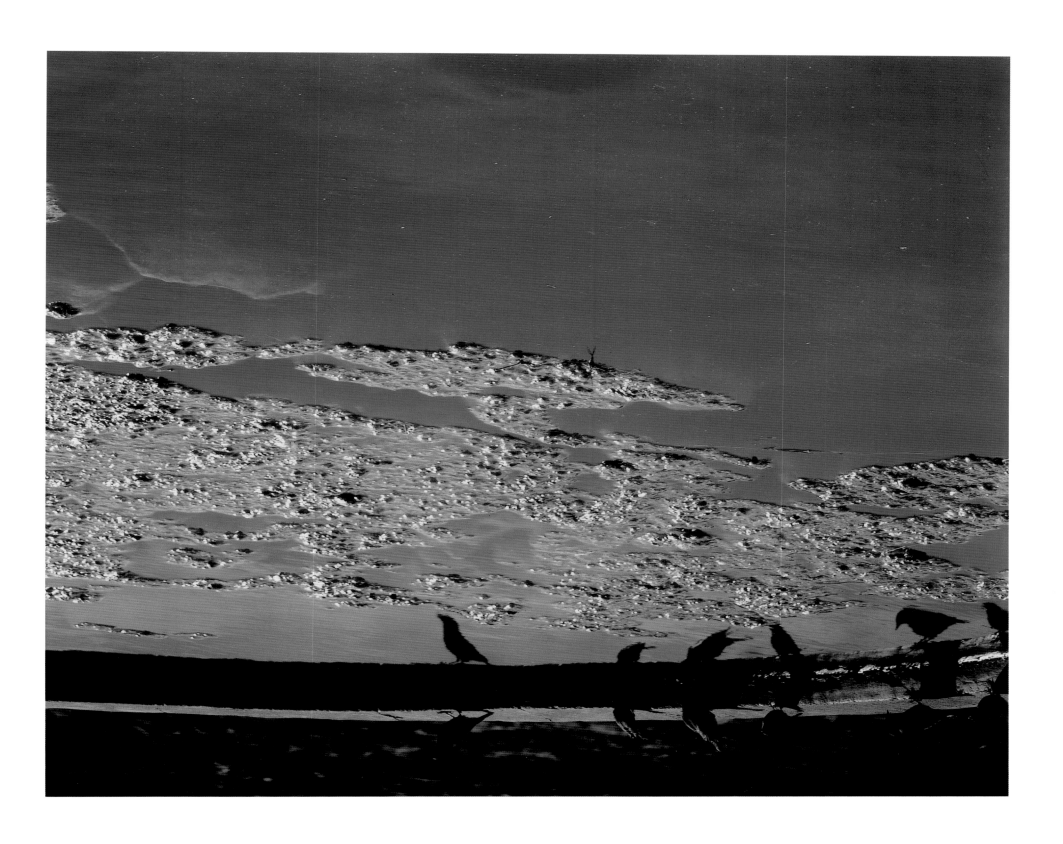

*Plate 95*. No. 358, December 2005–January 2006, 60.25/74.75 in.

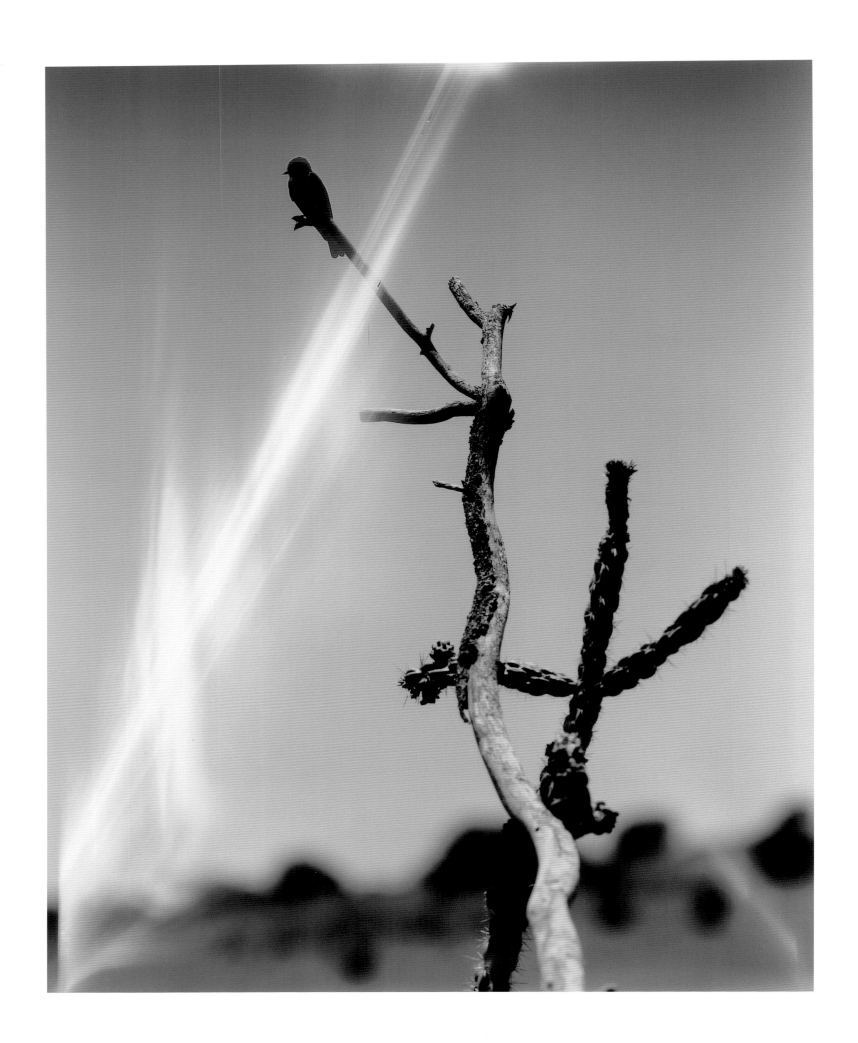

*Plate 96.* No. 334, April May 2005, 74.75 / 60.25 in.

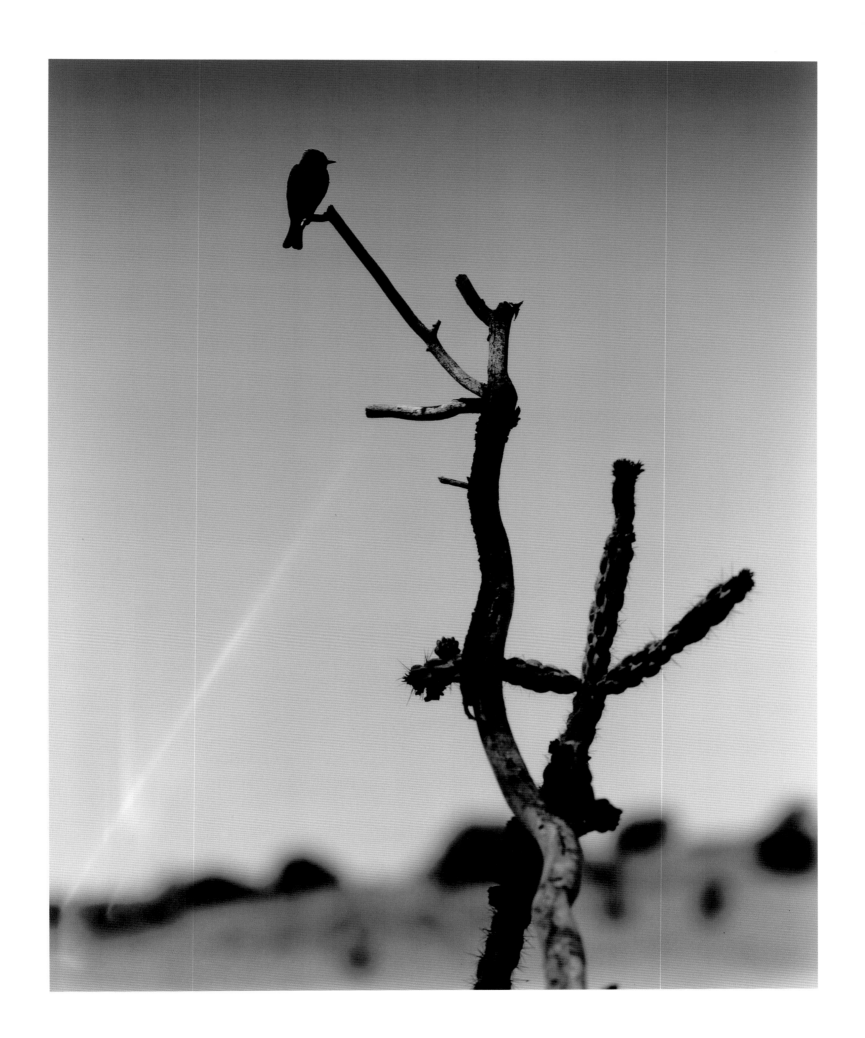

*Plate 97.* No. 335, April May 2005, 74.75/60.25 in.

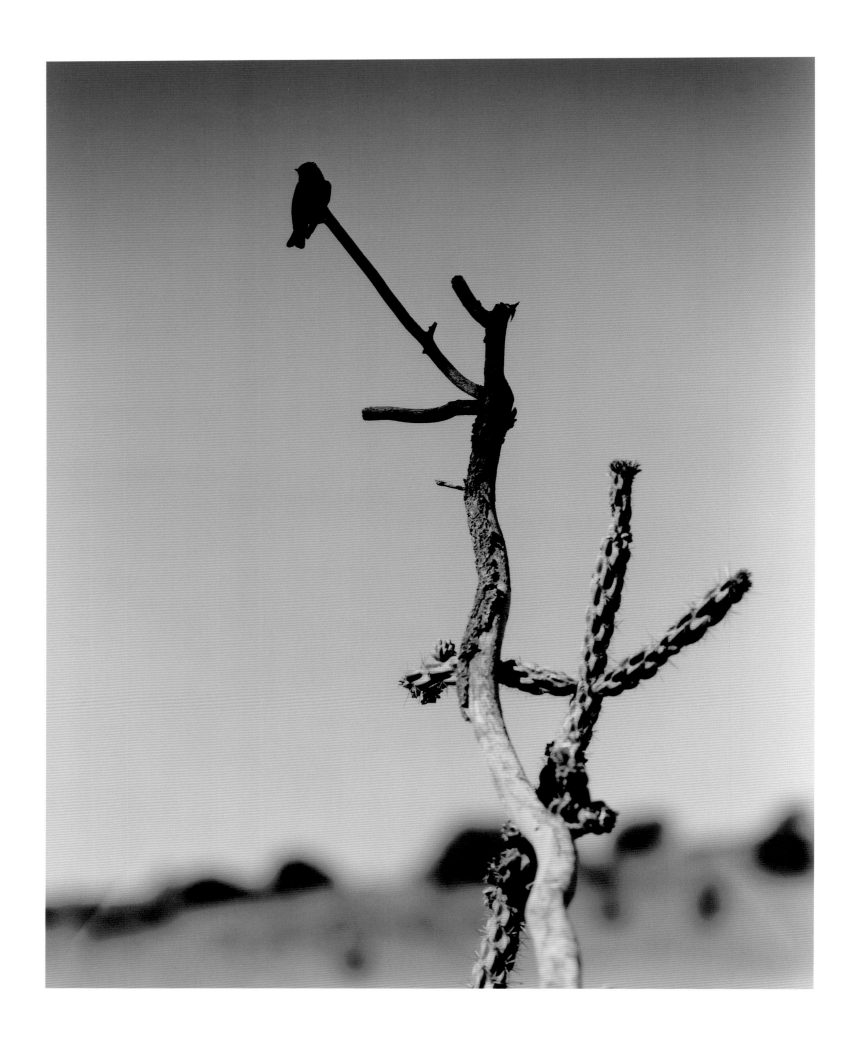

*Plate 98.* No. 336, April May 2005, 74.75/60.25 in.

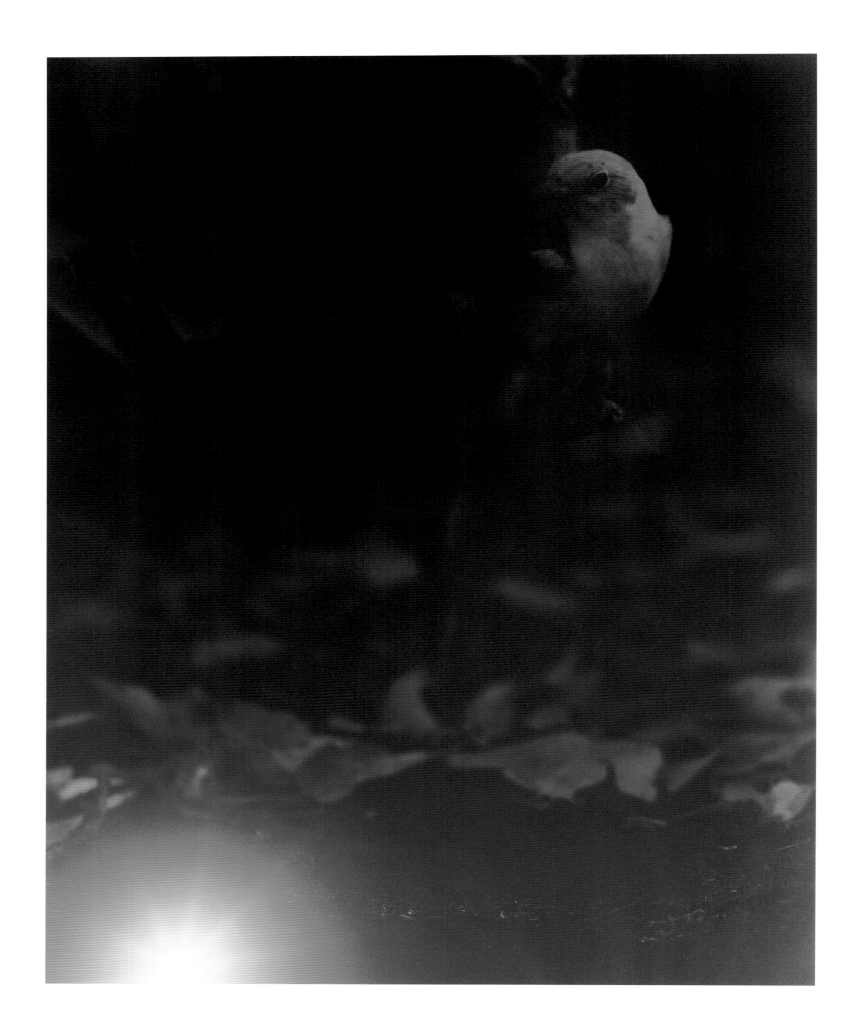

Plate 99. No. 401, April May 2006, 74.75/60.25 in.

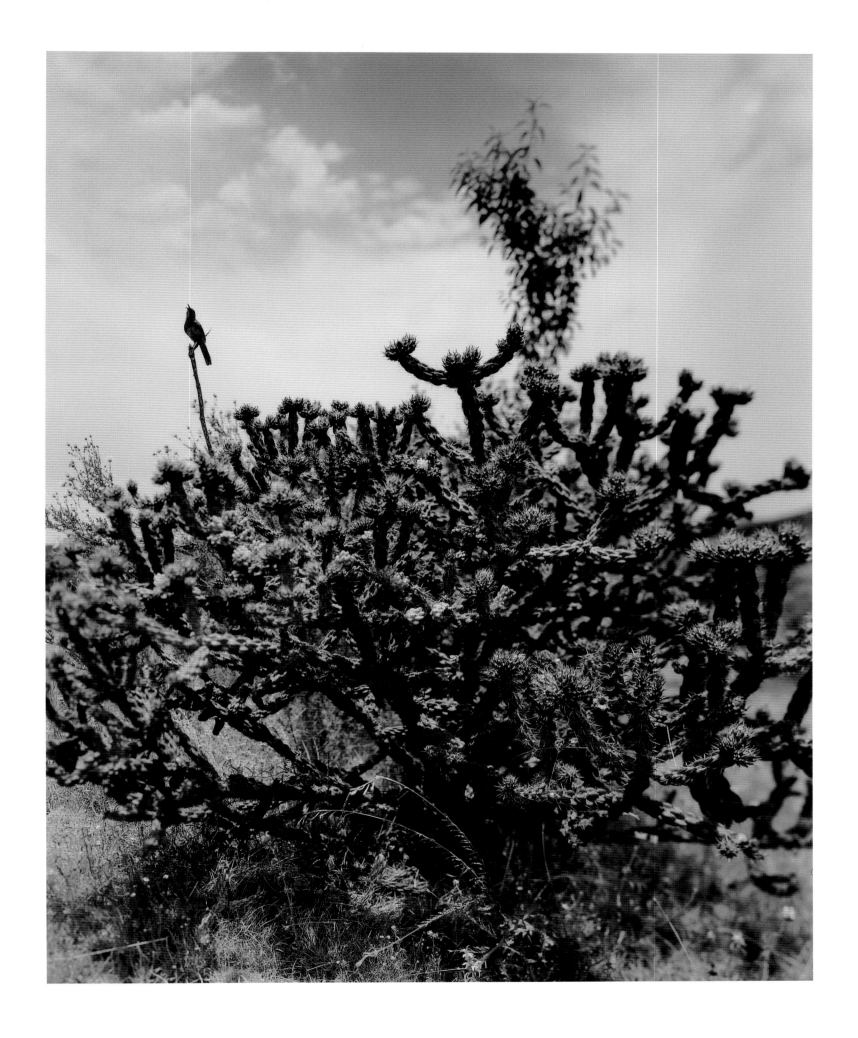

*Plate 100.* No. 342, April May 2005, 89.75/72 in.

# A Matter of Place

BY TERRIE SULTAN

JEAN LUC MYLAYNE'S ARTISTIC PRACTICE aligns a highly personal, almost metaphysical approach to image-making with an existential sense of humanity's impact on the environment. His precise staging brings together nature and human artifice, stasis and movement, calm and tension, to produce complex works of art that are as poetic as they are enigmatic. But his creative process is also driven by a deep desire to explore how humankind and nature can coexist.

Mylayne photographs commonplace birds, such as sparrows, starlings, and bluebirds, in natural habitats that range from small farms in rural France to grandly scaled landscapes in the southwestern United States. Although he takes pictures of birds, he is not a documentarian or naturalist: he locates birds in their natural environments but is not concerned with ornithological descriptions. Rather Mylayne in his works elucidates the intimate bond between himself and his skittish subject. His approach, which is entirely his own invention, combines exacting conception, formal acuity, and infinite patience. Taken over the course of a thirty-year career, his images are naturalistic records couched in the particulars of place and time. Paradoxically, they also convey a sense of the universal, one steeped in contrasts between stillness and motion, light and shadow. Mylayne is, above all, a storyteller, intent on introducing "the idea of equilibrium in our lives between what we want and what we have." [1] His photographs, then, seem to have as much to say about the paradoxes of human activities as they do about the routines and dramas of the avian world.

Mylayne and his wife and collaborator, Myléne Mylayne, have traveled extensively throughout Europe and the United States, at times spending months or even years in search of his chosen subjects. Perseverance pervades his life and career. "We sold everything to begin the project—the house, the car, everything," he recounts, somewhat ruefully. "We bought the photographic equipment, and we went to work, and for years we worked together, all alone, without really talking to anyone." This restless nomadic existence, punctuated by stopovers in temporary destinations, defines the structure of the Mylaynes' artistic quest, one characterized by technical invention, a keen aptitude for observation, and a moral imperative for ecological harmony.

In the fall and winter of 1993, Mylayne completed a series depicting the birds that nest in the Bordeaux region in France near Landes, a series that initiated a wide-ranging exploration of the color blue. In *No. 100 D6, October 1990—February 1993* (Plate 36), blue guides our eyes through space, from the foreground's blue rope, to the middle ground's truck, to the blue uniform and hay cart in the background. It is only after we register these elements that we focus on the bird standing almost dead center in the composition. The bird in *No. 100 D7, October 1990—February 1993* (Plate 61), is literally perched on the bottom edge of the picture, with a vast blue-gray sky, trees, and a building looming in the background like a rear projection or cinematic matte-painting. Mylayne's camera here is very close to the bird, some thirty centimeters (about one foot). "The bird didn't just consent to a picture. He posed, allowing me to take this portrait," Mylayne explains. "It took two years to achieve this result. And it isn't just about understanding

---

1    All quotes, unless otherwise noted, are taken from an interview conducted by the author with Jean Luc and Myléne Mylayne in Fort Davis, Texas, on May 16, 2006.

the life of birds. Above all, it is an exploration, a way to try and know ourselves, what we do and why we do it, through the bird."

Of all the species of birds that have captivated Mylayne's attention, bluebirds have special significance — for the artist, their color symbolizes nature. In the summer of 1999, the Mylaynes made their first visit to the United States, coming to New Mexico, where they canvassed the region like filmmakers scouting for shooting locations. Searching for ideal settings, they first visited Las Vegas, New Mexico, and then Bernal, a small town near Santa Fe. They sought out bluebirds and began to conceive what Mylayne calls a worldwide, universal "project about the color blue, the blue of the birds and the sky," which he imagines will ultimately take him from Texas, to the Philippines, and Peru. In the end, he has to follow the birds. "I know exactly where the bluebirds are. I understand how they function. They have to function according to their character: they are obliged to migrate, to follow the natural force to move."

And so the Mylaynes moved too, from Bernal to Marfa, Texas, pursuing the right landscape, clear skies, and ideal winter weather conditions — cold, but not too cold, snow, but not too much snow. This brought them to Fort Davis, Texas, in 2004, where, with the assistance of the Lannan Foundation and the cooperation of the rancher who arranged to rent them their guest house near the McDonald Observatory, they now spend six months each year patiently pursuing the three species of North American bluebirds that converge in a funnel-shaped area of western Texas and eastern New Mexico during their winter migration.[2] Located twenty-three miles north-west of Marfa, the Fort Davis area has long been a crossroads for Native American, Mexican, and early pioneer travelers, traders, prospectors, and hunters. A military post was established in 1854, and the small town soon became an early transit point for mail traveling between San Antonio and El Paso. A rugged and wild place nestled in the scrubby landscape of the Davis Mountains, it is both a stopping place for people and a way station on the migration routes of animals and birds. This remote location might seem a strange place for a conceptual artist who doesn't speak much English. But Mylayne notes, "Since I was ten years old, I knew that I would come here for the bluebirds. In particular I wanted to work with these three species of North American bluebirds because they have the most incredible blue color. I looked for a long, long time to find a place to see all three species at the same time."

Setting is an overarching imperative of Mylayne's creative vision. Cinematic metaphors aptly describe his routine: first he scouts the location, and then, as a self-described director, he engages with his avian subjects, who are "very good actors." He explains that "each one has its own personality, just like us. It's necessary for me to know how to distinguish them and to coax them into acting." And just like a film director, Mylayne mentally plans the angle of each shot, considering how season, time of day, and lighting will affect the composition and coloring of the landscape. Then it becomes a matter of waiting for days, weeks, possibly even years before his pursuit bears fruit and his vision is realized. After locating birds in the field, he must introduce himself to them and familiarize them to his presence. Proximity is paramount: Mylayne eschews

---

2 The habitat of the Mountain Bluebird (*sialia currucoides*) stretches from northern Canada through northern Mexico. The Western Bluebird (*sialia Mexicana*) has a habitat west of the Rocky Mountains from northern Oregon to northern Mexico. The Eastern Bluebird (*sialia sialis*) ranges from east of the Rocky Mountains across the United States and into southern Canada and the northern tip of eastern Mexico. The migratory paths of each species take them through west Texas. David Allen Sibley, *The Sibley Guide to Birds* (New York: Alfred A. Knopf, 2000): 400–401.

telephoto lenses in favor of some fifty personally designed lenses that allow him to obtain multiple focal-point perspectives within a single exposure. "Each mise-en-scène demands about three months of effort. It's very important to understand this about my work, the time it takes. It is necessary to analyze, to go very softly in order to make these images. It is not only about capturing a likeness of a bird; it's about understanding ourselves, about how we fit into the life of birds."

Mylayne describes his practice:
In my work, the difficulty is to find the right technique. I don't use a telephoto lens; I need to be close. I invented my own technique that permits me to see the bird clearly, sharply, and also to show parts of the landscape in various degrees of clarity. It is very complicated, and I've been working on it for thirty years. I start with a standard-focus lens, and then put the other lenses over it. These lenses allow me to change the positions of the planes in front of me—the foreground, middle ground, and far distance—to have several different focal points on one image. For example, sometimes the bird is soft and the landscape is sharp. Or I can do the opposite: the bird is sharp and the landscape, out of focus. The lenses can turn in the camera, so I can be in the same place but have different points of view, different points of focus. You can see that the focus I get from the lens is not the same as reality, or the way the eye perceives perspective and distance. With these lenses I can reconfigure the landscape to make it look just as it would if we were to perceive it with our eyes. One can, like an eye, focus on one place, another, and another. Again, it's like constructing a scene in a movie, but with only one image. That is to say, I can work like a painter with the landscape that is in front of my eyes, but verify it, because it's a photograph, so it is sure that the one instant existed. This complicated equipment records an image that is actually very simple. And if I succeed, then the technique disappears.

Each time he goes on location, Mylayne takes three days just to set up the scene and calibrate the cameras, lenses, and flash. The elaborate mechanics of his work create a paradoxical environment where machinery intrudes into the landscape it records. His equipment makes noises and movements that can startle birds, and a significant part of his time is spent simply habituating the birds to the noticeable click that the large-format camera makes when the shutter is released, or the sudden brightness of a flash. Once he has composed a scene, he does several takes, spending from ten hours to over three years to capture the right picture. Human presence in Mylayne's large-scale photographs is rarely seen or even acknowledged. Most often it is suggested through the architecture or the accoutrements of daily life, such as the tangential glimpse of a white picket fence in *No. 373, March April 2006* (Plate 80). Rarely do we see actual humans, and when we do, the disconnect between them and the primary subject is palpable, such as the blue-jacketed worker standing in front of his truck in the far distance of *No. 183, January February 2004* (Plate 76), who occupies a time and place parallel to, but at a far remove from, the Dark-eyed Junco in the foreground. Structural geometries may draw us into Mylayne's picture, but they are ultimately incidental to, or on the periphery of, the birds that attract and hold our attention. Human-avian contact is most direct in *No. 186, January February 2004* (Plate 73). Our eyes flicker left to right, glimpsing another Dark-eyed Junco in soft focus on the left,

confidently sharing space with the shapely denim-clad legs sensationally shod in red, black, and white cowboy boots. This is perhaps the artist's most humorous observation on the differences and similarities in animal and human modes of decoration and camouflage.

Usually, our attention is first drawn to the landscape, which is always privileged in Mylayne's oeuvre. The steely light of an almost gray sky, mirrored by patches of snow, aptly conveys the cold stillness of a winter day in *No. SP16, December 2003–January 2004* (Plate 22). This scene is suddenly punctuated by a splash of blue in the Western Bluebird perched on a bare branch. Neither in motion nor totally still, this bird seems, above all, urgently and vibrantly alive. The warm palette of *No. 368, February March 2006* (Plate 79) reflects spring in the high plains, while the composition—the dark mass of a gnarly tree branch, pushing into the picture from left, set against the tiny, ephemeral speck of a Black-chinned Hummingbird captured mid-flight in the photograph's center—creates a sense of elemental forces in dynamic opposition. In all of Mylayne's images, shifting, multiple points of focus affect a sense of immediacy in the captured moment that is the desired end point of the artist's patience.

For all their seeming transparency, Mylayne's pictures are carefully composed, blending formal concerns with color, form, and gesture into an amalgam of abstraction and representation. Capturing the moment when the image is fully apprehended, when perception intersects with consciousness, the artist proposes the camera as a scanning eye whose shifting depths of field suggest alternative temporal zones. Mylayne studied painting before turning to photography, and although he maintains a painterly eye toward the formal aspects of art-making, he prefers the camera's ability to "verify just one instant that truly exists, the captured moment." He adds: When I see a bird, I see at the same time that bird on a tree near the house. I see everything as an ensemble, and I realize that's how I see everything in life. The bird flits from one place to another. With my lenses, I can take in that place, then the tree, the bush, the house. I try to capture all those places at the same moment, just like our eye travels from one spot to another in taking in the scene, and I try to reconstitute it. One can try to do that with a painting, and it might be better, in a certain way, because there are a multitude of occurrences that happen at the same time that one can never remake. One could have all the patience in the world, but one will never be able to do that with a photograph. But all the same, I do, as much as possible, remake the scenes that I have seen, and the photograph is the proof that the scene existed. It's not like a painting, which interprets an experience, but never replicates it.

Like a world caught in one's peripheral vision, Mylayne's art hovers at the edges of observable reality. In this place the complicity between humans and animals that modernity has attempted to displace, deny, or deter still exists. While animals have been photographic subjects since the nineteenth century, they usually have been documented to create scientific records, most famously in the animal locomotion studies of Eadweard Muybridge (1830–1904). The documentary portraits painted by John James Audubon (1785–1851) in his landmark portfolio *Birds of America* (1826–1838) are a hybrid of scientific observation and personifying depiction. Mylayne has been referred to as the second Audubon, and although he is certainly deeply familiar with that artist, he feels they have nothing in common. "Audubon was really a portraitist of birds and an

ornithologist. He wanted to show people how to recognize birds by their color, their location, etc. That is not my point of view. I want to explore how to be a human being who can live in harmony with nature, and that's very different." He continues, "We don't really understand how we live in the world. We move quickly through the world, and we don't tread lightly. I feel that we must know something other than ourselves, and find a way to have distance and to re-see our thought processes and our modes of action. In my work, I capture what we are capable of seeing in relation to memory, not only in our capacity to see physically." Mylayne's pursuit of birds, then, is as much about depicting the dynamics of a time as it is about the forces of nature.

In English, there is only one word for time, but other languages make distinctions between instant and sequential time. Mylayne's view of time as something refracted, fluid, and immutable most closely reflects the ancient Greek differentiation between *cronos* (time as duration, a quantitative concept of time as a linear movement through space, time as the future passing through the present, thus becoming memory), and *kairos* (time as indeterminate, a qualitative notion of time as now, a decisive, immeasurable instant that is the ultimate expression of the present tense). Mylayne's process embodies this paradox—the *cronos* time of his technical approach, and the *kairos* time of the captured instant. His powerful records of the brief merging of time, space, and subject are saturated with what David Givens has described as "a 'this is how it is' cohabiting with a 'this is how it was.'"[3] Or, as Mylayne says, "Life evolves in at least four different dimensions. One of them is time, which has yet to be precisely conceptualized. Humankind has a special relationship with this dimension, which leads to isolation in a condition of paradoxical ambiguity: a vertiginous, intoxicating acuity is pitted against an insidious otherness."[4]

The notion of "memory time" influences Mylayne's approach to art and life. "Humans have particularly developed memory," he says, "and that's the point of departure for experience—memory." Like Marcel Proust's *A la recherché du temps perdu*, Mylayne's art posits an exacting reconstruction of our memory of seeing something.[5] But the absolutes of first impressions quickly become fungible as his shifting focal points visually act out the idea of being able to catch yourself seeing a memory: seeing a picture as it becomes memory, and then seeing and having the memory simultaneously. Mylayne's lenses allow him to interpose specifically human, memory-based perception on the complex fluidity of the natural world. Just as Mylayne, the person, lives in two worlds, Mylayne, the artist, operates in two modes—memory and immediacy. It is this conflation of the two—or perhaps the struggle between the two—that gives his images their lasting power.

3    David Givens, "Confessions of a Bird Watcher," *Frieze*, November/December 1999: 81.
4    Jean-Luc Mylayne, *Parkett*, no. 50-51 (1997): 130.
5    Marcel Proust (1871–1922) wrote *In Search of Lost Time* (sometimes referred to as *Remembrance of Things Past*), which was published in seven volumes from 1913 to 1927.

# Time Lapse

BY LYNNE COOKE

IN 1999 JEAN LUC MYLAYNE MADE his first trip to the American Southwest in quest of a particular bluebird he had long dreamt of photographing against a snowy backdrop. After scouting several locations, his search evolved into a multilayered project that would encompass some five years and as many transatlantic trips.[1] To date, more than 200 images of numerous types of birds have been shot at two locations. A ranch in Bernal outside of Santa Fe became his abode in the winters of 2003–04 and 2004–05; in the following two years, when harsh weather caused the birds to migrate further south than in more clement seasons, he settled on a ranch outside Fort Davis in west Texas.

Mylayne employs the same techniques in approaching his quarry in the United States as those he has used over the past thirty years when working in his native France. Most of his photographs feature a sole bird whose role varies greatly from one setting to the next. It may appear prominently in one composition, prove teasingly elusive in another, or almost escape notice in a third (*No. 334, April May 2005; No. 290, February March 2005; and No. 399, April May 2006*) (Plates 96, 82, and 91). And sometimes even a specialist would have trouble deciphering its ornithological identity. Only when a number of works are assembled together does the constant presence of one or occasionally several birds somewhere in these pictures betray itself. The environs also vary, but they are always places where the impact of humankind on the landscape is clearly evident. In general, rural settings, especially farmland, are favored, but gardens, parks, woods, and the sea have all proved fruitful. After scouting a site at some length, Mylayne gradually narrows his focus to one particular bird and a specific location, time of day, set of weather conditions, and vantage point—in short, the frame in which the bird, whose bearing and conduct he has also predetermined, will appear. When determining the frame, he also decides upon the size and format of each work, the result. Given how integral pre-planning is to his conception of the final image, the photograph might best be described as a tableau in which the avian motif plays a carefully designated role; that is, the bird acts in accordance with the artist's detailed script in the making—as distinct from the taking—of the photograph.

Over the next weeks (or sometimes even months), as attested by the titles, which indicate the duration of each quest, Mylayne gradually habituates each bird to the conditions under which the photograph in which it figures is to be made. Day after day, the cumbersome camera equipment (including, on occasion, supplementary lights) is painstakingly installed on that site, until the technology and its handlers—the artist and his wife—come to seem, at least to the bird, simply another set of familiar elements in the built environment. By the time Mylayne actually takes the shot, he will have so accustomed the bird to even the sharp sound of the shutter being released that he can predict precisely where and how it will react, and hence appear, within the pictorial structure. By adjusting multiple lenses, which have been individually fabricated to

1    When the three variants of this particular bluebird—the Mountain, Eastern, and Western Bluebird—migrate, they converge in the region around Santa Fe or, in colder winters, further south near Marfa, Texas. *No. SP16. December 2003–January 2004* (Plate 22), an image of a bluebird on snowy ground, was among the first images Mylayne realized in New Mexico; it is highly unusual in its straightforwardly iconic portrayal. Other species he subsequently photographed include hummingbirds, vermilion flycatchers, towhees, tufted titmouses, and juncos.

his specifications, he can ensure whether the bird will be in focus or blurred, partially obscured or clearly legible in the elaborately constructed spatial field. With few exceptions, in the final image the subjects under study appear indifferent to both the human presence and the elaborate technical setup; on rare occasions, they respond more directly, gazing with curiosity or composure at the apparatus that conceals its operator.[2]

While the body of work that Mylayne produced during these five long sojourns in North America may constitute a discrete episode within his larger project, these photographs do not comprise a series per se, nor do they offer a comprehensive portrait of the avian inhabitants of a particular region during a particular season. Rather than highlighting its rarest or most distinctive specimens, the choice of the individual creatures results from chance encounters, casual interactions, or observations during which the artist experiences a sense of rapport or fascination with one among the many within a flock. Given that the several locations in two different states are not identified in the titles, the importance of place per se is not evident to the viewer.[3] And nothing of those vast spaces so dominant in historical depictions or popular imaginings of the West is glimpsed here. The sole exception is *No. 186, January February 2004* (Plate 73), in which a piquant reference to the ever-present myths of the West may be gleaned from the cowboy boots—though with their stylish red trim they appear to prioritize fashion over functionality and so identify their wearer as an outsider, an interloper. Transplanted to the West in pursuit of his prey, Mylayne alludes less to its resilient cultural myths than to such abiding issues as land management: where ownership was once the contentious issue, today questions relating to land use, and hence to issues of preservation, prevail. Thus, when choosing his vantage points, Mylayne neither explored the vast vistas visible from the perimeters of the huge west Texas ranch, nor sought out the more exotic features within those locations, opting instead to stay close to the immediate and familiar environs of the homestead. Sorting yards, pens, and wire fences indicate that this is cattle country, yet no animals other than the birds are to be seen; details of the farmhouses, whose white picket fences segregate domestic terrain from the working world beyond, are all that signal the daily proximity of man and bird. To the viewer of these works, far more striking than the sites themselves is the artist's formal inventiveness in composing and structuring what are obviously curtailed, almost mundane locales.

Underpinning his project with the bluebirds is a carefully crafted intellectual and formal program that will shape and hone the resulting works into a singular ensemble when exhibited. Conceived independently of, but in parallel with, this long-term project—and hence more a condition than an imperative of his trip to the American Southwest—are the remaining photographs from these locations, photographs that feature other species. Governed by quite distinct conceptual frameworks, these two bodies of work were subject in 2007 to an overriding curatorial

2  In several earlier works, the bird looks directly at the camera; in others it hovers in close proximity to the apparatus, though its gaze is elsewhere. Being habituated to the presence of the mechanical equipment and its operators indicates a level of trust on the part of the bird in the benign intentions of these particular humans; no effort to train or tame the birds, for example by feeding them, is ever made.

3  It is not apparent, for example, that the second site, near Fort Davis, was chosen partly for its closeness to the McDonald Observatory, a major research center for spectroscopy (the decoding and study of light that has traveled for billions of light years from distant stars and galaxies). Yet, for the artist, the proximity of technology capable of measuring the vast durations of the universe adds another dimension to his abiding preoccupation with multiple temporalities. A fuller study than is possible in this text would elucidate the rich back story to this project, along with those particular to Mylayne's other projects.

gambit when a selection was made for an exhibition in Houston devoted exclusively to photographs he shot in the United States. Verging on the idiosyncratic, Mylayne's finely parsed installation strategies play a determining role in the construction of meaning in his art.[4] Whether responding to an invitation to produce a solo show or to participate in a group exhibition, Mylayne always assumes the mantle of curator, proposing a selection of his works choreographed into an ensemble whose governing format is designed to make evident his larger enterprise.[5] Each show therefore assumes an identity in and of itself. In the recent show at Blaffer Gallery, the Art Museum of the University of Houston, certain motifs endemic to their mise-en-scène, such as boundaries demarcated by fences or a brilliant cloudless sky, became thematic tropes echoed and counterpointed throughout the ensemble. Also integral to this presentation was the inclusion of both a triptych and a diptych, which together serve to underline the conceptual basis of the project at large. Through the play of repetition and difference, they foreground the role of the bird as symbol and symptom in an encompassing metaphysical register. Based on a quintessentially religious format, *No. 334, April May 2005; No. 335, April May 2005*; and *No. 336, April May 2005* (Plates 96, 97, and 98), comprise three different views of the same bird perching on the end of a dead branch, silhouetted against an azure sky; a virulent cactus thrusts upward alongside the skeletal tree. In the left-hand image, and more faintly in the central one, a diagonal beam made by light catching the lens infuses a sense of portent into the almost stereotypical composition.[6] The luminous flash would conjure a visionary timelessness were it not for the disquieting juxtaposition of dead and living vegetation, for in that laconic pairing of antagonists, virile and spent, benign and noxious, lies a hint of menace and pathos inimical to a pastoral paean. In *No. 357, December 2005–January 2006*, and *No. 358, December 2005–January 2006* (Plates 94 and 95), one of the pair of almost identical images in the diptych is inverted. This deft sleight of hand has the effect of once again transforming a bucolic impression that otherwise courts cliché into something more ambivalent. Reflections cast by a small group of birds standing on the edge of a cattle trough join those of the clouds above and mingle with the clumps of algae floating on the water. When the image is rotated, the plant forms, now occupying the upper register, suggest a toxic storm that threatens the birds' idyll; eliding substance and silhouette, the reflections here become the negative of what, in the partner image, had seemed disarmingly innocent.

As always in Mylayne's practice, a single color print is produced from the 8 x 10-inch negative: each photograph is consequently unique. Normally quite large, the dimensions of a work are

---

4   The plan governing installation of the bluebird project focuses on the changing ratios of sky to ground in the sequence of images as they descend along a diagonal axis from upper left to lower right, then rise from that nadir point to the upper right, creating a large V-shape that approximates a schematic rendering of a bird in flight. More than purely diagrammatic in its impulse, this eccentric configuration traces a relation between the earthbound and a creature commanding the air, a symbol of unconstrained freedom. To date, one segment of this ambitious project has been realized ("Jurassic Technologies Revenant," Biennale of Sydney, 1996); to realize the remainder may take decades.

5   Compare, for example, the different agendas and modalities employed in exhibitions for the 1996 Sydney Biennale, "Terra Incognita," at the Neues Museum Weserburg, Bremen, in 1998, and "Jean Luc Mylayne: Blazing Red," Barbara Gladstone Gallery in New York in 2003. In each instance, a cornerstone or linchpin with symbolic resonance served as a point of reference.

6   In this flash of light, we may glean veiled references to St. Francis's stigmata and his preaching to the birds. In his celebration of their freedom and beauty, St. Francis became a resonant figure who intrigued a number of postwar artists, from Roberto Rossellini, Pier Paolo Pasolini, and Olivier Messiaen to, more recently, Pierre Huyghe, Tacita Dean, and others. See the program for composer Olivier Messiaen's *Saint Francois d'Assise* at Opera Bastille, Paris, 2004–05.

calibrated with reference to the scale of the human viewer as well as to the actual size of the birds within the image. Mostly, they are relatively far afield. When they are seen in close-up, as it were, they are never represented larger than in actuality. Moreover, when the spectator does find herself in unexpected proximity to a tiny creature, as in *No. 186, February March 2004* (Plate 73), this closeness does not seem unnatural: far from voyeuristic, it establishes a sense of intimacy. Sometimes when the ground plane is not visible or the setting abbreviated, as in the aforementioned triptych, it's not clear exactly where the spectator is relative to the motif, but the scenario always remains plausible.

Mylayne's decision to concentrate on the medium of photography, rather than on painting or poetry to which he is also strongly attracted, was determined by the fact that it is the vehicle of truth, and that its verifying function is predicated on issues of temporality.[7] Nothing in any single image may seem exceptional, yet what is needed to realize that work *is* exceptional: an extraordinary commitment of time. Given the strict parameters governing the project, coupled with the lengthy period of adjustment required for any bird to accommodate itself to the presence of the humans and their technology, opportunities to create a work are always at a premium. Studying the habits of these North American birds, Mylayne had noted that when ranging in search of food, they stray over far greater distances than would their European counter-parts. Thus their daily location was difficult to predict. On many days during his sojourns in the Southwest, the individual birds he was tracking did not appear at any of the various spots he had identified as his vantages; when they did come to feed at the places he had designated, some-times they moved on before he could install his equipment. On other days, the prerequisite of a light-filled azure backdrop was contravened by gray skies. Thus, while the final image is rigorously prefigured, almost all the variables impacting the artist's ability to work on any given day lie outside his control. In vying with the serendipitous forces of nature, vigilance is his principal weapon, and time, measured in massive increments of patience and dedication, his arsenal. Lapidary records of the duration required for the making of each piece, the works' titles hint at his existential agon. Time is, perforce, the real subject of his art.

II

That the earliest works in Mylayne's oeuvre date to 1978, when the artist was already thirty-two years old, is doubtless the product of stringent editing. The absence not only of juvenilia but of exploratory works belonging to his formation gives his practice an unusual degree of coher-ence and cogency, which is reinforced in turn by its seeming adherence to a single prototype: a largish color photograph of an avian subject in a man-made or -shaped environment. Certain formal devices, such as the repetition in two dramatically different sized prints of the same image within a single frame (for example, *No. 4, June July August 1979*) (Plate 3), or the mirroring and inversion of a motif, or the recourse to a stock profiling of the avian subject, reinforce the con-ceptual underpinnings of this singular project while pointing to the artist's familiarity with Conceptual art practices of the late 1960s and '70s. By dint of its intellectual substructure and

7   Implicit in the record of an actual moment is the verification of the existence of that which is recorded. See unpublished interview with Terrie Sultan and Mylène Mylayne, Fort Davis, Texas, May 16, 2006.

thematic, Mylayne's oeuvre defines itself as an existential enquiry whose primary address is to a contemporary art world audience. In theorizing his practice in such terms, he shows a close affinity with a number of his peers for whom photography is their preferred medium: Candida Hofer (b. Eberswalde, Germany, 1944), Thomas Joshua Cooper (b. San Francisco, 1946), Jeff Wall (b. Vancouver, 1946), and Hiroshi Sugimoto (b. Tokyo, 1948). While these artists have worked quite independently of each other, indeed often without knowledge of each other's work (at least until recently), certain fundamentals link them, not least their commitment to a lifework project, reliance on a high degree of technical skill, deep knowledge of the history of the medium, orientation to the field of contemporary art rather than to that of photography proper, and proclivity for a metaphysics grounded in a poetics as opposed to a more discursive idiom.

In the surprisingly scant literature devoted to Mylayne's work, there are few references to the role of photography other than as a conduit, a convenient vehicle, for a metaphysical statement. Nor has there been any sustained attempt to place his practice within a historical context. Frequent reference to his biography—to his nomadic lifestyle in particular—supports a reading of his work as a phenomenon apart: literally and figuratively a lone figure, he is seen as sui generis. Dedicated with monastic devotion to the exigencies of his project, his peripatetic life manifests the philosophical lineaments of his aesthetic as clearly do his artworks.[8] Didier Arnaudet first articulates this now standard critical reception in an article published in 1995. Claiming that "birds are no more than a pretext for seeing the world," while nonetheless conceding that "this pretext rests on a thorough knowledge of ornithology," he summarizes Mylayne's position as fundamentally existential: "What he is addressing is a way of being in the world, linked to an attitude of patience, openness and entreaty."[9] Writing more recently, David Givens echoes this canonical approach when he states that a photograph by Mylayne is "a meeting of time, space and subject having everything and nothing to do with the depicted birds, being 'about' them—but only in passing—and moving out towards a chance at the infinite."[10] Continuing the tendency to locate philosophical abstraction in a wedding of the biography of the maker with the habits of his subjects, Givens concludes that Mylayne's "concentrated and singularly sustained dedication to the investigation of a particular belief as concept, as song of life, embodies a piety of living, a probity of regard and a passionate interest in the implementation of a single structure for understanding how we, as humans, are in the world."[11]

Concrete ballast is provided for these speculative conjectures in a text whose title doubles aptly as a dedication: "For Jean Luc Mylayne."[12] Written by Mark Dion, a young American sculptor who shares the older man's passionate regard for the world of the natural sciences, it sketches major shifts in ornithology and related fields and, most importantly, resituates the source of Mylayne's aesthetic in these disciplines. As Dion notes, recent studies in cognitive ethnology indicate that birds are a highly evolved species, deploying cognition, language, memory, feeling, and an aesthetic disposition in parallel with humans. Such research has reinforced the difficulty, increasingly evident to many scientists, of constructing boundaries to intelligent life

8    The artist's own published writings, many of which take the form of poems, have reinforced this tendency to metaphysical abstraction.
9    Didier Arnaudet, "Jean Luc Mylayne, le souci de la beaute (A Concern of Beauty)," *Art Press* (March 1995): 42–43.
10   David Givens, "Confessions of a Bird Watcher," *Frieze*, no. 49 (November/December 1999): 80.
11   Ibid., 81.
12   Mark Dion, "For Jean Luc Mylayne," *Parkett*, no. 50–51 (1997): 113–21.

and consciousness. Although Mylayne's focus is not ornithology per se, his handling of his avian subjects is critical to the construction of meaning in his work. No didactic address to the plight of endangered species is ever discernible in his art, even if these birds are currently threatened by global warming or other environmental predations. What is stressed instead is the mutuality of the realm inhabited by both birds and humans. Identified as an individual being, the bird is almost always positioned in ways that embody recognition of its otherness. Sometimes isolated so that it commands the unfettered skies, sometimes engulfed in terrain molded by human activity, it is mostly shown negotiating boundaries between the natural and human worlds (compare *No. 160, September October 2003; No. 186, January February 2004; No. 198, January February 2004; No. 290, February March 2005;* and *No. 300, March April 2005* (Plates 75, 73, 74, 82, and 88). Always, its place in these increasingly interdependent systems is fragile, liminal, and tenuous. Implicit in Mylayne's acknowledgment of the otherness of the bird is a sensitivity to the levels of trust it must extend if the image is to be realized: Dion observes, albeit somewhat rhetorically, "The individual bird accomplishes a task still difficult for most of humanity." [13]

Just as overtones of sentimentality are (barely) averted, so is any anthropomorphizing of the animal. In lieu of a romantic identification with the disarmingly vulnerable subject, the work enjoins a response to the manifest beauty of the image itself. [14] Aesthetic impact, and affect, depends upon the singular way in which the photograph reveals itself as a product at once of artifice and of indexicality. Ultimately, however, given the level of contrivance and calculation deployed in its generation, it is apprehended less as a trace than as a construct.

In a series of articles surveying the role played by photography in vanguard artistic practices in the late 1960s, Jeff Wall has pointed to the ways that artists such as Bruce Nauman, Douglas Huebler, and Robert Smithson drew on photojournalistic tropes, mining their potential as reportage for performances and events created expressly for the camera. By a blatant "deskilling" of the technical means, they infused their conceptually based photo-works with disarming directness and improvisatory immediacy. Conversely, in their concurrent work Bernd and Hilla Becher almost single-handedly established a new credibility for photography as a fine art within a contemporary art practice. The product of an inherently melancholy, conservationist impulse, their signature works convey an effect of unmediated presentation and documentary truth appropriate to the protocols of the archive. The Bechers' contribution to the debate around the use and potential role of photography was amplified toward the end of the 1970s when forces in the art market and the museum together began to construct histories and aesthetic oeuvres for hitherto anonymous artisanal practitioners working in the nineteenth century. As a result, by the mid-seventies the craft of fine photography (re-)entered contemporary art practice harnessed to conceptual ends. Thus, for example, Thomas Joshua Cooper shaped the legacy of certain strands of pioneering landscape photography into an existential study, creating cartographically determined projects from single shots made in situ with a large format camera. By contrast, Wall looked to photography's relation to painting and cinema, finding in their figurative idioms its deepest source of inspiration (while in such commercial technologies as the light box, he discovered a contemporary vehicle for display). Mylayne, too, explored relations between painting

---

13  Ibid., 115.
14  The beauty of the image as a construct is the means by which the birds are transformed from pathos-ridden symbols of doom into models of ecstasy. From the beauty of the image the viewer derives the sense of pleasure, the intensified feeling of cognitive awareness that stimulates enquiry.

and photography, but unlike Wall, he concentrated on formal parallels, which he underscored by echoing the older art form's compositional structures, its use of a life-size scale, and its grounding in a unique, original artifact. To the degree that his works declare themselves as staged photography, they evoke traditions paramount in studio practices, notably the construction of imaginary spaces and a sense of time outside time, while nonetheless recognizing the instantaneity that is the substratum common to all photography. Mylayne's work is thus premised in the dual ontologies that dominate histories of photography. The first stresses the indexical character of the medium's status as a vehicle of truth, as a record of that which exists in the world; its seamless actuality becomes a form of documentation and testimony. The second, its antithesis, focuses on the artificiality of photography; originating in late nineteenth-century experimental techniques developed within the confines of the studio, it foregrounds photography's constructed nature. The instantaneity that is particular to the medium is thus differently parsed in each modality; whereas the former stresses the fleeting and the evanescent, the latter freezes the momentary into an eternal present, a timeless realm that appears to lie outside the vicissitudes of the passing instant.

In embracing both histories, Mylayne has created a hybrid form. Even as his photographs declare themselves as rigorously and fastidiously constructed entities made with a large format camera employing complex lenses, the viewer recognizes that they depict wild creatures, rather than tamed or trained specimens. Photographers dedicated to a study of untamed nature normally seek the unexpected, their "hunter's consciousness" approximating, in Lee Friedlander's celebrated metaphor, the nervous looking of a "one-eyed cat." In such work the role of composition, far from sovereign, is limited to what Wall terms "a dynamic of anticipatory framing."[15] Mylayne's disdain for the predator's inspired seizing of an unsuspecting quarry is commensurate with his spurning of both improvisation and spontaneity. If his model is closer to that of the diligent gardener who patiently cultivates the natural to fruitful ends, his rationale is closer to that of Wall's, which similarly rejects unanticipated effects. "The reliance on immediate spontaneity thins out the image, reducing the level at which the permanent dialectic between essence and appearance operates in it," Wall argues in a statement that articulates certain precepts fundamental to Mylayne's aesthetic. "I'm not convinced that the beauty isn't in a way limited by its dependence on the immediate surface of things. That kind of photography," Wall concludes, "is condemned always to gaze at the world in wonder and irony rather than engage in construction."[16]

Mylayne's prioritizing of a constructed beauty at the expense of verisimilitude becomes, as it does in Wall's practice, the means to cognitive enquiry. Among the most compelling aspects of the Frenchman's signature works are their complexly constructed multi-focal spaces. Sometimes, as seen in *No. 6, June July August 1979*, and *No. 117e, June 1991–August 1992* (Plates 4 and 39), a section of the foreground may be in focus as well as areas in the distance while the midfield is blurry. Replacing the customary monofocal vanishing point with plummeting, unstable spatial fields that require an attentive negotiation of distance and proximity, these images demand another kind of scrutiny. Reading thus proceeds cumulatively, part by part, rather

15    Jeff Wall, "'Marks of Indifference': Aspects of Photography in, or as, Conceptual Art," 1995; reprinted in *Jeff Wall: Selected Essays and Interviews* (New York: The Museum of Modern Art, 2007): 146.
16    Ibid., 195.

than synoptically, as the viewer's eye moves searchingly, even hesitantly, through these mutating spatial registers. Eschewing the consistency of a gestalt so beloved by documentary representations, Mylayne's photographs slow normal rates of assimilation, inviting a sustained study, which in turn stimulates reflections on time. Faced with contrasting temporalities—the interrupted flow of time in the natural world *and* the charged instant that is captured in the photographic representation—the spectator becomes reflexively aware of the unusually protracted duration needed to explore this image and how that then becomes an analogue for the extended duration inherent in its making. It is, however, only when his works are viewed collectively, as an ensemble in an exhibition context, that the crux of Mylayne's project fully reveals itself. While it may never require the spectator consciously to analyze the medium and its mechanisms, Mylayne's work depends on the potential, unique to photography, for manipulating temporal registers, first to beguile, then to prompt critical reflection.

"My practice has been to reject the role of witness or journalist, of 'photographer,' which in my view objectifies the subject of the picture by masking the impulses and feelings of the picture maker," Wall argues in an interview in 1996. "The 'poetics' or the productivity of my work," he continues, "has been in the stagecraft and pictorial composition.... [T]he theme has been subjectivized, has been depicted, reconfigured according to my feelings and my literacy.... That is why I refer to my pictures as prose poems."[17] In teasing out the seminal role of what he refers to as "stagecraft and pictorial composition" in the construction of his "prose poems," Wall has recourse to discursive analysis and exegesis, the rhetorical vehicles he privileges when addressing his practice. For the most part, the writing of poetry has served as a proxy for Mylayne's voice. While the differences in their practices are many, that which unites them is equally significant. Wall's finely articulated redaction of the place and functioning of a poetics in his practice consequently offers a model through which to address Mylayne's work (as a practice grounded in photography conceived as both art form and medium), and criteria by which it may be located in a specific historical context.

17 "Arielle Pelenc in Correspondence with Jeff Wall," 1996; reprinted in *Jeff Wall: Selected Essays and Interviews*, 258.

# Jean Luc Mylayne

Born 1946, Marquise, France
Baccalaureat, Philosophy
Lives and works in the world

Solo Exhibitions

2007    JEAN LUC MYLAYNE, Blaffer Gallery, the Art Museum of the University of Houston, September 8–November 10. Traveled to the Henry Art Gallery, University of Washington, Seattle; Museum of Contemporary Art Cleveland; and the Krannert Art Museum, University of Illinois, Urbana-Champaign.
JEAN LUC MYLAYNE, Texas Gallery, Houston, September–October

2005    JEAN LUC MYLAYNE, Lannan Foundation, Santa Fe, New Mexico
JEAN LUC MYLAYNE, Ink Tree edition, Kusnacht, Switzerland, in collaboration with Christophe Daviet Thery Gallery, Paris

2004    JEAN LUC MYLAYNE, Lannan Foundation, Santa Fe, New Mexico, March 6–27
JEAN LUC MYLAYNE: LES OIES SAUVAGES RIAIENT ET DIEU S'ENDORMIT TÔT (The Wild Geese Laughed and God Went to Sleep Early), Musée des Arts Contemporains, Grand Hornu, Belgium, August 8–October 3. Catalogue, texts by Jean Luc Mylayne and Laurent Busine

2003    JEAN LUC MYLAYNE: BLAZING RED, Barbara Gladstone Gallery, New York, June 5–August 15

2002    JEAN LUC MYLAYNE: THE MIRRORS OF THE KAIRICIFORMS, Patrick Painter, Inc. Santa Monica, California, June 1–July 6
JEAN LUC MYLAYNE: KAIRICIFORMS' IMPRESSION, Galerie Monika Sprüth, Cologne, September 13–October 19
JEAN LUC MYLAYNE, Ink Tree edition, Kusnacht, Switzerland

1999    JEAN LUC MYLAYNE: AS WE ARE THE FIRST KAIRICIFORMS, The Photographers' Gallery, London, December 3–January 29, 2000
JEAN LUC MYLAYNE: WE ARE THE FIRST KAIRICIFORMS, Barbara Gladstone Gallery, New York, May 22–June 25

1997    JEAN LUC MYLAYNE, Barbara Gladstone Gallery, New York, May 3–31

1996    JEAN LUC MYLAYNE, Galerie Météo at "Art 27 '96," Basel, June 12–17

1995    JEAN LUC MYLAYNE, ARC/Musée d'Art Moderne de la Ville de Paris, January 20–March 5 Catalogue, texts by Bernard Lamarche-Vadel and Laurence Bossé
JEAN LUC MYLAYNE: AVIAN TIME, Boca Raton Museum of Art, Boca Raton, Florida, September 8–October 22. Catalogue, texts by Timothy A. Eaton

1994    JEAN LUC MYLAYNE: L'ATELIER, Musée d'Art Moderne, Saint-Etienne, France,
        July–August. Catalogue, text by Bernard Larmarche-Vadel

        JEAN LUC MYLAYNE, Galerie Barbier-Beltz, FIAC, Paris, October 8–16

1993    JEAN LUC MYLAYNE, Musée de l'Abbaye Sainte-Croix, Les Sables-d'Olonne, France

1992    JEAN LUC MYLAYNE, Musée Bonnat, Le Carré, Bayonne, France. Catalogue, texts by
        Didier Arnaudet and Vincent Ducoureau

        JEAN LUC MYLAYNE, Centre d'Art, Vitre, France

        JEAN LUC MYLAYNE, Galerie Météo, Paris

1991    JEAN LUC MYLAYNE, Musée d'Art Moderne, Saint-Etienne, France. Catalogue, texts by
        Louis Calaferte, Patrick Lenouene and Jean François Chevrier

1990    JEAN LUC MYLAYNE, Bibliothèque Nationale, Paris, August 1–September 1. Publication,
        text by Jean Claude Lemagny

        JEAN LUC MYLAYNE, Centre Regional de la Photographie, Nord-Pas de Calais, France

1989    JEAN LUC MYLAYNE, 1989–1990, Musée des Beaux-Arts, Calais, France. Catalogue,
        texts by Patrick Le Nouene and Louis Calaferte

        Selected Group Exhibitions

2006    NOEL GRUNEWALD AND JEAN LUC MYLAYNE, Glenn Horowitz Bookseller,
        East Hampton, New York, July 8–August 8

2004    ANIMALS, Haunch of Venison Gallery, London, June 24–September 11

2002    AVIARY, Edward Thorp Gallery, New York, December 12–January 25, 2003

2001    COLLABORATIONS WITH *Parkett*: 1984 TO NOW, The Museum of Modern Art,
        New York, April 5–June 5. Catalogue, texts by Deborah Wye and Susan Tallman

        CONNIVENCE, 2001 Biennale d'art contemporain de Lyon, Musée d'Art Contemporain,
        Lyon, France, June 23–September 23. Catalogue, texts by Thierry Raspail, Thierry
        Pratt, and additional contributors

        BEAUTIFUL PRODUCTIONS: ART TO PLAY, ART TO WEAR, ART TO OWN,
        Whitechapel Art Gallery, London, July 6–August 19. Traveled to Irish Museum of
        Modern Art, Dublin, June 20–October 27, 2002

2000    FRENCH COLLECTION, Barbican Art Gallery, The Barbican Centre, London

1999    NEW NATURAL HISTORY, National Museum of Photography, Film and Television,
        Bradford, England, September 17–November 14. Catalogue, text by Val Williams

1998    TERRA INCOGNITA: ALIGHIERI E BOETTI, VIJA CELMINS, NEIL JENNEY, JEAN LUC
        MYLAYNE, HIROSHI SUGIMOTO, Neues Museum Weserburg, Bremen, Germany,
        May 10–August 23. Catalogue, text by Lynne Cooke

THE NATURAL WORLD, Vancouver Art Gallery, Canada, October 10–January 24, 1999. Catalogue, text by Mark Dion

SENTIMENTALE JOURNÉE, Musée d'Art Moderne et Contemporain, Strasbourg, November 6–January 7, 1999

1997    GROUP EXHIBITION, Galerie Gilbert Brownstone, Paris
        GROUP EXHIBITION, Galerie Météo, Paris

1996    JURASSIC TECHNOLOGIES REVENENT, Tenth Biennale of Sydney, July 27–September 22. Catalogue, text by Lynne Cooke

1995    ZEICHEN UND WUNDER (SIGNS AND WONDER) NIKO PIROSMANI AND RECENT ART, Kunsthaus Zürich, March 31–June 18. Traveled to Centro Galego de Arte Contemporánea, Santiago de Compostela, Spain, July 20–October 20. Catalogue, text by Bice Curiger

1994    GROUP EXHIBITION, Galerie Météo, Paris
        GROUP EXHIBITION, Musée des Beaux Arts, Agen, France
        GROUP EXHIBITION, Galerie Claudine Papillon, Paris

1993    GROUP EXHIBITION, Galerie Barbier-Beltz, Paris

Selected Bibliography

2006    Bertrand, Anne. "Denkbilder." *Camera-Austria* (Issue 93): 18–29
        Olivarez, Russel, ed. *Exit* (Issue 22): 154–55

2005    Zaunschirm, Thomas. "Das Tier als Readymade. (The Animal is Readymade)" *Artforum International* (Issue 174): 68
        Scemama, Patrick, ed. "Opera Bastille: Olivier Messian's Saint Francois d'Assisse." [Opera publication with photographs by Jean Luc Mylayne], October–November 2004

2004    Artschwager, Richard. "20 Years of Parkett Artists." *Parkett* (Issue 71)
        Elliot, Fiona, Marjorie Jongbloed, Brigitte Oetker, Yvonne Quirmback, Christiane Schnieder, eds. *Jahresring 50.* Germany: Verlag der Buchhandlung Walther Konig Publishers, 2004

2003    Kuspit, Donald. "Three Photographers: Luis Mallo, Jean-Luc Mylayne, Takihiro Sato." *Art New England* (October/November 2003)
        Newhall, Edith. "Fine Feathered Friends." *New York Magazine* (June 22, 2003): 79
        Scott, Andrea. "Jean Luc Mylayne." *Time Out New York* (June 26–July 3, 2003): 56
        Yablonsky, Linda. "Postcards from the Edges." *Art Review* (September 2003): 29–30

2002    Kertess, Klaus. *Photography Transformed: The Metropolitan Bank Trust Collection.* New York: Harry N. Abrams, Inc., 2002

2001    Franklin, Catherine. "Lyon: Connivence, Sixième Biennale d'Art Contemporain." *Art Press* [France] (Issue 272)

2000    Curiger, Bice. "Jean Luc Mylayne." *Fresh Cream: Contemporary Art in Culture*.
        London: Phaidon Press, Ltd., 2000

        Jones, Jonathan. "Bird's Eye View." *The Guardian* (January 4, 2000)

        Rugoff, Ralph. "A uniquely human bird's eye view of the landscape." *Financial Times*
        (January 17, 2000)

        _____. "Top 10," *Artforum* (December 2000)

        "The Photographers' Gallery, London." *Zoom* (January/February 2000)

1999    Givens, David. "Confessions of a bird watcher." *Frieze* (November/December 1999)

        Leffingwell, Edward. "Jean Luc Mylayne at Barbara Gladstone." *Art in America*
        (October 1999)

        Mikhall, Kate. "Waiting for the bird man of Amiens." *The Independent* (December 14, 1999)

        Mitchinson, Amanda. "Watch the birdie." *Sunday Telegraph Magazine* (November 28, 1999)

1997    Arnaudet, Didier. "Image of a Gift." *Parkett* (Issue 50–51): 122–726

        Cooke, Lynne. "Cosmologer." *Parkett* (Issue 50–51): 103–107

        Curiger, Bice. "Back to Back." *Parkett* (Issue 50–51): 132

        Dion, Mark. "For Jean Luc Mylayne." *Parkett* (Issue 50–51): 113–21

        Jeffrey, Ian. *The Photography Book.* London: Phaidon Press, Ltd., 1997

        Mylayne, Jean Luc. "Two Text Pieces Untitled." *Parkett* (Issue 50–51): 130

1995    *Kunst Bulletin*, (March/June 1995)

        Arnaudet, Didier. "Jean Luc Mylayne: A Concern for Beauty." *Art Press* [France]
        (Issue 200 (March 95)): 41–45

        Guéhenneux, Lise. "La Création." *Révolution* (February 16, 1995)

        Guerrin, Michel. "Le Photographe Jean Luc Mylayne Chasse le Oiseaux." *Le Monde*
        (February 8, 1995)

        Jover, Manuel. "Les silences de Mylayne." *Beaux-Arts Magazine* (February 1995)

        Nuridsany, Michel. "Mylayne Saint-Francois photographe." *Le Figaro* (January 31, 1995)

        Ollier, Beatrice. "Mylayne, espece en voie de disparition." *Liberation* (January 28, 1995)

1994    Jouannais, Jean-Yves. "La Photographie comme cosa mentale." *Art Press* [France]
        (September 1994)

1993    Gourmelon, Mo. "L'eloquence de la peinture." *Arte Factum # 48* [Anvers, Belgium]

1992    Arnaudet, Didier. "Comme un haiku." *Art Press* [France] (March 1992)

        Lamarche-Vadel, Bernard. "Les Veilleurs des Crepuscules." *Art Press* [France]
        (Special Issue)

Plates

### Artist's Acknowledgments

We wish to thank the following people who have helped us in the realization and presentation of the work: Lynne Cooke; J. Patrick Lannan, Jr., Douglas Humble, and Christie Mazuera Davis of the Lannan Foundation; the Board of the Lannan Foundation, which includes Marian P. Day, Sharon Ferrill, Karen A. Hetherington, William E. Johnston, Sharron Lannan Korybut, John R. Lannan, Lawrence P. Lannan, Jr., Frank C. Lawler, Mary M. Plauche, and Howard M. McCue III; the staff of the Lannan Foundation, including Jaune Evans, Laurie Betlach, Susie Bousson, Linda Carey, Jo Chapman, Ray Freese, Martha Jessup, Kristin Ryan, and Ruth Simms; friends Andrea Tuch, Kristin Bonkemeyer, Suzanne and Tom Dungan, and Barbara and Ray Graham; Barbara Gladstone, Maxime Falkenstein, Rosalie Benitez, Stacey Tunis, Bridget Donahue, Adam Ottavi-Schiesl, and Miciah Hussey, and the rest of the staff at Barbara Gladstone Gallery; Don McIvor, Scott and Julie McIvor and their daughters Locke Ann and Mae, and Deb McIvor; Lily and Gregg Wilson; Jean Francois Gallois, Pierre Moutet, and the staff of Central Color; Terrie Sultan and the staff of Blaffer Gallery, the Art Museum of the University of Houston; Fredericka Hunter, Ian Glennie, and the staff at Texas Gallery; and Jack Woody and the staff at Twin Palms Publishers.

> Myléne and Jean Luc Mylayne

### Acknowledgments

Blaffer Gallery, the Art Museum of the University of Houston, gratefully acknowledges the generosity and support of the following: The Lannan Foundation; The Eleanor and Frank Freed Foundation; the Texan-French Alliance for the Arts and its presenting partner the Levant Foundation; and the French Cultural Services.

I would like to thank Blaffer staff members Kelly Bennett, Jeffrey Bowen, Youngmin Chung, Susan Conaway, Michael Guidry, Nancy Hixon, Katherine Lopez, Claudia Schmuckli, Katherine Veneman, and Karen Zicterman; interns Susan Itin, Steven Thompson, and Aja Young; Alexandra Irvine and Polly Koch; Christopher French; Lynne Cooke for her insightful essay; Suzanne and Tom Dungan for introducing me to the work; and Jack Woody for this wonderful book. Thanks to colleagues Richard Andrews and Elizabeth Brown at the Henry Art Gallery, University of Washington, Seattle; Jill Snyder and Margo Crutchfield at the Museum of Contemporary Art Cleveland; and Kathleen Harleman at the Krannert Art Museum, University of Illinois, Urbana-Champaign for sharing my enthusiasm for Jean Luc Mylayne's art. Working with Jean Luc and Myléne Mylayne has been an enormous pleasure, and I deeply appreciate their generosity and dedication to this project.

> Terrie Sultan, Director
> Blaffer Gallery, the Art Museum of the University of Houston

Colophon

This first edition of *Jean Luc Mylayne* is limited to 2,000 casebound copies. The photographs and texts are copyright Jean Luc Mylayne, 2007. "A Matter of Place" is copyright Terrie Sultan, 2007. "Time Lapse" is copyright Lynne Cooke, 2007. Book contents are copyright Twin Palms Publishers, 2007. Book design by Jean Luc Mylayne and Jack Woody. Typography by Arlyn Eve Nathan. Production management by Jonathan Hollingsworth. Printed and bound in Korea.

ISBN 978-1-931885-67-6

TWIN PALMS PUBLISHERS
Post Office Box 10229
Santa Fe, New Mexico 87504
800.797.0680
www.twinpalms.com